50 MODERN ARTISTS
YOU SHOULD KNOW

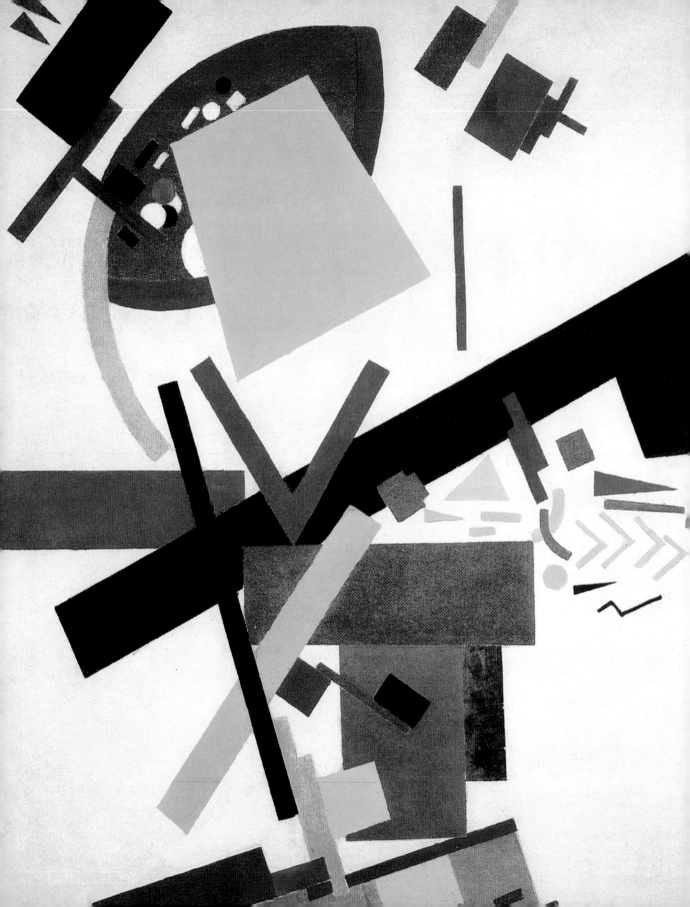

50 MODERN ARTISTS
YOU SHOULD KNOW

Christiane Weidemann
Christine Nippe

Prestel
Munich · Berlin · London · New York

Prestel Verlag, Munich
A member of Verlagsgruppe Random House GmbH

Prestel Verlag
Königinstrasse 9
80539 Munich
Tel. +49 (0)89 24 29 08-300
Fax +49 (0)89 24 29 08-335

Prestel Publishing Ltd.
4 Bloomsbury Place
London WC1A 2QA
Tel. +44 (0)20 7323-5004
Fax +44 (0)20 7636-8004

Prestel Publishing
900 Broadway, Suite 603
New York, NY 10003
Tel. +1 (212) 995-2720
Fax +1 (212) 995-2733

www.prestel.de

www.prestel.com

The Library of Congress Number: 2010930558

British Library Cataloguing-in Publication Data: a catalogue record for this book is available from the British Library; Deutsche Nationalbibliothek holds a record of this publication in the Deutsche Nationalbibliografie; detailed bibliographical data can be found under: http://dnb.d-nb.de

Project management by Andrea Weißenbach
Copy edited by Laura Hensley, Chicago
Timeline by Regina Herr
Translated from the German by Paul Aston, Rome
Cover and design by LIQUID, Agentur für Gestaltung, Augsburg
Layout by zwischenschritt, Rainald Schwarz, Munich
Production by Astrid Wedemeyer
Origination by ReproLine Mediateam
Printed and bound by Druckerei Uhl GmbH & Co. KG, Radolfzell

FSC
Mixed Sources
Product group from well-managed
forests and other controlled sources
Cert no. GFA-COC-001526
www.fsc.org
© 1996 Forest Stewardship Council

Verlagsgruppe Random House FSC-DEU-0100
The FSC-certified *Opuspraximatt* paper in this book
is produced by Condat and delivered by Deutsche Papier.

Printed in Germany

ISBN 978-3-7913-4470-6

CONTENTS

1804 Napoleon Bonaparte becomes Emperor of the French

1848 Karl Marx and Friedrich Engels publish Communist Manifesto

1865 Abolition of slavery in the United States

1785 1790 1795 1800 1805 1810 1815 1820 1825 1830 1835 1840 1845 1850 1855 1860 1865 1870

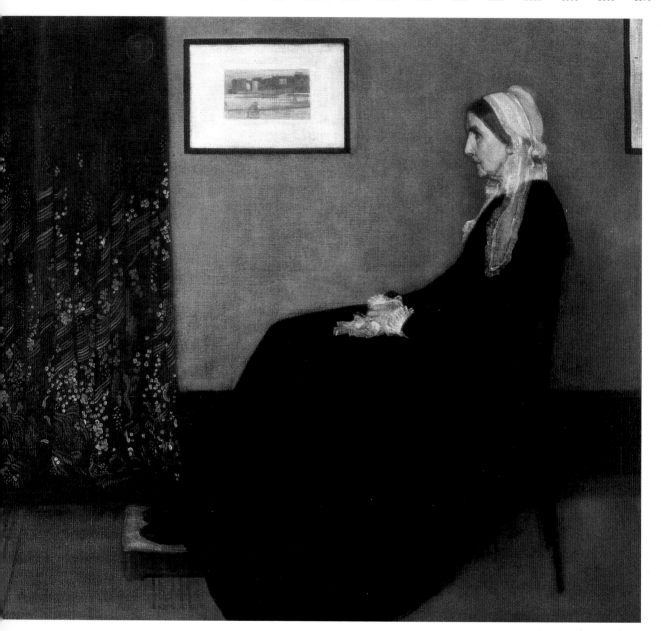

James McNeill Whistler, *Arrangement
in Gray and Black: Portrait of the Artist's
Mother*, 1871, oil on canvas,
144.3 x 165.2 cm, Musée du Louvre, Paris

1875 1880 1885 1890 1895 1900 1905 1910 1915 1920 1925 1930 1935 1940 1945 1950 1955 1960

JAMES MCNEILL WHISTLER

James McNeill Whistler is considered the first major American artist to earn an international reputation. He played an important part in popularizing Impressionism in Great Britain and North America. Whistler interpreted the Impressionist style in an original way, linking it with elements of Symbolism.

Pared-Down Landscape Panoramas

Born in Lowell, Massachusetts, in 1834, Whistler spent part of his childhood in St. Petersburg, Russia. He lived in Europe from 1855, mostly in England, but sometimes in France, where, like many Impressionists, he enrolled at the studio of Charles Gleyre. Most influential on him, however, were his encounters with realist painter Gustave Courbet and the avant-garde artists close to him, including Edouard Manet and Edgar Degas.

Later, in England, Whistler increasingly moved away from realism. He was particularly interested in Japanese art, a fashion that became widespread in Europe from 1860. One of the high points of that period of his career is the painting *Variations in Violet and Green*, which demonstrates a new kind of landscape picture developed under the influence of the Far East. In many of his works, he reduced the landscape to almost empty panoramas, thereby coming close to abstract representation. This made Whistler an important model for British printmaking, which he helped revitalize in the second half of the 19th century.

Musical Works

Whistler also established a reputation as a portrait painter; one of his best-known works is *Arrangement in Gray and Black: Portrait of the Artist's Mother*. At the end of the 1870s, he did a series of nocturnal views called *Nocturnes*, including numerous views of the Thames, generally in monochromatic coloration. The subject matter recalls the Impressionist preference for urban landscapes and watercourses, but unlike those artists Whistler was mainly concerned with the harmony and aesthetics of color. In the *Nocturnes*, he attempted to render music in painting. To emphasize purely aesthetic functions, he had already begun to give his works musical designations such as "symphony" or "harmony." The linking of art and music was not without influence on subsequent painters. Even Whistler's

design for the Peacock Room in a private London house was of art-historical importance. The decoration he did there for art collector Frederick Richards Leyland is considered a precursor of Art Nouveau.

Whistler had a certain combative streak. The personalities in French or British cultural life with whom the eccentric artist struck up an acquaintance or friendship—before ultimately dropping them—were legion. He hit the headlines in 1878 with his libel suit against art critic John Ruskin. Although Whistler won his case, the derisory damages and high court costs bankrupted him.

1834 Born on July 11 in Lowell, Massachusetts
1843 Moves with his family to St. Petersburg, Russia
1851–1854 Attends the U.S. Military Academy at West Point, New York
1855 Moves to Paris
1859 Moves to London
1877 Decorates the "Peacock Room"
1878 Sues Ruskin for libel; begins his first experiments in lithography
1879 Declares bankruptcy; sells his London property and possessions
1880 Departs for Venice
1885 Presents the "Ten O'Clock" lecture in Princess Hall, London
1890 Publishes *The Gentle Art of Making Enemies*
1901 Closes his studio in Paris
1903 Dies on July 17 in London

James McNeill Whistler, December 1878, photograph, Whistler Collections, University Library, Glasgow

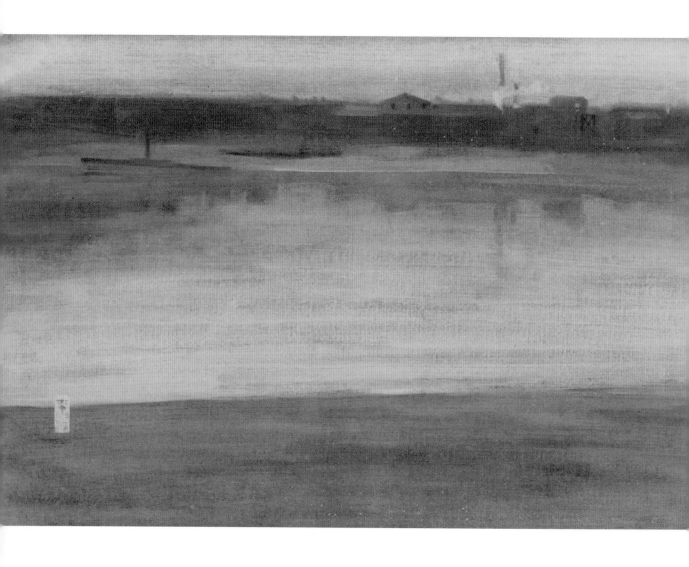

above
James McNeill Whistler, *Symphony
in Gray: Early Morning, Thames*, 1871,
oil on canvas, 45.7 x 67.3 cm, Freer
Gallery of Art, Smithsonian Institution,
Washington, D.C.

right page
James McNeill Whistler, *Nocturne in Blue
and Gold–Old Battersea Bridge*, 1872–77,
oil on canvas, 68.3 x 51.1 cm, Tate
Gallery, London

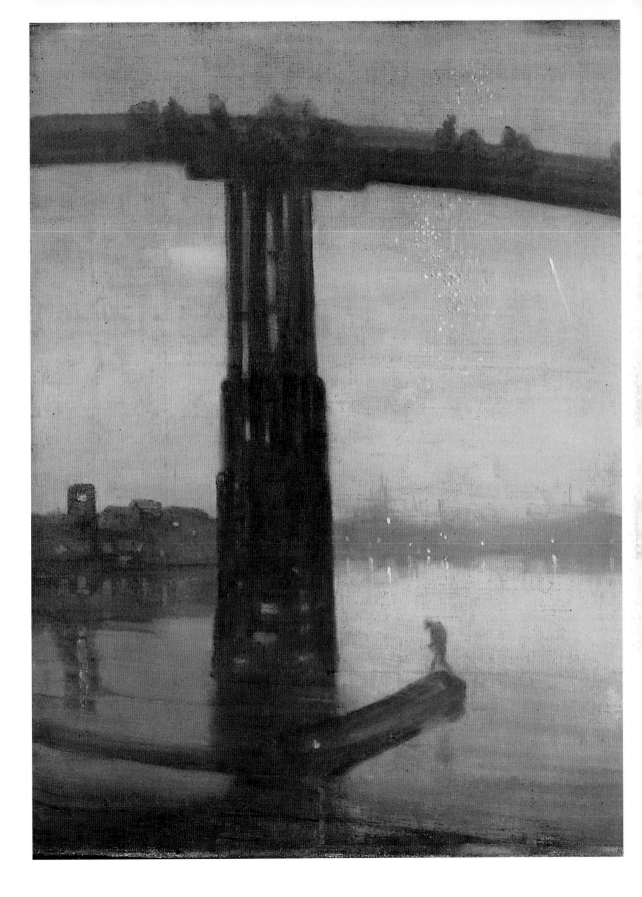

1826 First photograph **1857** *Madame Bovary* **1871** Prussian
(Gustave Flaubert) armies
occupy Paris

| 1790 | 1795 | 1800 | 1805 | 1810 | 1815 | 1820 | 1825 | 1830 | 1835 | 1840 | 1845 | 1850 | 1855 | 1860 | 1865 | 1870 | 1875 |

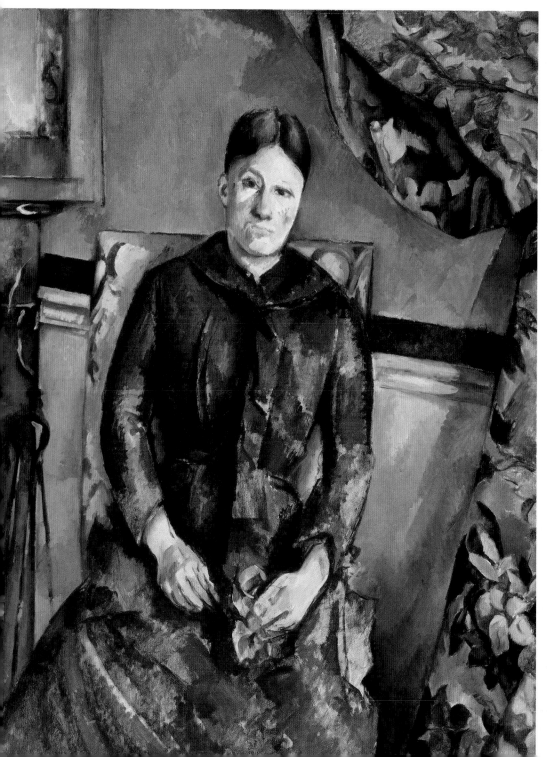

Paul Cézanne, *Hortense
Fiquet in a Red Dress*,
1888–90, oil on canvas,
116.5 x 89.5 cm, The Metro-
politan Museum of Art,
New York

1887–1889 Construction of **1901** * Walt Disney **1914–1918** World War I
Eiffel Tower in Paris
1897–1899 First *Water Lilies* (Claude Monet)
1888 *Sunflowers* (Vincent van Gogh) **1905/11** Founding of "Die Brücke" and
"Der Blauer Reiter" groups of artists

1880 1885 1890 1895 1900 1905 1910 1915 1920 1925 1930 1935 1940 1945 1950 1955 1960 1965

PAUL CÉZANNE

"Cézanne is the father of us all."—Pablo Picasso
"I am the forerunner of the new art. And I sense my work will be continued."—Paul Cézanne

Paul Cézanne is considered the uncontested master of Post-Impressionism, and at the same time the crucial innovator to whom the Cubists, Fauves, and Expressionists owed the essential features of their art.

After going to the lycée and art school in his hometown of Aix-en-Provence, in the south of France, Cézanne attended law school. He soon gave this up, however, to move to Paris in 1861 and enroll as a student at the Académie Suisse, an independent atelier that constituted a kind of alternative to the official academy of art. His encounter there with Impressionists associated with Claude Monet, Auguste Renoir, and Edgar Degas proved all-important. Cézanne changed his palette completely, and instead of the dark tones he had used to that point, he now experimented with light, brilliant colors. Unlike the Impressionist painters, however, he was not trying to record transitory visual moments, but rather to render the essence and permanence of visual phenomena. His application of paint was also less spontaneous than that of the Impressionists. Evolving a picture was much more of a persevering struggle for Cézanne, involving a decidedly time-consuming process.

Moving on from Impressionism

From the 1870s, Cézanne focused on landscapes and still lifes in which he sought to reduce visual objects to their basic geometric forms. In 1877, he abandoned Impressionist techniques in order to go his own way in the seclusion of Provence. Among his most famous subjects is Mont Sainte-Victoire, an impressive limestone ridge close to his hometown, which he painted directly from nature in drawings, oil paintings, and watercolors. Like his still lifes, the landscape paintings manifestly strive for a progressive simplification of elements, as Cézanne depicts houses as cubes, trees as cylinders, and the mountain as shapes layered on top of each other. He produced the impression of depth not, as was customary, through lines and contours, but rather through the contrast between warm and cool colors. He defined objects with color, then gave them firm outlines.

Harmony by Design

Cézanne's painting *Les Grandes Baigneuses*, done shortly before his death, may be considered his intellectual legacy. The purely abstract approach adopted by artists later in the 20th century can already be discerned in the structure of facets and shapes in this work. For Cézanne, works of art were independent worlds of color and shape, "harmony parallel to nature"; he sought not to imitate his subjects but rather to represent them, so as to bring out their internal essence. This conviction would become an essential basis of modernism.

1839 Born on January 19 in Aix-en-Provence, France
1852 Makes friends with the future novelist Émile Zola
1861 Cézanne moves to Paris for the first time
1869 Meets his lover, Hortense Fiquet
1870 Lives in the fishing village of L'Estaque during the Franco-Prussian War
1872 Cézanne's son Paul born
1886 Breaks off contact with Émile Zola. Marries Hortense in April.
1895 Cézanne's first major exhibition held in Paris
1900 His pictures are also shown in Germany
1906 Dies on October 22 in his birthplace, Aix-en-Provence

Paul Cézanne, photograph

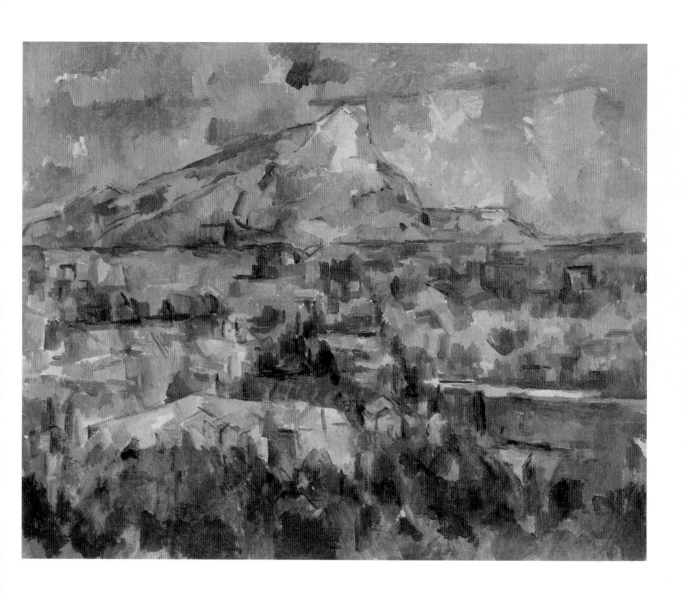

Paul Cézanne, *Mont Sainte-Victoire Seen from Les Lauves*, 1902–04, oil on canvas, 69.8 x 89.5 cm, Philadelphia Museum of Art, Collection George W. Elkins

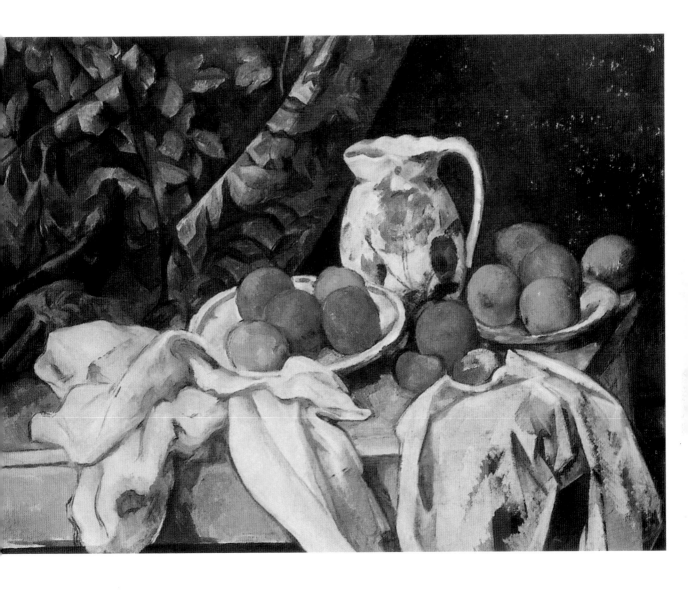

Paul Cézanne, *Still Life with Drapery*,
1898/99, oil on canvas, 54.7 x 74 cm,
Hermitage, St. Petersburg

1837 Victoria becomes queen of
the United Kingdom

1871 Prussian
armies
occupy Paris

1826 First photograph

1790 1795 1800 1805 1810 1815 1820 1825 1830 1835 1840 1845 1850 1855 1860 1865 1870 1875

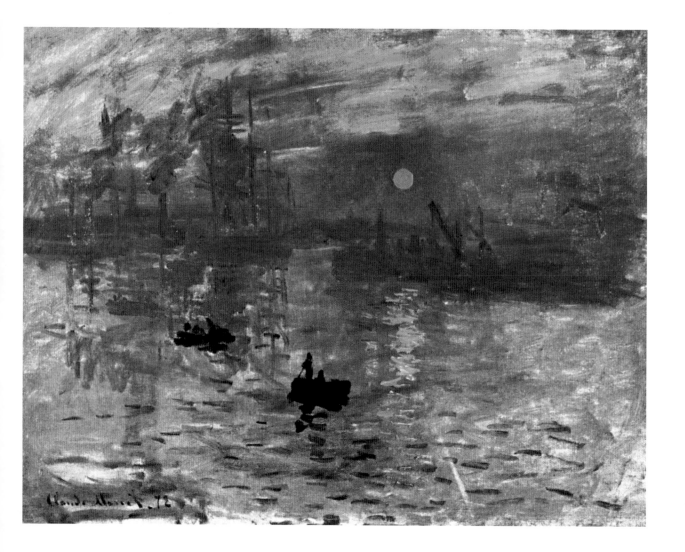

Claude Monet, *Impression, Sunrise*,
1872, oil on canvas, 49.5 x 65 cm,
Musée Marmottan, Paris

1888 *Sunflowers* (Vincent van Gogh)

1887–1889 Construction of Eiffel Tower
in Paris

1914–1918 World War I

1921 Einstein awarded Nobel Prize for Physics

1905/11 Founding of "Die Brücke" and
"Der Blauer Reiter" groups of artists

1927 Lindbergh flies solo across
the Atlantic

| 1880 | 1885 | 1890 | 1895 | 1900 | 1905 | 1910 | 1915 | 1920 | 1925 | 1930 | 1935 | 1940 | 1945 | 1950 | 1955 | 1960 | 1965 |

CLAUDE MONET

In his long artistic career, Claude Monet was an intermediary between tradition and modernism. While considered one of the main representatives of Impressionism, which he helped to establish, he also transcended the Impressionist style in his later work.

During the 19th century, it was repeatedly and loudly asserted that artists could adequately render nature only by directly viewing it. But it was only the Impressionists, and in particular Monet, who managed to carry this through with conviction. Indeed, even during his training as a young artist in Le Havre (where he had grown up from 1845), in northwest France, and later in Paris, Monet was a champion of open-air painting. In this, he was united with Alfred Sisley, Auguste Renoir, and other like-minded artists who joined him for painting sessions in the forest of Fontainebleau, south of Paris. It was during this period (1865–66) that he created his famous painting *Déjeuner sur l'Herbe*.

Snapshots

Monet's pursuit of a modern visual idiom in his early works resulted in Impressionism. In 1874, he showed his work *Impression, Sunrise* at the first group exhibition with his fellow artists. Critic Louis Leroy believed that "wallpapers at a very early stage [are] more finished than this seascape." (He also described all of the artists mockingly as "Impressionists," thereby giving the group its name.) The painting is an exemplary demonstration of the fundamental Impressionist principle of only aiming to render what is purely visible. In his view of the Seine estuary near Le Havre, Monet records not the objects themselves, but rather the impression he gets of them. He shows the port in a bluish haze so that ships and boats, cranes and chimneys can only be dimly perceived, just as they appeared at the moment of recording.

The Painter of Light

Monet was interested in light, color, and changing nature. From 1872 to 1878, he lived in Argenteuil-sur-Seine, where he did paintings of bridges and boats, views of town and country, and family scenes in the garden. This was the heyday of Impressionism. Monet attributed an intrinsic importance to every object, and he selected the relevant shade of color without regard to the total effect of the work. He aimed to show how light changes colors and also influences the perception of reality.

Monet's efforts to do justice to the constantly changing impressions of reality led him to abandon Impressionist techniques from 1880. His light, bright paintings gave way to works in dark tones, often showing cliffs and coastal landscapes in extreme weather conditions. After the painter had settled in the small village of Giverny, near Paris, in 1883, he began to work on series involving a single subject at different times of day—haystacks, poplars, or Rouen Cathedral.

Dissolution of Shapes

In the garden of his estate in Giverny, Monet also found the subject matter—water lilies—that would represent the greater part of his late work. As his eyesight steadily deteriorated, he often worked on canvases up to 6 meters (20 feet) wide, producing a radical rendering of what he saw in terms of pure surface. These landscapes of water and water lilies—lacking a horizon and devoid of any firmly outlined structure or perspective—come across as pictures of a peaceful, ideal world. Created apart from contemporary avant-garde developments, they were long neglected by critics and other artists. It was only in the 1950s that these expressive pictures were rediscovered, especially by the Abstract Expressionists.

1840 Born on November 14 in Paris
1845 The Monet family moves to
Le Havre
1856 Earns money with caricatures
1872 Paints river landscapes from his
houseboat
1874 Monet's picture *Impression:
Sunrise* features at the first
Impressionist exhibition
1883 Rents a house in Giverny, where
he lays out his famous garden
1897 Produces his first water-lily
paintings in Giverny
1900 His eyesight declines increasingly
through illness
1926 Dies on December 6 in Giverny

Claude Monet, photograph

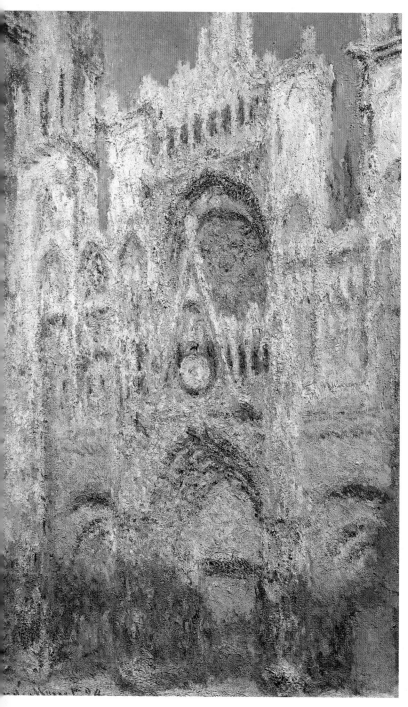

Claude Monet, *The Rouen Cathedral in the Evening*, 1894, oil on canvas, 101 x 65 cm, Pushkin Museum, Moscow

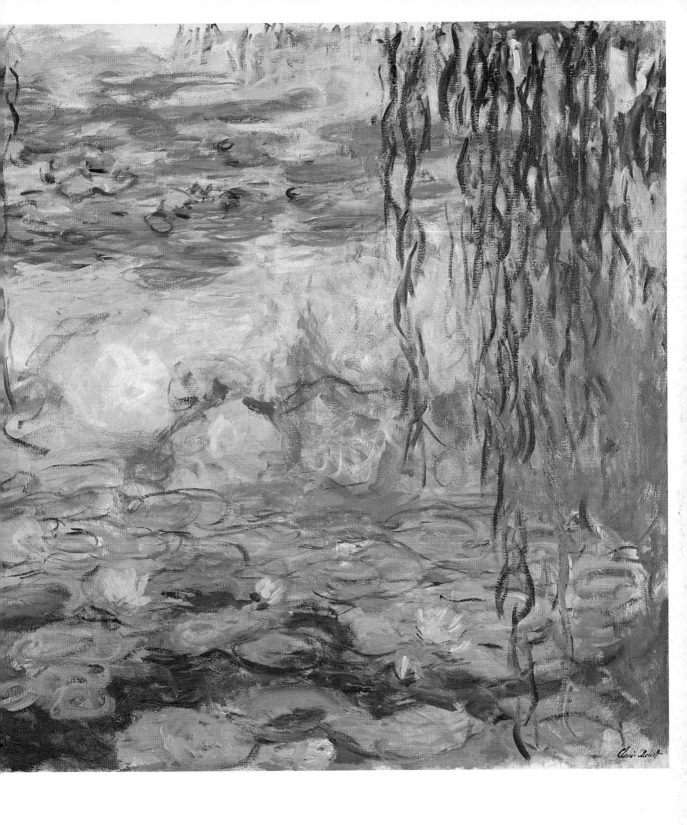

Claude Monet, *Water Lilies*, 1916–19,
oil on canvas, 150 x 197 cm, Musée
Marmottan, Paris

1871 Wilhelm I
becomes
Kaiser of
Germany

1790 1795 1800 1805 1810 1815 1820 1825 1830 1835 1840 1845 1850 1855 1860 1865 1870 1875

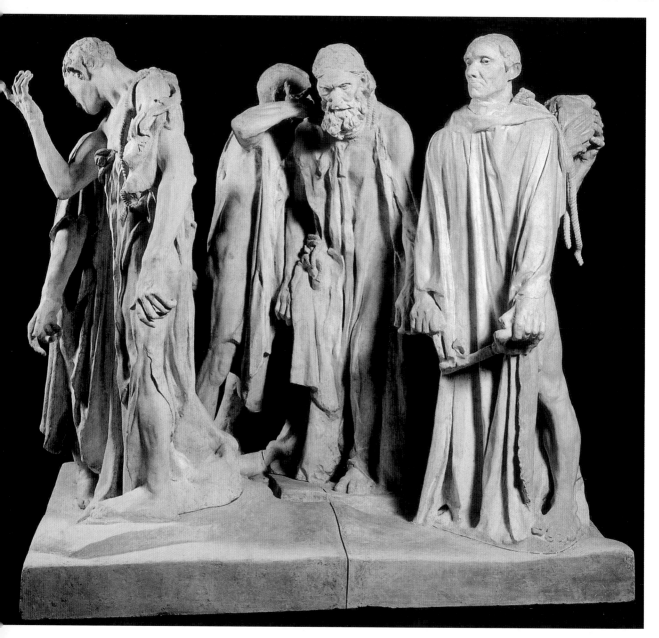

Auguste Rodin, *The Burghers of Calais*,
1889, gypsum, 231.5 x 248 x 200 cm,
Musée Rodin, Paris

1876 World's Fair in Phila-　1887–1889 Construction of Eiffel　　1907 *Les Demoiselles d'Avignon* 1921 Einstein awarded Nobel Prize
delphia, Alexander　　　　　Tower in Paris　　　　　　　　(Pablo Picasso)　　　　　　for Physics
Bell's telephone
　　　　　　　　　　　　　　　　　　　　　1900 World's Fair in Paris　　1914–1918 World War I　　　　　　　　　　　　1939–1945 World War II
　　1880 Degas paints 14-year-old　　1897–1899 First *Water Lilies* 1910 Futurist Manifesto, Italy
　　　　　ballet dancer　　　　　　　(Claude Monet)

1880　1885　1890　1895　1900　1905　1910　1915　1920　1925　1930　1935　1940　1945　1950　1955　1960　1965

AUGUSTE RODIN

Auguste Rodin is considered the most important representative of sculpture in the late 19th century. His concept of sculpture had considerable influence on the development of art in the 20th century, and can be compared with the advances his contemporaries Vincent van Gogh and Paul Cézanne achieved for painting.

The Gates of Hell

When Rodin was commissioned in 1880 by the French state to design the monumental doorway for the future Museum of Decorative Arts in Paris, he could not foresee the magnitude of the job. *The Gates of Hell*, inspired by Dante's *Divine Comedy*, would keep him busy for nearly 37 years. By his death, he had completed nearly 200 individual figures, yet still the job remained unfinished. Rodin succeeded in transferring Dante's depiction of the journey through the realms of the hereafter—Hell, Purgatory, and Paradise—into a fresco of human passions and emotions, thereby expanding the traditional concept of sculpture in a revolutionary fashion.

The Gates of Hell project was an inexhaustible source of new ideas and works for its creator. Rodin created some of the figures as independent works, such as the sculpture *The Thinker*, representing the poet Dante. The cast of this figure was the first work by the artist to be erected in a public place—in front of the Pantheon in Paris, in 1906. Rodin was the first sculptor to deliberately produce fragmentary works, treating the torso as an autonomous form and elevating the incomplete to an artistic principle. In leaving the surface in various stages of modeling, he managed to create an impression of potential movement. *The Kiss*, one of the best-known creations by the French sculptor and an icon of fervent love between man and woman, also comes from the monumental work for *The Gates of Hell*.

Psychological Images

The Burghers of Calais was another important monumental work by Rodin, which he began in 1884 and took many years to complete. It was to be a tribute to a group of citizens who, in 1347, had handed themselves over to Edward III to persuade him to abandon the siege of Calais. The composition emphasizes the individuality of the hostages, each of whom handles the situation quite differently.

Rodin wanted to avoid the classic memorial setup and envisaged the work as devoid of a plinth, which triggered a lengthy controversy. It was an idea that anticipated fundamental changes in sculpture from the 1960s onward.

Though his studio in Meudon, near Paris, was fast taking on almost factory-like proportions—with more than 50 casters, masons, and marble workers making sculptures—the master also had time for works on paper, which he considered an autonomous part of his output. After his death in 1917, Rodin left numerous erotic sketches of female figures. Executing them using various drawing techniques, in these works he sought to capture the passing moment with dynamic lines and fluid colors.

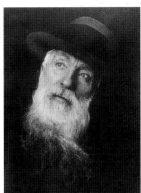

1840 Born on November 12 in Paris
1854–57 Attends the state-run school of arts and crafts, the Petite École, in Paris
1862 After the death of his older sister, Maria, joins a Christian order for a few years and turns away from art
1866 Has a son with lifelong companion Rose Beuret
1875 First entry accepted into the Paris Salon: *Man with the Broken Nose*
1880 Receives his first major state commission, for *The Gates of Hell*
1893 *The Kiss* brought to the Columbian Exposition in Chicago and rejected for being too erotic for public display
1917 Dies on November 18 in Meudon, France

left
Auguste Rodin, *The Thinker*, bronze, 71.9 x 45.1 x 56.2 cm, Musée Rodin, Paris

above
Pierre Choumoff, Auguste Rodin, 1916/17, photograph

1874 First Impressionist
exhibition in Paris

1801 Thomas Jefferson becomes **1865** Slavery abolished in the United States
3rd U.S. president
 1871 Charles Darwin
1809–1825 South American wars **1851** Great Exhibition in London publishes the
of independence *Descent of Man*

1795 1800 1805 1810 1815 1820 1825 1830 1835 1840 1845 1850 1855 1860 1865 1870 1875 1880

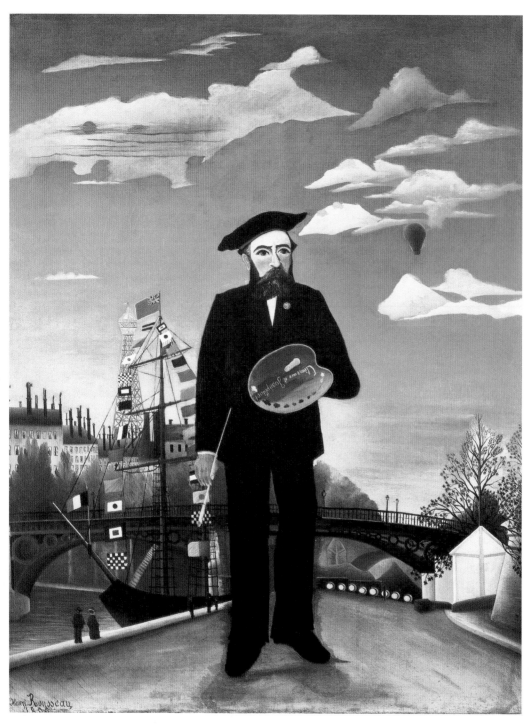

Henri Rousseau, *Myself,
Portrait-Landscape*, 1890,
oil on canvas, 143 x 110 cm,
National Gallery, Prague

| 1895 First Venice Biennale | 1914–1918 World War I | 1939–1945 World War II |
| 1900 Paris opens its first metro line | | 1946 Founding of UNESCO |

1885 1890 1895 1900 1905 1910 1915 1920 1925 1930 1935 1940 1945 1950 1955 1960 1965 1970

HENRI ROUSSEAU

Henri Rousseau was something of an oddball of modernism: his work is difficult to categorize into any single established artistic style. His fantastic compositions belonged to no tradition, and yet they opened up new worlds to art that made them all the more attractive to the avant-garde of the early 20th century.

Rousseau was born in Laval, in northwest France, in 1844. As an adult, he worked as an employee of the French Customs and Excise administration until he retired. Not until he was around 40 years old did he pursue painting more or less full-time, without having attended art school.

After artists Paul Signac and Maximilien Luce discovered the works Rousseau had been doing on his own, from 1886 he took part in the non-official salon, the Salon des Indépendants in Paris, where he exhibited together with Vincent van Gogh, Henri Matisse, and others. The praise and respect his works commanded were remarkable for an autodidact. Less surprising, given official tastes, was the critical panning of his naïve style, especially by conservative art critics.

Naïve Outlook

After the turn of the century, Rousseau—or the *Douanier* (Customs Official), as they called him— became a kind of cult figure for the new avant-garde. "Henri Rousseau showed us what simplicity has to offer. That side of his versatile talent is currently his principal merit," declared Vasily Kandinsky in the *Blauer Reiter* almanac in 1912, where seven paintings by Rousseau were reproduced. The "Douanier" developed into one of the most important inspirations of artistic modernism, from Cubism and realism to Magic Realism and Pittura Metafisica. The Surrealists in particular were inspired by the unselfconsciousness—indeed, the downright childlike innocence—of his pictures. They regarded him as an artistic genius who, on the strength of his individual experiences, could see further than an academically trained painter.

Rousseau's works came entirely from his imagination. His motifs derived first and foremost from an imaginary world and had little relationship with reality. That applied particularly to his famous jungle scenes, which he built up in flat planes to express his emotions—without ever having seen a jungle

(although he claimed otherwise). In these intensely colorful paintings with meticulously represented vegetation and exotic inhabitants, things look motionless and magical, and the settings seem fixed in a time warp; reality cannot be distinguished from the dream. Along with jungle pictures, to which Rousseau dedicated himself almost exclusively in the last six years of his life, he did portraits, urban scenes, landscape pictures, and floral still lifes, which he likewise stripped back to their essentials.

Rousseau died in Paris in 1910, having lived all his days in poverty. After his death, his works commanded huge prices.

1844 Born on May 21 in Laval, France
1868 Marries and moves to Paris
1871 Works at customs office
1884 Begins painting and shows his work with independent artists in Paris
1890 Produces *Myself, Portrait-Landscape*
1893 Quits his job for painting
1894 Shows *The War*
1907 Because of financial problems he commits a fraud
1910 Dies on September 2 in Paris

Henri Rousseau, 1895, photograph

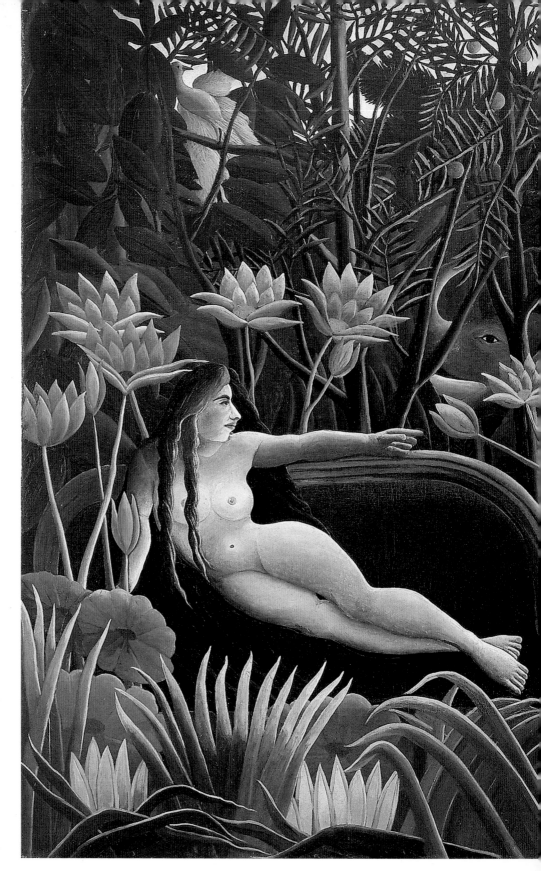

Henri Rousseau, *The Dream*, 1910,
oil on canvas, 204.5 x 198.5 cm,
The Museum of Modern Art, New York

1871 Charles Darwin
publishes the
Descent of Man

1865 Slavery abolished in the
United States

1795	1800	1805	1810	1815	1820	1825	1830	1835	1840	1845	1850	1855	1860	1865	1870	1875	1880	

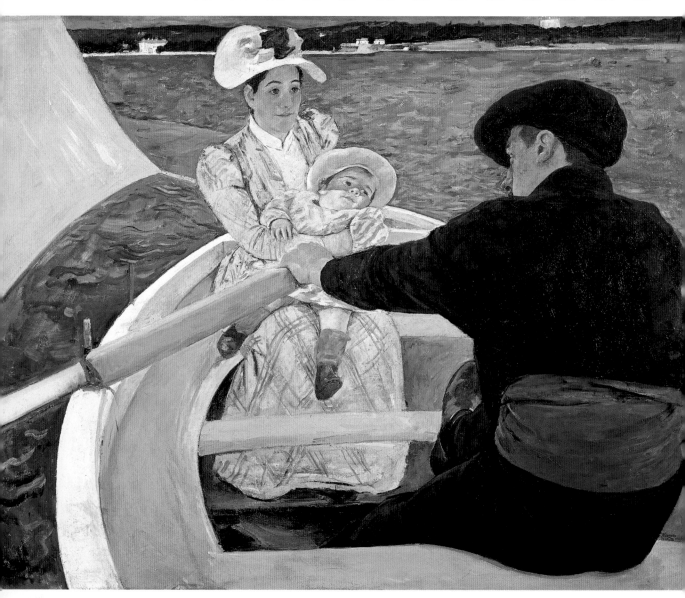

Mary Cassatt, *The Boating Party*, c. 1893/94,
oil on canvas, 90 x 117 cm, The National
Gallery of Art, Washington, D.C.

1887–1889 Construction of Eiffel Tower in Paris

1900 Paris opens its first metro line

1917 November Revolution in Russia

1929 Wall Street crash

1939–1945 World War II

1946 Founding of UNESCO

1961 Construction of Berlin Wall

| 1885 | 1890 | 1895 | 1900 | 1905 | 1910 | 1915 | 1920 | 1925 | 1930 | 1935 | 1940 | 1945 | 1950 | 1955 | 1960 | 1965 | 1970 |

MARY CASSATT

Painter Mary Cassatt was the only American member of the original French Impressionist group. She faced the difficulties and prejudices that professional female artists encountered in the 19th century with astonishing self-assurance and established an important position within the history of modern art.

Cassatt grew up in Philadelphia and studied at the Pennsylvania Academy of the Fine Arts, the most progressive American art school in the second half of the 19th century—both in terms of its curriculum and its reputation for fostering female talent. In 1865, she decided to continue her training in Europe, with the conviction that she could develop her creativity better there. As women had not yet been admitted to art academies in France at that time, she received private instruction from distinguished artists such as Charles Chaplin, and she became a pupil of Jean-Léon Gérôme in Paris.

Dialogue with Degas

In the following years, Cassatt traveled throughout Europe and took active part in the intellectual and political life of the French capital. She studied the art of the Old Masters in depth, admired Edouard Manet and Gustave Courbet, and was particularly enthusiastic about the works of Edgar Degas. Degas for his part discovered Cassatt's pictures at the annual Paris Salon in 1874 ("There is someone who feels just as I do," he told a friend); he then invited her to join the Impressionist group. It was the first artistic movement that welcomed women with open arms.

Mother and Child

Like Claude Monet focusing on his cathedrals and haystacks, Cassatt focused on particular subject matter. She dedicated herself first to public life in theaters, but then found more congenial subject matter in the private domestic sphere, particularly in the relationship between two figures. Her subjects spanned generations, and her models often came from her acquaintances and friends. Cassatt did numerous variations on the theme of mother and child, such as the early *Mother Washing Her Sleepy Child*, for which she is perhaps best known today. At the time, the mother and child motif was also just coming into the focus of literary, philosophical, and

psychological research. With her gifts of observation and sensitivity to the different stages of life, Cassatt used these themes to find an artistic voice of her own and a way to show psychological depth in paint.

An avowed feminist thinker, Cassatt worked professionally as a painter, took regular part in exhibitions, and was able to support herself from sales. She had a major role in popularizing Impressionist painting in the United States. She prompted art dealer and gallery owner Paul Durand-Ruel to put on exhibitions there, and she advised art collector Louisine Elder Havemeyer as she made her considerable purchases, which were later given to the Metropolitan Museum of Art in New York. After undergoing a first operation for cataracts in 1915, ten years later Cassatt was almost completely blind. She died in 1926 in France, at Château Beaufresne in Mesnil-Théribus.

1844 Born on May 22 in Allegheny City, Pennsylvania
1851–55 Takes an extended sojourn with her family in Europe
1860 Enrolls in women's classes at the Pennsylvania Academy of the Fine Arts in Philadelphia
1865 Travels to Paris to study
1870 Rejoins her family in Altoona, Pennsylvania
1871 Accepts a commission to copy works by Correggio in Parma, Italy
1872 Takes a six-month sojourn in Spain
1874 Settles in Paris
1877 Degas visits Cassatt in her studio; he invites her to exhibit with the Impressionists
1879 Cassatt exhibits her work in the fourth Impressionist exhibition (and will exhibit in three more)
1890–91 Creates the print suite known as the "Set of Ten"
1893 Exhibits the mural *Modern Woman* at the World's Columbian Exposition in Chicago
1894 Acquires the Château Beaufresne in Mesnil-Théribus, Beauvais, France
1898 Takes a final visit to the United States
1926 Dies on June 14 in Mesnil-Théribus

Mary Cassatt, photograph

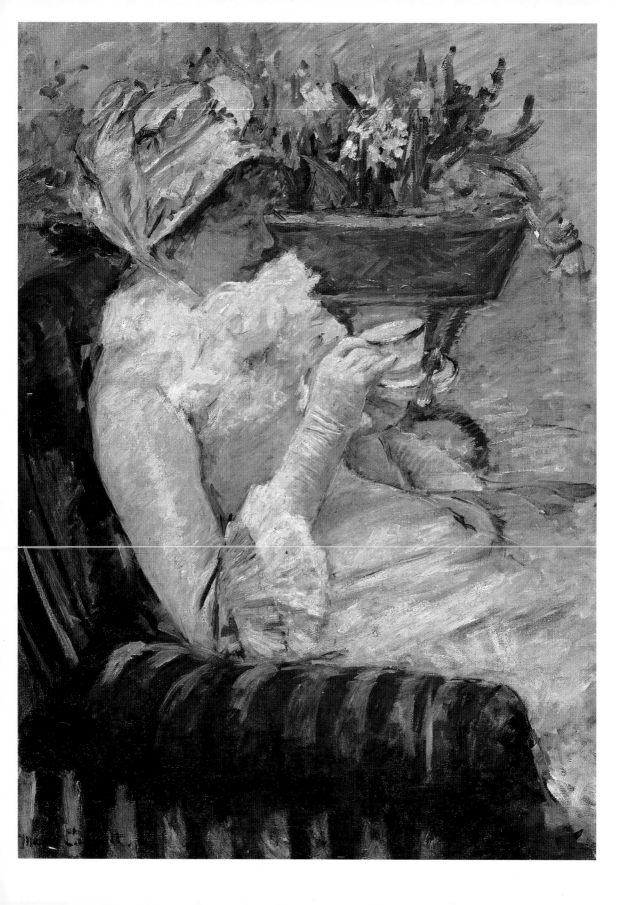

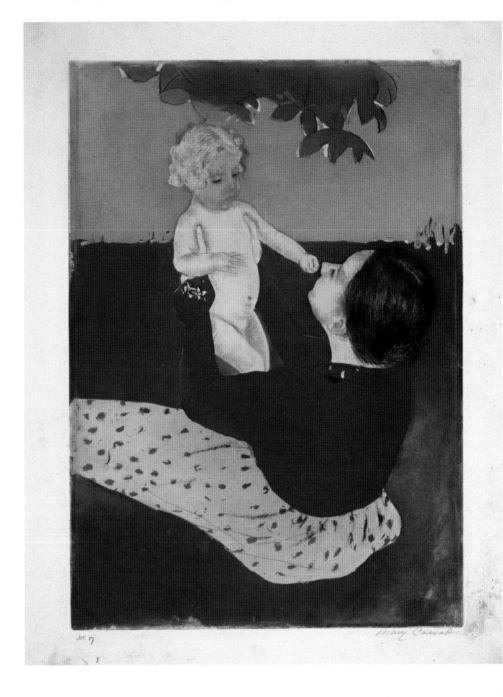

left page
Mary Cassatt, *The Cup of Tea*, c. 1880/81, oil on canvas, 92.3 x 65.5 cm, The Metropolitan Museum of Art, New York

above
Mary Cassatt, *Under the Horse Chestnut Tree*, c. 1898, drypoint and aquatint, color, 40.3 x 28.7 cm, Library of Congress Prints and Photographs Division, Washington, D.C.

1809–1825 South American wars of independence

C. 1830 Founding of Barbizon School

1848 Michael Knoedler opens first art gallery in New York

1857 *Madame Bovary* (Gustave Flaubert)

1870–1871 Franco-Prussian War

1874 First Impressionist exhibition in Paris

1800 1805 1810 1815 1820 1825 1830 1835 1840 1845 1850 1855 1860 1865 1870 1875 1880 1885

Paul Gauguin, *When Will You Marry?*, 1892, oil on canvas, 105 x 77.5 cm, Rudolf Staechelin'sche Familienstiftung, Basel

1893 Edvard Munch paints *The Scream* **1910–1929** Mexican Revolution
1897–1899 First *Water Lilies* (Claude Monet) **1913** Armory Show in New York
1905/11 Founding of "Die Brücke" and
"Der Blauer Reiter" groups of artists

| 1890 | 1895 | 1900 | 1905 | 1910 | 1915 | 1920 | 1925 | 1930 | 1935 | 1940 | 1945 | 1950 | 1955 | 1960 | 1965 | 1970 | 1975 |

PAUL GAUGUIN

Paul Gauguin sought unspoiled life and art. After starting out as an Impressionist, he gave up realistic representation and found a new revolutionary style of his own. The works he painted in the South Seas, with their exotic subject matter and brilliant colors, had a particular influence on the Expressionists.

An Unsteady Life

Born in Paris in 1848, Gauguin grew up in Peru and worked as a sailor for several years before embarking on a professional career as a stockbroker. Successful speculation made him prosperous. In 1873, he married Mette Gad, who came from a reputable Danish family; he lived with her and their five children in a Paris suburb. On the side, he was an enthusiastic collector of Impressionist art and began to create his own paintings.

Following the stock market crash in 1882, Gauguin lost his job in a Parisian financial company and decided henceforth to make a living for himself and his family from his painting. During the financial hardships that followed, his marriage fell apart and his wife returned with the children to Copenhagen. Gauguin went after her at first, but then decided to return with his son Clovis to Paris.

In 1886, Gauguin moved to Pont-Aven in Brittany, where an avant-garde group of artists formed within two years. Here, together with Émile Bernard and Paul Sérusier, Gauguin painted not only landscapes, but also scenes of peasant life such as the *Dance of the Four Breton Women*. In these works, he emphasized the simple, often coarse beauty of the local women, which was so different from the refined beauty of Parisian models. Gradually he moved away from the Impressionist style, and his development led him to Syntheticism and Symbolism, and to a form of representation no longer dependent on imitating nature. Perspective and three-dimensionality took a backseat, and Gauguin largely dispensed with modeling shapes and internal drawing; this left him to pursue expressiveness chiefly though the intensity of his palette. While Gauguin was living in Brittany, he also visited Vincent van Gogh in Arles. Despite the calamitous collaboration between the two painters, one outcome of the period was fascinating portraits such as *Vincent van Gogh Painting Sunflowers*.

The Quest for "Paradise Lost"

Fed up with Western civilization, Gauguin first traveled to the South Sea region in 1891. He lived on Martinique among the native islanders and recorded their "primitive" ways in numerous rapid images. Here he found the source for the renewal of art he had been looking for, and at last he found his own voice. His works took on the idiom of archaic, primordial art. The painter deliberately gave the pictorial objects a stiff, rather crude character; with a bold simplification of technique, he idealized the simple lifestyle of the natives.

From 1895, Gauguin remained permanently in the South Seas. His late work produced on Tahitian themes is notable for its sense of harmony, intensity of color, and serene composure. As his artistic legacy, we may take the painting *Where Are We From? Who Are We? Where Are We Going?*, a meditation on the meaning of life.

1848 Born on June 7 in Paris
1851–55 Lives in Lima, Peru
1865–71 Joins the Navy and travels
1874 Begins hobby to paint
1885 Leaves his wife and children to live in Paris
1887 Travels to Panama and Martinique with Charles Laval
1889 Takes part in a group exhibition with Émile Bernard and Paul Sérusier at Café Volpini, Paris
1891 Travels to Tahiti
1899 Founds *Le Sourire*, his own journal
1903 Dies on May 8 in his hut in Atuona, Tahiti

following double page, left
Paul Gauguin, *The Black Pigs*, 1891, oil on canvas, 91 x 72 cm, Museum of Fine Arts, Budapest

following double page, right
Paul Gauguin, *Tahitian Women on the Beach*, 1891, oil on canvas, 91 x 53 cm, Academy of Art, Honolulu

Harlingue-Viollet, Paul Gauguin, 1893/94, photograph

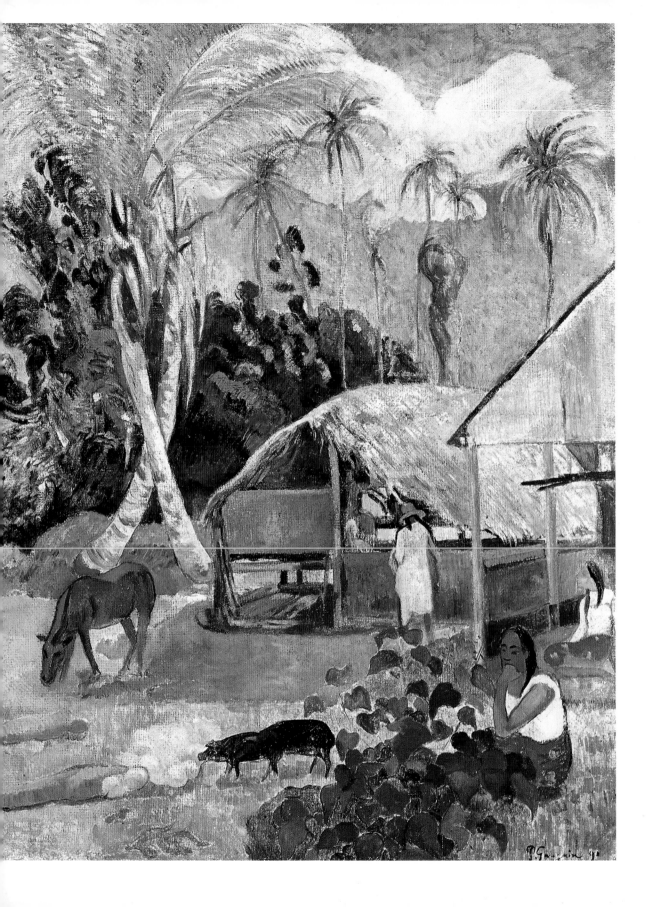

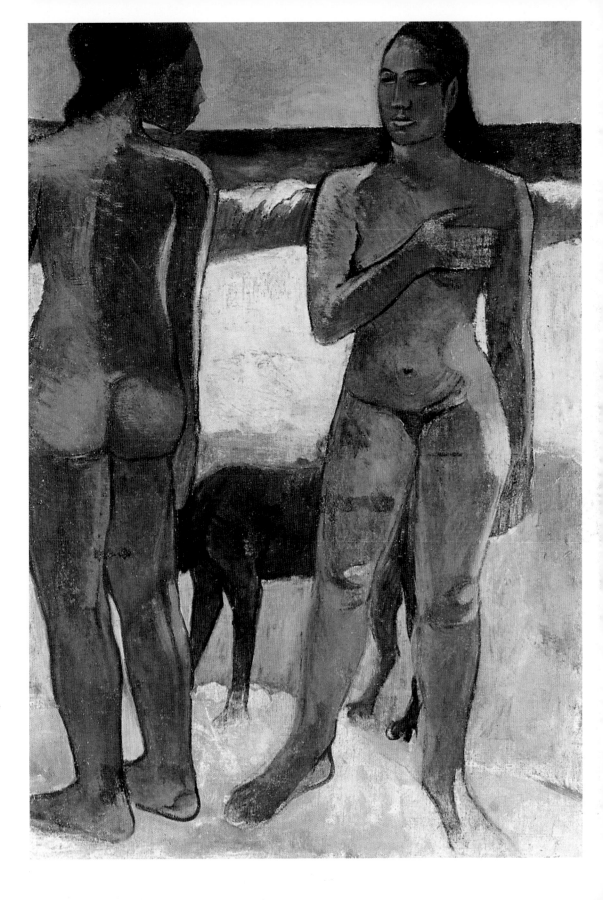

VINCENT VAN GOGH ▬▬▬▬▬▬▬▬▬▬▬▬▬▬▬▬▬

CLAUDE MONET ▬▬▬▬▬▬▬▬▬▬▬▬▬▬▬▬▬▬▬▬

GEORGES SEURAT ▬▬▬▬▬▬▬▬▬▬▬▬

1826 First photograph **1857** *Madame Bovary* **1871** Prussian armies **1887–1889** Con-
 (Gustave Flaubert) occupy Paris struction of
 Eiffel Tower
 in Paris

| 1805 | 1810 | 1815 | 1820 | 1825 | 1830 | 1835 | 1840 | 1845 | 1850 | 1855 | 1860 | 1865 | 1870 | 1875 | 1880 | 1885 | 1890 |

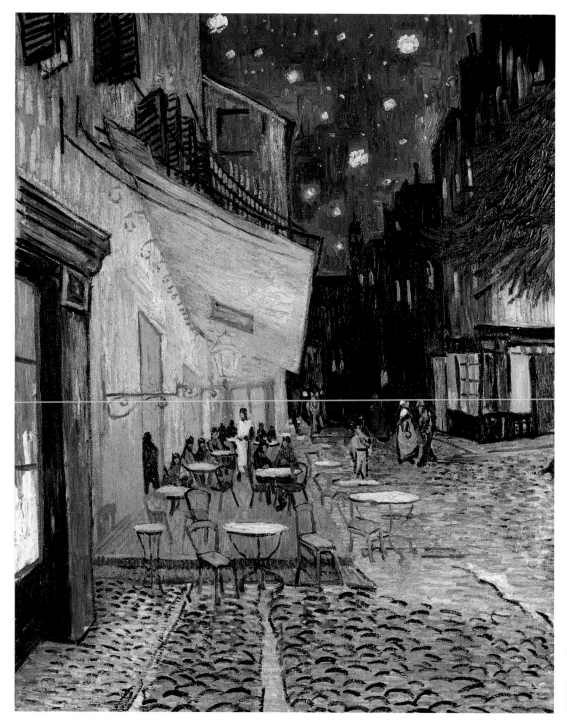

Vincent van Gogh,
Café Terrace at Night,
1888, oil on canvas,
81 x 65.5 cm,
Rijksmuseum
Kröller-Müller,
Otterlo

1895 First public film screenings **1914–1918** World War I

1905/11 Founding of "Die Brücke" and
"Der Blauer Reiter" groups of artists

1897–1899 First *Water Lilies*
(Claude Monet) **1921** Einstein awarded Nobel Prize for Physics

1895 1900 1905 1910 1915 1920 1925 1930 1935 1940 1945 1950 1955 1960 1965 1970 1975 1980

VINCENT VAN GOGH

Vincent van Gogh paved the way for modern painting with an extraordinary but powerful oeuvre. His pictures tell of deep, scrupulous feelings and an uncompromising flouting of painterly tradition.

Born in the Netherlands in 1853, van Gogh floundered for years, looking for a suitable occupation. He worked in a bookshop, tried his hand as a teacher, and embarked on theological studies, all unsuccessfully. His efforts as a missionary in Brussels were also a failure.

Life in Poverty

In order to be able to cope with his inner conflicts, in the early 1880s van Gogh began to draw, initially from models by Jean-François Millet, but then on his own. Although he enrolled at the art academies in Brussels and Antwerp, he was primarily self-taught. On the advice of painter Anton Mauve, who was a relative, he began to experiment with oil paints. In this early phase of his career, van Gogh took realism as his guiding star. The socio-critical novels of Zola and Flaubert also had a marked influence on him—he wanted to dedicate his art to simple people. *The Potato Eaters* is one of his many heavy, dark paintings from this period, witnesses of an honest empathy for the way peasants lived.

Moving Pictures

In 1886, van Gogh moved to Paris to live with his brother Theo, with whom he had regularly corresponded for years. (They would continue their correspondence until Vincent's death.) Through his brother, who ran an art gallery, he came into contact with the Impressionists and Pointillists. His pictures changed as a result: he now chose lighter, clearer colors, and his brushstrokes became more expressive. In 1888, van Gogh moved to the small town of Arles, in the south of France. In Provence, he finally attained his mature style. This is where he did the sunflower pictures and many other works that later made him famous. He worked day and night in the open air, applying bright colors to the canvas with dynamic brushstrokes.

That autumn, after repeated invitations, Paul Gauguin finally came to Arles, but instead of the fruitful collaboration they hoped for, the two painters ended up violently arguing with each other. Gauguin's departure plunged van Gogh into a deep psychic crisis. In spring the following year, van Gogh had a nervous breakdown and was taken to a hospital in Arles. Subsequently he was admitted to a mental asylum at Saint-Rémy. During this period, he continued to work at times as if possessed, fearing that his illness was getting worse.

The following spring, his condition seemed to have improved. Van Gogh left the clinic and traveled to Auvers-sur-Oise, although he remained under medical supervision. Over a period of two months, he turned out around 70 paintings in an expressive style that gave vent to his internal agitation and despair. On July 27, 1890, van Gogh went into a field and shot himself. He died two days later in the arms of his brother Theo. Up to his death, his fight for artistic recognition during his lifetime had been unsuccessful.

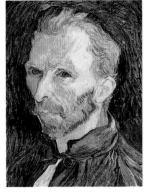

1853 Born on March 30 in Zundert, Holland
1879 Goes to Cuesmes as an auxiliary preacher and begins drawing
1882 Takes painting lessons at the The Hague
1886 Moves to Paris and meets the Impressionists
1888 Travels to Arles in the south of France and finds his unmistakable style there
1888 Paul Gauguin visits van Gogh in his yellow house
1889 Van Gogh is admitted to the psychiatric hospital in Saint-Rémy
1890 Sells an oil painting at an exhibition for the first time
1890 Dies on July 29 in Auvers-sur-Oise

following double page, left
Vincent van Gogh, *Sunflowers*, 1889, oil on canvas, 95 x 73 cm, Van Gogh Museum, Amsterdam

following double page, right
Vincent van Gogh, *The Church at Auvers*, 1890, oil on canvas, 94 x 74 cm, Musée d'Orsay, Paris

Vincent van Gogh, *Self-Portrait as a Painter*, 1899, oil on canvas, 57 x 43.5 cm, Collection Mrs. John Hay Whitney, New York

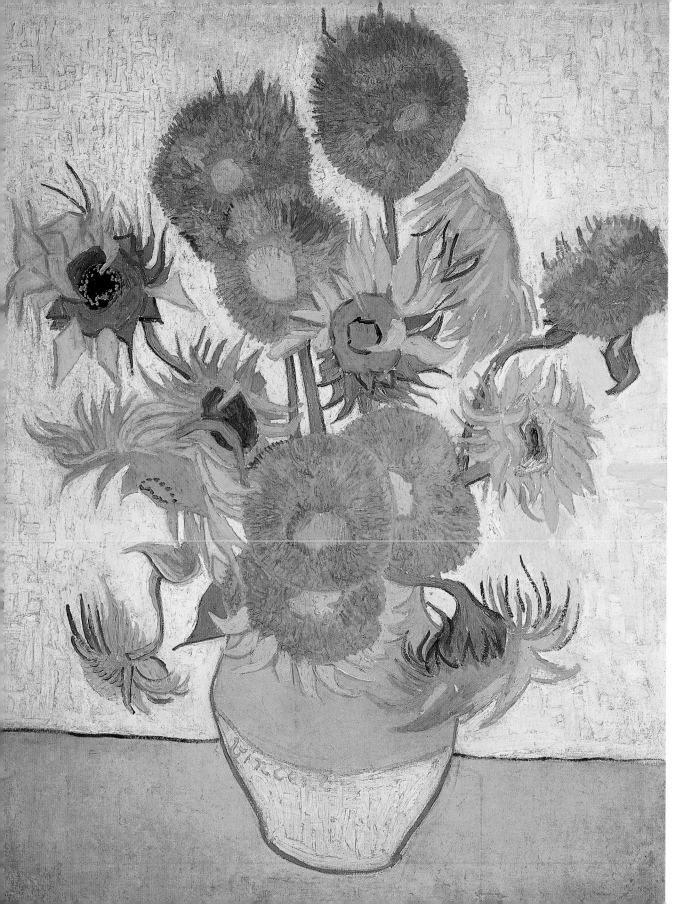

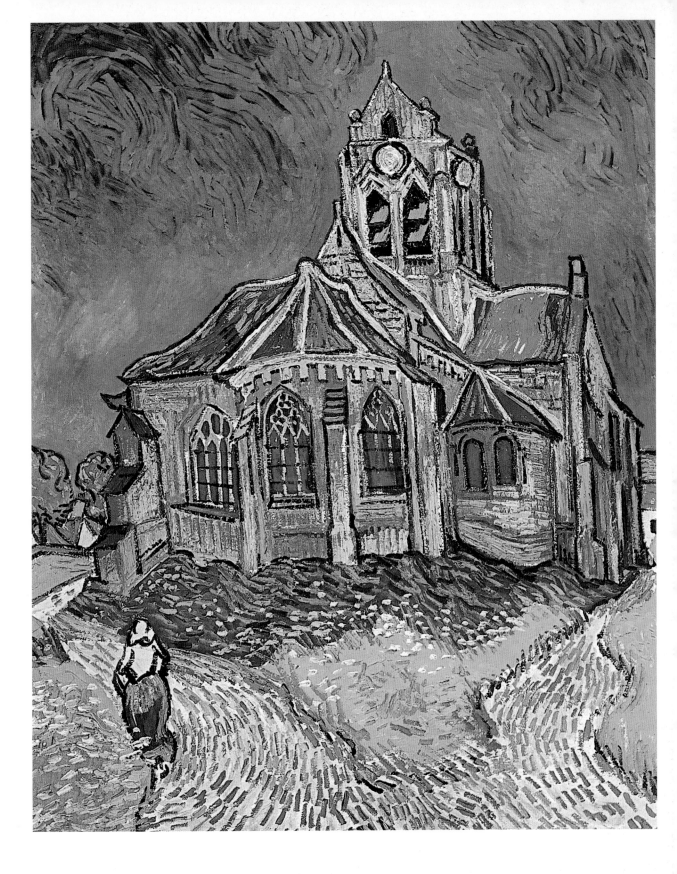

1826 First photograph

1857 *Madame Bovary* (Gustave Flaubert)

1871 Prussian armies occupy Paris

1887–1889 Construction of Eiffel Tower in Paris

1895 First public film screenings

| 1810 | 1815 | 1820 | 1825 | 1830 | 1835 | 1840 | 1845 | 1850 | 1855 | 1860 | 1865 | 1870 | 1875 | 1880 | 1885 | 1890 | 1895 |

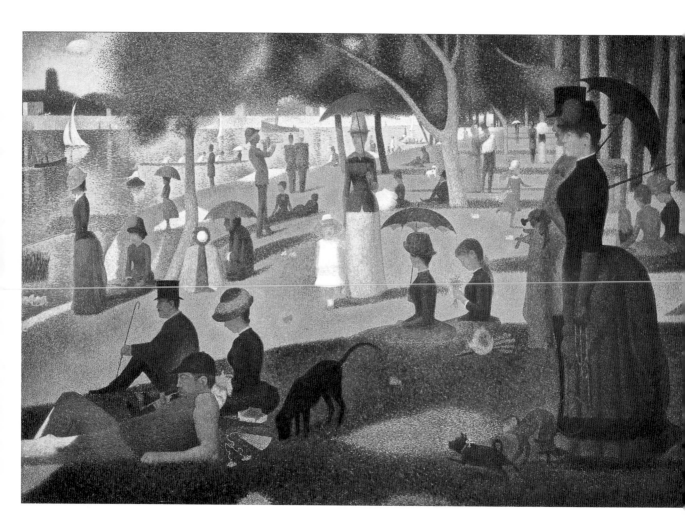

Georges Seurat, *La Grande Jatte*,
1884–86, oil on canvas, 206 x 306 cm,
The Art Institute of Chicago

GEORGES SEURAT

French painter Georges Seurat managed to go beyond Impressionism by systematically developing a basic idea. Like the Impressionists, he wanted to render the optical phenomena of reality, but he rejected the Impressionists' fluid visions captured in dissolution. His striving for form and structure led him to develop a scientifically rationalized style called Pointillism, or Neo-Impressionism.

During his time as a student at the École des Beaux-Arts in Paris in 1878–79, Seurat was particularly interested in research on color theory undertaken by leading physicists. This became the basis of his new art theory, which involved applying a series of optical principles to the production of works of art.

The Inventor of Pointillism

Seurat's first painting using these principles was *Bathers in Asnières*, in which he covered the whole canvas with tiny dots (*"points"* in French) that he carefully placed next to one another. Starting from the discovery in physics that light is made up of the colors of the spectrum, he broke the colors down into their basic elements. The pure, unmixed particles of color fuse together in the viewer's eye, producing realistic shapes only when perceived at a distance. In this way, Seurat achieved a great intensity of color and brilliance in his picture.

He perfected the Pointillist style with the great composition *La Grande Jatte* (1884–86). Painting it was a long and time-consuming process; the actual painting was preceded by at least 33 oil studies and 28 drawings. The preliminary studies were often done *en plein air*, while the final versions of his work were produced in the studio. The painting aroused much commotion at the eighth and final Impressionist exhibition in 1886. The source of controversy was not the subject matter—Seurat was painting an ordinary scene on the popular Grande Jatte recreation island, a typical Impressionist subject—but rather the artist's decision to couch the impressions of the moment within a strictly ordered structure. Some people saw him as the initiator of a new avant-garde. Others, however, criticized him for his "scientific impressionism" and the work's unrealistic, lifeless character and absence of spontaneity, with one reviewer noting: "If you strip from his figures the colored fleas that cover them, you are left with nothing, no thought, no soul, nothing. ... I very much fear that there is too much technique, too much system in it, and not enough coruscating fire, not enough life."

In his late work, Seurat was preoccupied with marginal groups of society such as circus performers. Although pictures such as *The Circus* are actually about movement, the figures seem frozen and convey the impression of an unchanging existence. His efforts were directed neither at psychological expression nor achieving a subjective, spontaneously expressed painterly hand. Up to his early death at the age of 31—he died of diphtheria—Seurat worked at implementing a precise grid of dots and perfecting his theory.

1859 Born on December 2 in Paris
1878 Enters the École des Beaux-Arts
1879 Military service in Brest
1884 *Bathers at Asnières* is rejected by the Salon. Seurat becomes a co-founder of the Société des Artistes Indépendants.
1886 Shows *La Grande Jatte* the first time
1890 His partner, Madeleine Knoblock, gives birth to a son
1891 Dies on March 29 in Paris, presumably of diptheria

Georges Seurat, photograph

GUSTAV KLIMT ▬▬▬▬▬▬▬▬▬▬▬▬▬▬▬▬▬▬▬▬▬▬▬▬▬▬▬▬

VINCENT VAN GOGH ▬▬▬▬▬▬▬▬▬▬▬▬▬▬▬▬▬▬▬▬▬▬▬▬▬▬▬▬▬

VASILY KANDINSKY ▬▬▬▬▬▬▬▬▬▬▬▬▬▬▬▬▬▬▬▬▬▬▬▬▬▬▬▬

1826 First photograph

1871 Prussian armies
occupy Paris

1888 *Sunflowers* (Vincent
van Gogh)

1886 First gasoline-fueled
internal combustion
engines

| 1810 | 1815 | 1820 | 1825 | 1830 | 1835 | 1840 | 1845 | 1850 | 1855 | 1860 | 1865 | 1870 | 1875 | 1880 | 1885 | 1890 | 1895 |

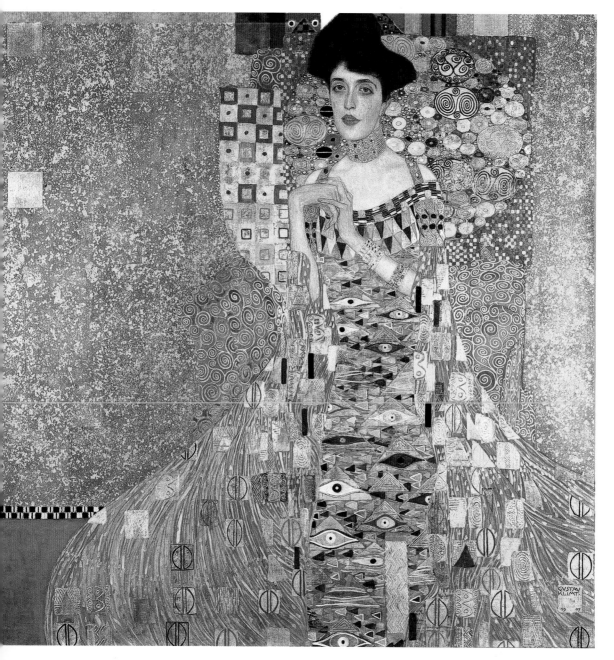

Gustav Klimt, *Portrait of Adele Bloch-
Bauer I*, 1907, oil and gold on canvas,
138 x 138 cm, Neue Galerie, New York

1905/11 Founding of "Die Brücke" and
"Der Blauer Reiter" groups of artists

1933 Hitler becomes Führer
and Chancellor

1895 First public film screenings **1914–1918** World War I

1921 Einstein awarded Nobel Prize for Physics

| 1900 | 1905 | 1910 | 1915 | 1920 | 1925 | 1930 | 1935 | 1940 | 1945 | 1950 | 1955 | 1960 | 1965 | 1970 | 1975 | 1980 | 1985 |

GUSTAV KLIMT

Gustav Klimt was one of the outstanding representatives of Austrian Art Nouveau, and was a key figure in the international avant-garde's breakthrough in Vienna. By resorting to pre-formed stylistic elements, he developed a new symbolic/ornamental visual idiom.

Born in 1862, the son of a gold engraver, Klimt studied at the state arts and crafts school in Vienna. Together with his brother Ernst and fellow student Franz Matsch, he founded an "artist company" that soon prospered. From 1880, they were awarded public contracts for projects such as decorative work at the Kunsthistorisches Museum and the Burg Theater in Vienna. In those early days, their art borrowed stylistically from Hans Markart and his decorative, neo-Baroque history paintings, and thus still reflected the popular tastes of the late 19th century.

Klimt was one of the forces behind the formation of the Vienna Secession in 1897, a forum for young Art Nouveau artists who were protesting against officially approved Salon painting. "To every age its art, to art its freedom" was the motto written on the pediment of the new Secession building in Vienna. During those years, Klimt began to develop a style of his own, combining erotically posed figures with ornamental decorative elements. In contrast to his successful early works, the allegorical works he created for Vienna University post-1900 were rejected, as was his "Beethoven frieze," which was directly applied to the wall in the new Secession exhibition building. In the last part of this sequence of images devoted to the composer, a naked couple was shown embracing in the middle of the golden paradise. The work aroused violent criticism, with some critics finding the depictions of the human body to be "obscene, shameless caricatures."

A Fascination with the Feminine
After the scandal of the university and Secession pictures, Klimt withdrew from public commissions. He spent his summer holidays almost every year beside Lake Attersee, where he did landscape paintings, generally in a square format. At his studio in Vienna, he worked on private commissions from the liberal-minded *grande bourgeoisie*. These almost invariably concerned portraits of women, including the famous portrait of Margaret Stonborough-Wittgenstein of 1905, and the portraits of his partner, fashion designer Emilie Flöge.

The high points of Klimt's "golden phase" include his portrait of Adele Bloch-Bauer, known as "Golden Adele," and his masterpiece, *The Kiss*. The latter, probably the most famous painting by the Art Nouveau artist, has as its principal subject a couple fused into a single shape, with only their heads, arms, and legs shown naturalistically. Consisting of several large ornamental areas dominated by gold coloring and real gold leaf, the metallic sheen frustrates any sculptural or three-dimensional effect and glorifies the subject.

By this time, the artist was already well known far beyond national borders. He died from a stroke on February 6, 1918, at the age of 56. He left numerous unfinished paintings such as *Adam and Eve* and *The Bride*. After his death, more than 4,000 drawings were also published, many of them erotic depictions of women.

1862 Born on July 14 in the village of Baumgarten near Vienna
1876 Attends the Vienna Kunstgewerbeschule
1886 Produces pictures for the Burg Theater in Vienna with his brother Ernst
1893 The Minister of Culture refuses him a professorial chair
1897 Klimt and friends found the Secession
1898 Landscape at the Attersee becomes a theme
1902 Klimt paints the "Beethoven frieze" in the Secession building. Auguste Rodin is impressed.
1910 Participates successfully in the Venice Biennale
1918 Dies in Vienna on February 6 after a stroke

Klimt outside his studio in his garden in Josefstädterstraße, c. 1912/14, photograph

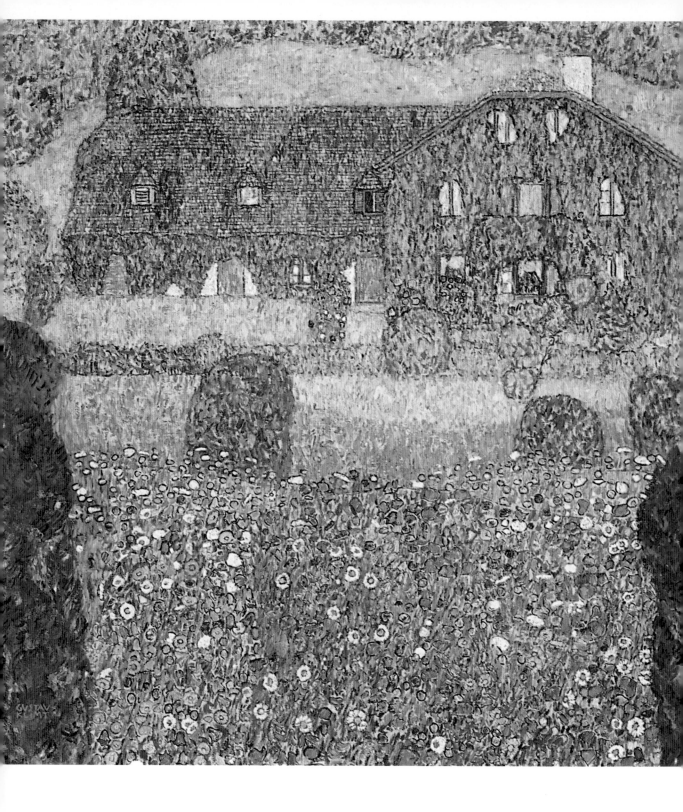

Gustav Klimt, *Villa on the Attersee*,
1914, oil on canvas, 110 x 110 cm,
Private collection

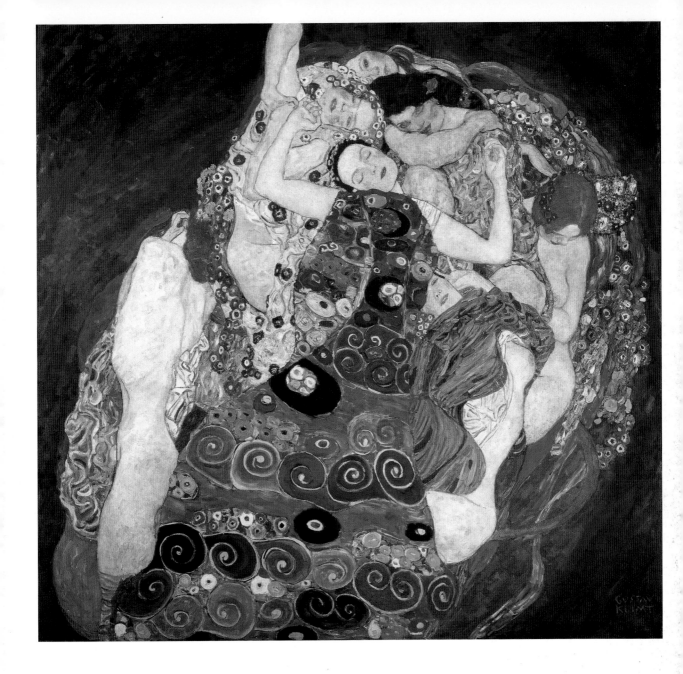

Gustav Klimt, *The Virgin*, 1913, oil on
canvas, 190 x 200 cm, National Gallery,
Prague

1897 Founding
of Vienna
Secession

1871 Prussian armies occupy Paris

1895 First public film
screenings

1815 1820 1825 1830 1835 1840 1845 1850 1855 1860 1865 1870 1875 1880 1885 1890 1895 1900

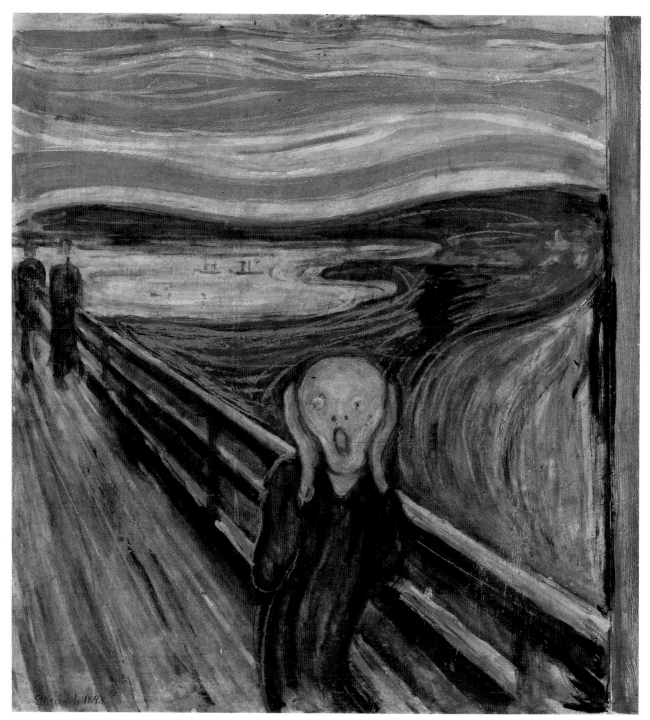

1900 Freud's *Die Traumdeutung*
 (Interpretation of Dreams)

1927 Lindbergh flies solo across the Atlantic

1933 Hitler becomes Führer and Chancellor of Germany

 1914–1918 World War I

1939–1945 World War II

1937 "Degenerate Art" exhibition in Munich

1905 1910 1915 1920 1925 1930 1935 1940 1945 1950 1955 1960 1965 1970 1975 1980 1985 1990

EDVARD MUNCH

Norwegian painter Edvard Munch was a pioneer of modern art. Like Vincent van Gogh, he focused on depicting the problems of human existence in a disjointed world. Fear, distress, love, illness, and death are the main themes of his work.

Painter of the *Frieze of Life*

In his manifesto on art, written in 1889, Munch said that it was time to paint people who breathe and feel, suffer and love, rather than interior scenes of women reading and knitting. In the decade from 1892, he did the paintings of his *Frieze of Life*, a series that established him as an artist of international stature. The *Frieze of Life* was intended, the artist said, as "a series of related images that in sum should give a picture of life … the diversity of life with its cares and joys." For Munch, this meant above all representing inner experiences, and thus rejecting the prevailing style of Impressionism, which dealt primarily with the visible world. To realize his ambition, he focused on the principal subject and omitted all unnecessary details, at the same time simplifying shapes and intensifying colors. A major solo exhibition of Munch's works in Berlin in 1892 led to violent protests, with the doors of the show closing after only a few days.

In his paintings and graphic works, Munch constantly returned to the same life-determining themes, always trying to create numerous versions of them. Munch's mother died when he was five years old, and his sister Sophie fell ill with tuberculosis nine years later; both losses—and in particular his sister's agonizing death—were very traumatic for the boy. As a result, illness and death would become recurrent themes in is work: for example, he would explore the theme of the sick child through painting, lithography, and etching. His famous work *The Scream* also grew out of personal experience and became a vivid expression of existential anxiety.

Forerunner of Expressionism

Munch spent the years to 1908 mainly in Oslo, Paris, and Berlin. After a nervous breakdown, he gave up city life and restless traveling and returned to Norway to lead a quiet life in Ekely, near Oslo. The change is reflected in his art. Calm fjord landscapes became the subject of many works, along with scenes of working people, portraits, nudes, and self-portraits in which the artist took a critical look at himself. With this change toward a less emotional, more extroverted, more formally rigorous art, coloration became more important to him than it had previously. Symbolic of this new phase is the powerful painting *The Sun*, part of a mural project Munch created for the university assembly hall in Oslo. This and other works in this mural series symbolized life and love, youth and age. Another monumental work followed in 1922 with the painting of 12 wall panels in the dining room of Freia's chocolate factory in Oslo. Thus the oeuvre of Munch, who was likewise notable for his vivid, artistically perfect scenes in the field of graphic art, was seminal for the development of Expressionism.

1863 Born on December 12 in Løten, Norway
1879 Visits a technical college
1880 Leaves college and joins the Realists
1881 Studies at the Royal School of Art and Design
1889 Visits the Bonnat Art School in Paris
1902 Exhibits *Frieze of Life* at Berlin Secession
1908 Mental breakdown, hospitalized in Copenhagen, Denmark
1913 Leaves Berlin Secession
1923 Becomes member at the Prussian Academy of Art
1927 Retrospective at Nationalgalerie Berlin
1944 Dies on January 23 in Ekely, Norway

left page
Edvard Munch, *The Scream*, 1893, oil, tempera, and pastel on cardboard, 91 x 74 cm, National Gallery, Oslo

above
Edvard Munch, 1902, photograph

VINCENT VAN GOGH

EDVARD MUNCH

1858 Charles Frederick Worth opens first **1874** First Impressionist exhibition in Paris
great fashion house in Paris

1830 July Revolution in France

1882 Robert Koch discovers **1895** Röntgen dis-
TB bacillus covers X-rays

1851 "Great Exhibition" **1867** Execution of the Emperor
in London Maximilian (Manet)

1884 Bathers in Asnières (Seurat)

1815	1820	1825	1830	1835	1840	1845	1850	1855	1860	1865	1870	1875	1880	1885	1890	1895	1900

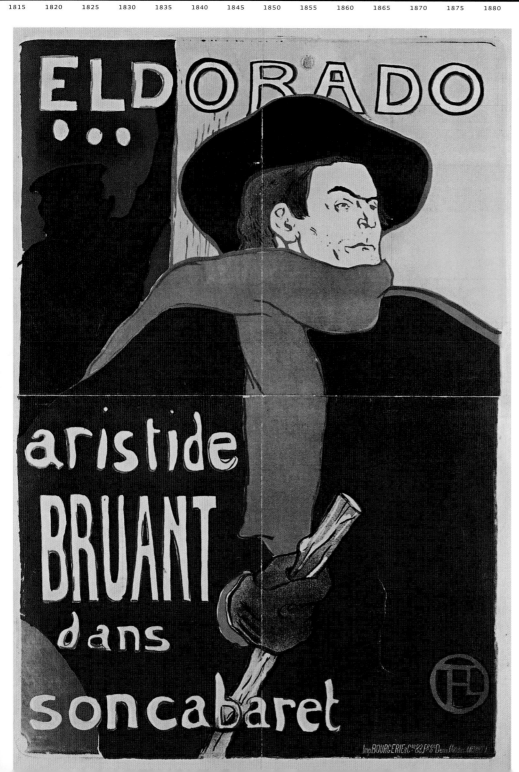

Henri de Toulouse-Lautrec,
Eldorado, Aristide Bruant, 1892,
color lithograph, 137 x 96.5 cm

1923 Russian Empire becomes
Soviet Union

1939–1945 World War II

1914–1918 World War I

| 1905 | 1910 | 1915 | 1920 | 1925 | 1930 | 1935 | 1940 | 1945 | 1950 | 1955 | 1960 | 1965 | 1970 | 1975 | 1980 | 1985 | 1990 |

HENRI DE TOULOUSE-LAUTREC

In his work, Henri de Toulouse-Lautrec focused on areas of life that were not previously considered worth painting. With his candid scenes of the glamorous nightlife of the French capital, the artist showed another side of the Belle Époque. Only after his premature death were the deeper meaning and cheerful irony of many of his pictures appreciated.

Amusements

Henri Marie Raymond de Toulouse-Lautrec was born to an old aristocratic French family, and he began to draw under supervision even during his school days. From 1882 he continued his training under Fernand Cormon and Léon Bonnat in Paris, where he led the life of a bohemian. His particular gift for portraits is evident in an early self-portrait of 1880 and in portraits of his mother from 1881 and 1883.

From the late 1880s, Toulouse-Lautrec's favorite topics were to be found in Paris's nightlife—in the worlds of cabarets, dance floors, the theater, and sleazy bars, and among washerwomen and prostitutes. The artist—whose growth had been stunted due to a hereditary disease and two riding accidents, leaving him under 1.5 meters (5 feet) tall—presumably felt less of an outsider in the unsavory district of Montmartre than he did elsewhere.

After the Moulin Rouge cabaret opened in 1889, Toulouse-Lautrec became a regular guest, doing drawings and paintings that portrayed the women working there, the dancers and singers, the visitors and spectators. His painting *At the Moulin Rouge* of 1892 brings out the charm as well as the dubious side of life in this artificial paradise. To render the momentary nature of the situation in the best possible way, the painter went for an unusual, seemingly arbitrary scene. The cropped, mask-like face on the edge of the picture also clearly shows how he used color as a vehicle of expression, regardless of its representational function.

Modern Art Poster

The artist also created posters for the Moulin Rouge. These works had considerable influence on the subsequent development of this aspect of commercial art, and in the hands of Toulouse-Lautrec they acquired the status of an independent art form. He introduced stylistic innovations, chose a bold graphic design, and found inspiration in Japanese art, which at the time was extremely popular. One of his best-known lithographs announcing upcoming theater and cabaret performances relates to the appearances of musician Aristide Bruant in the Champs-Elysées. Thus the artist's sensational, avant-garde art became a familiar feature on the streets of Paris.

Toulouse-Lautrec is now known particularly for his extensive graphic oeuvre. In addition to posters, he did series and single sheets, theater programs, and illustrations for various newspapers and magazines. After a debauched and ultimately destructive life, he died at the age of 36 in his family's home, the Château Malromé, near Bordeaux.

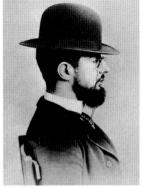

1864 Born on November 24 in Albi, France
1881 Graduates in Toulouse and travels to Paris
1882 Works with Léon Bonnat
1882–86 Works at studio of Fernand Cormon and becomes acquainted with Louis Anquetin, Émile Bernard, and Vincent van Gogh
1897 Goes through a deep crisis
1899 Is institutionalized in a hospital near Neuilly
1900–01 Lives in Bordeaux
1901 Dies on September 9 in Malromé

Henri de Toulouse-Lautrec, photograph

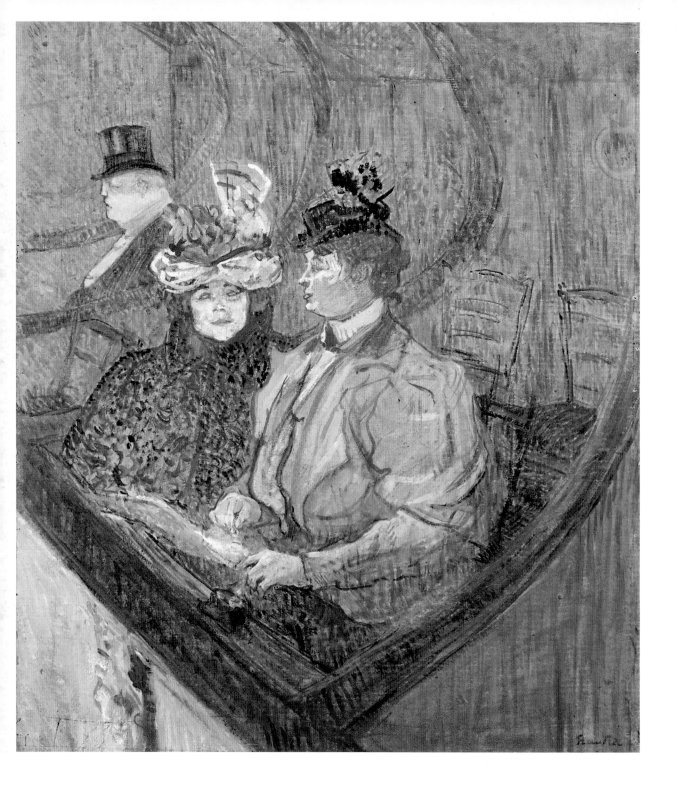

Henri de Toulouse-Lautrec, *La Grande
Loge*, 1896, oil and gouache on card-
board, 55.5 x 47.5 cm, Private collection

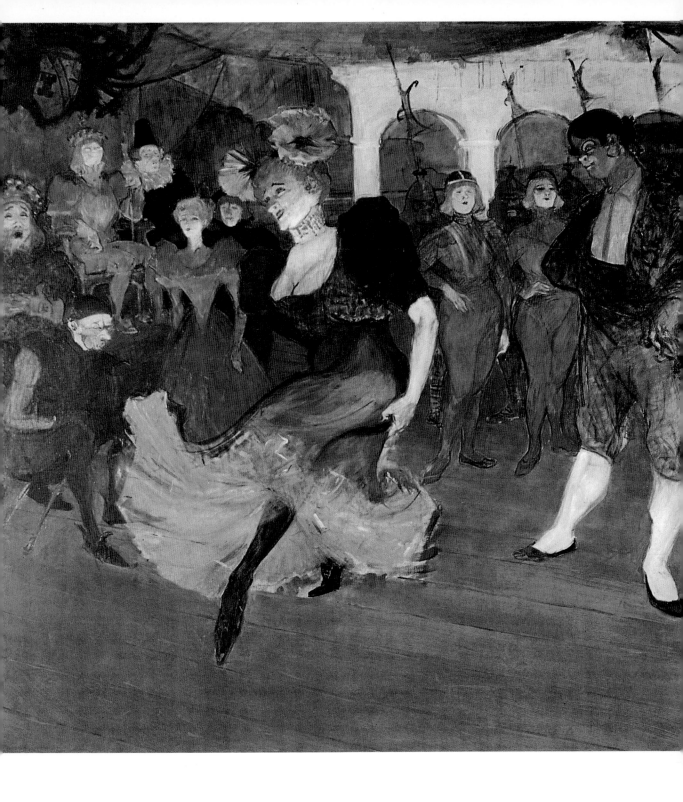

Henri de Toulouse-Lautrec, "Chilpéric,"
1896, oil on canvas, 145 x 150 cm,
National Gallery of Art, Washington,
D.C., Gift of Mrs. John Hay Whitney

1840 * Peter Tchaikovsky **1871** Prussian armies occupy Paris **1895** First public
 film
 screenings

1815 1820 1825 1830 1835 1840 1845 1850 1855 1860 1865 1870 1875 1880 1885 1890 1895 1900

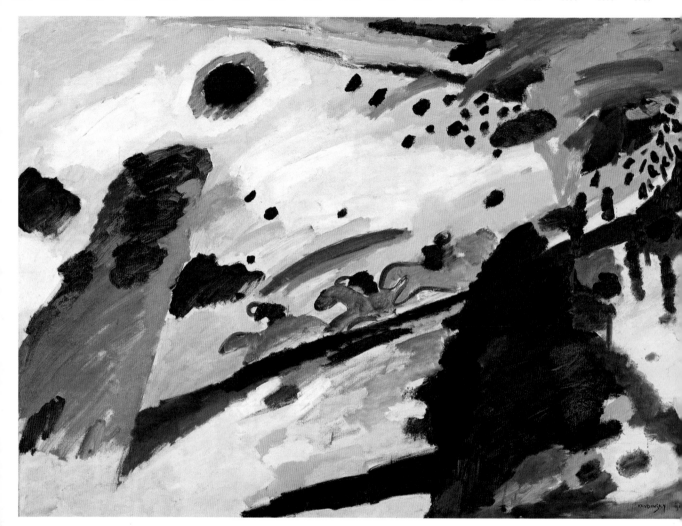

Vasily Kandinsky, *Romantic Landscape*,
1911, oil and tempera on canvas,
94.3 x 129 cm, Städtische Galerie im
Lenbachhaus, Munich

1905/11 Founding of "Die Brücke" and **1927** Lindbergh flies solo across the Atlantic
"Der Blauer Reiter" groups of artists
 1921 Einstein awarded Nobel **1937** "Degenerate Art" exhibition in Munich
Prize for Physics **1939–1945** World War II
1914–1918 World War I **1933** Hitler becomes Führer and Chancellor of Germany

1905 1910 1915 1920 1925 1930 1935 1940 1945 1950 1955 1960 1965 1970 1975 1980 1985 1990

VASILY KANDINSKY

Vasily Kandinsky triggered the most radical revolution in painting since the Renaissance, steering painting toward abstraction and influencing later artists' explorations of a non-figurative world.

Born in 1866 in Moscow, the son of a prosperous tea merchant, at the age of almost 30 Kandinsky was on the verge of becoming a professor of political economics at the University of Tartu, until he opted for painting instead. The intellectual parameters of the day were manifest in Kandinsky's thinking at the time: his interests ranged from contemporary theories of color and light, cosmology, morphology, and quantum mechanics, to the development of reprographics and photography, to exploring the similarities between painting and music, color and sound. These ideas formed the basis of Kandinsky's art, laying the foundation for his importance in the coming years not only as a theorist but also as a painter who methodically explored these ideas in his work.

Der Blaue Reiter

Kandinsky was a founding member of the Munich-based Blaue Reiter group of artists, who significantly influenced the German Expressionists. A major concern for him, as an essay he wrote in 1912 explained, was the "spiritual element in art." He felt that pure art had no purpose, but rather existed solely for its own sake. Influenced by Romanticism, this tenet came across as akin to religion: artistic activity should match "inner necessity." Members of the Blaue Reiter wanted their art to touch the viewer's soul—what mattered was emotional depth and sensitization in art. Basic emotions such as love, pleasure, and fear did not count, however, as Kandinsky considered them too ordinary. In his work, his key objective was to venture into the zones of pure spirit.

The First Abstract Paintings

Kandinsky was nearly 45 years old when, between 1910 and 1913, he crossed the frontier into abstraction. His famous "first abstract watercolor" was long considered the epitome of abstract painting. There is an anecdote attached to his new approach to painting. Kandinsky came home at twilight, saw one of his pictures standing on its side, and did not recognize it. It seemed like the work of a stranger, but he liked it. Kandinsky saw only colors "pervaded by an inner glow." He therefore realized that the painting must be independent of the material object.

Yet abstraction was not a dogma for Kandinsky. Again and again, he introduced tangible things into his pictures in the following years—riders, angels with trumpets, boats, domes, hills, and valleys—and over it heavenly bodies like the sun or moon. These signs refer to the visible world like scraps of memory, and yet Kandinsky's painting moved increasingly toward abstraction.

1866 Born on December 4 in Moscow
1896 Decides to become an artist and moves to Munich
1909 Lives with Gabriele Münter in Murnau
1910 Paints his first abstract watercolor
1911 Founds "Der Blaue Reiter" group of artists with Franz Marc
1912 His essay *Über das Geistige in der Kunst* (About the Spiritual in Art) appears
1922 Becomes professor at the Bauhaus in Weimar and Dessau
1928 Becomes a German citizen
1937 The National Socialists confiscate his pictures as "degenerate art"
1939 Kandinsky acquires French citizenship
1944 Dies on December 13 in Neuilly-sur-Seine, France

Vasily Kandinsky, 1913, photograph

1887–1889 Construction of Eiffel Tower
in Paris

1820 1825 1830 1835 1840 1845 1850 1855 1860 1865 1870 1875 1880 1885 1890 1895 1900 1905

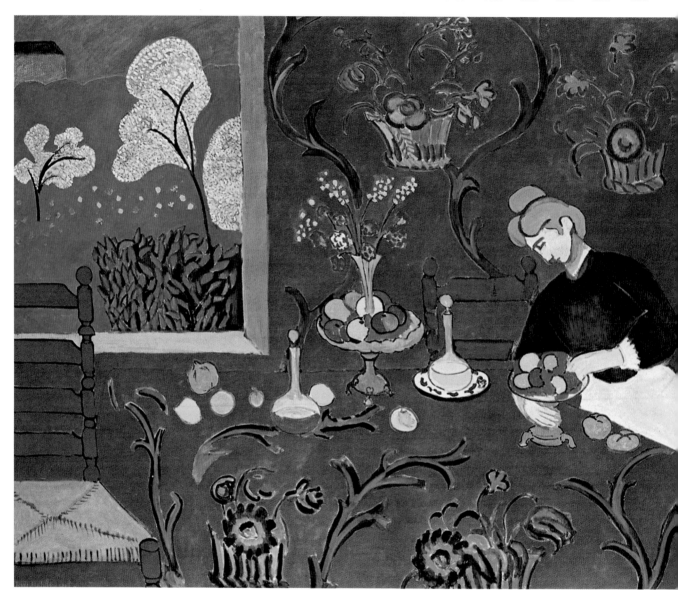

Henri Matisse, *Harmony in Red*, 1908,
oil on canvas, 180 x 200 cm,
The Hermitage, St. Petersburg

1937 *Guernica* (Picasso)			
1914–1918 World War I	**1939–1945** World War II	**1955** Beginnings of Pop Art	**1969** Moon landing (United States)
1927 Lindbergh flies solo across the Atlantic	**1945** Atom bombs dropped on Hiroshima and Nagasaki		

| 1910 | 1915 | 1920 | 1925 | 1930 | 1935 | 1940 | 1945 | 1950 | 1955 | 1960 | 1965 | 1970 | 1975 | 1980 | 1985 | 1990 | 1995 |

HENRI MATISSE

"I dream of an art of balance, purity and peace, devoid of 'issues' or any kind of disturbing subject matter, which gives the mental worker . . . mental reassurance, soothes his soul, and means a respite from the toils of the day and his work for him."—Henri Matisse, 1908

Experiments with Color

Born in northern France in 1869, Matisse pursued a law degree before taking up painting in 1889, at the age of 20. After formally studying art for a time, he became interested in more experimental developments and became the spokesman and cofounder of the group of artists known as Fauves (meaning "wild beasts"), formed in 1905 in France. Forging the first artistic revolution of the young 20th century, the Fauves took the expressive possibilities of color to their consummation. During his Fauvist period, Matisse worked with bright, bold colors, which he applied to the canvas with rapid brushstrokes, away from a real-life model. "You can't live in an over-regulated household, a household of aunts from the provinces," Matisse said of the painting of his day. "So we sally forth into the wilderness in order to find simpler ways that don't stifle the spirit."

Among the first works by Matisse and the Fauves were numerous portraits, an art form in which resemblance had historically been the chief purpose. Pictures such as Matisse's *Woman with Hat* (1905) aroused vehement criticism among contemporaries, who found the work's liberal use of color, reduction to the elemental, and simplification of shape to be primitive. Moving far beyond the Impressionist style that critics had just gotten used to, the artist aimed instead to achieve harmony within the picture.

Two years later, Matisse—the undisputed master of Fauvism—abandoned the style (without challenging its importance) in search of a new kind of painting. In works like *Harmony in Red*, he re-introduced the decorative element into painting. A short time later, he did large-format paintings on the subject of dance and music using only three colors—red, green, and blue. With his complete abolition of central perspective and his use of continuous ornamental patterns in these works, the artist again encountered fundamental criticism.

From the 1940s to his death in 1954, Matisse devoted himself to *papiers découpés* (paper cutouts), which represented the quintessence of his oeuvre for him. He regarded the cutouts, which he combined into collages, as an unbroken continuation of his previous work, saying, "I arrived at shapes stripped to essentials only by means of greater absoluteness and greater abstraction." In these works, he managed to combine drawing with color.

Matisse's entire body of work is notable for its stark simplicity and clarity. His quest for balance and harmony culminated rather belatedly in the decoration of the chapel of Notre Dame du Rosaire, in Vence, France, in 1950.

1869 Born on December 31 in Le Cateau-Cambrésis, France
1889 Begins painting when confined to bed after an appendicitis operation
1898 Marries Amélie Parayre, and has a daughter with her. Two sons are born later.
1905 The Fauves hold their first exhibition in Paris
1912 Matisse travels to Morocco
1930 Travels to Tahiti
1936 Discovers the silhouette as an art form
1938 Moves into an apartment in the former Hotel Régina near Nice
1940 Amélie and Matisse separate
1954 Dies on November 3 in Nice

Henri Matisse in Nice, 1953, photograph

PAUL KLEE

VASILY KANDINSKY

PABLO PICASSO

1886 First gasoline-fueled **1900** Freud's *Die Traumdeutung*
 internal combustion engines (Interpretation of Dreams)

1894 Construction **1905/11** Founding of "Die
 of Reichstag in Brücke" and "Der Blauer
 Berlin Reiter" groups of artists

1830 1835 1840 1845 1850 1855 1860 1865 1870 1875 1880 1885 1890 1895 1900 1905 1910 1915

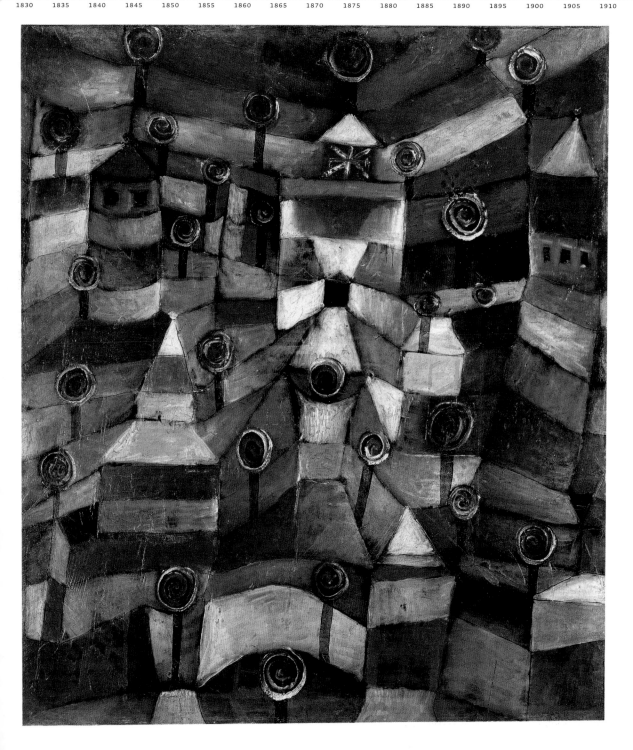

1933 Hitler becomes Führer and Chancellor of Germany

1939–1945 World War II

1914–1918 World War I

1937 "Degenerate Art" exhibition in Munich

1960 John F. Kennedy becomes U.S. president

1920 1925 1930 1935 1940 1945 1950 1955 1960 1965 1970 1975 1980 1985 1990 1995 2000 2005

PAUL KLEE

Painter, theorist, and art teacher Paul Klee was one of the most important artists of the 20th century. With his fantastic, eccentric, poetic pictures, he combined the abstract and figurative in a style that was completely his own. His programmatic statement about art—"Art does not reproduce the visible; rather, it makes visible"—acquired epochal importance.

Klee was born in Münchenbuchsee (near Berne), Switzerland, in 1879, the son of a music teacher and a singer. After a long process of self-discovery and wavering between art and music, he decided to study at the Munich Academy of Fine Arts under Franz von Stuck, but left early when it seemed too conservative. At first Klee worked primarily as a graphic artist, doing etchings and engravings and experimenting on glass plates. After years of work in artistic isolation, he found a link to the avant-garde in the early 1910s, after encounters with the artists of the Blaue Reiter and making the acquaintance of artists Vasily Kandinsky and Robert Delaunay.

A World Full of Symbols

A significant turning point in Klee's development came in 1914, with a trip to Tunisia with his fellow artists and friends August Macke and Louis Moilliet. "Color has got me. I don't need to fish for it any- more," Klee wrote in a letter. "Color and I are one. I'm a painter." His breakthrough to painting was followed by a move to abstraction. Klee created a variety of watercolor paintings with abstract symbols—letters, numbers, or visual symbols such as eyes and spirals—that are reminiscent of children's drawings. These works are more simpli- fied and direct than his previous work. His starting point was a confrontation with the phenomena of nature: rather than trying to imitate outward appearances, his goal was instead to make the mysterious interior of things visible.

From 1920 to 1931, Klee taught and worked at the State Bauhaus in Weimar and Dessau, in Germany. In the inspiring community of the Bauhaus, he developed increasingly complex visual techniques and developed a growing thematic richness. His investigation of his own artistic practice also led him to important theoretical conclusions.

Two years after he moved to the State Art Academy in Düsseldorf, Klee was branded a "degenerate" artist by the Nazi regime and fired.

After immigrating to Berne and developing a serious illness, diagnosed posthumously as scleroderma, Klee was overcome by a severe crisis. As the Nazis confiscated more than 100 of his works from German museums, the artist was in a state of total exhaus- tion. Yet his final years would be hugely productive. He produced an autonomous, extensive body of work, creating 1,253 works in 1939 alone. He added new ideas and techniques as he simplified shapes and colors, inventing a language of hieroglyphs and symbols in larger picture formats. His highly expressive work from this period ensured that his influence continued after his death, earning him an elevated status in the history of art. Klee died in 1940 in Muralto, Switzerland, shortly after the start of World War II.

1879 Born on December 18 in München- buchsee, near Berne, Switzerland
1898 Moves to Munich, where he studies art
1903 Produces his first etchings
1911 Shows his pictures in the "Blaue Reiter" galleries
1914 Travels to Tunisia with his painter friends August Macke and Louis Moilliet
1917 Klee is called up into the armed forces
1920 Becomes a teacher at the Bauhaus
1924 An exhibition of his pictures is shown in New York
1937 Seventeen works by Klee feature in the Nazi "Degenerate Art" exhibition in Munich
1940 Dies on June 29 in Muralto

left page
Paul Klee, *Rose Garden*, 44, 1920, oil and ink on paper mounted on board, 49 x 42.5 cm, Städtische Galerie im Lenbachhaus, Munich, Gabriele Münter und Johannes Eichner-Stiftung and Städtische Galerie

above
Paul Klee in Weimar, 1925, photograph

KASIMIR MALEVICH ▬▬▬▬▬▬▬▬▬▬▬▬▬▬▬▬▬

VASILY KANDINSKY ▬▬▬▬▬▬▬▬▬▬▬▬▬▬

JOAN MIRÓ ▬▬▬▬▬▬

1905/11 Founding of "Die Brücke" and "Der Blauer Reiter" groups of artists

1891 Work starts on Trans-Siberian Railway

1900 *Die Traumdeutung* (Freud)

1906 First German U-Boot

1830	1835	1840	1845	1850	1855	1860	1865	1870	1875	1880	1885	1890	1895	1900	1905	1910	1915

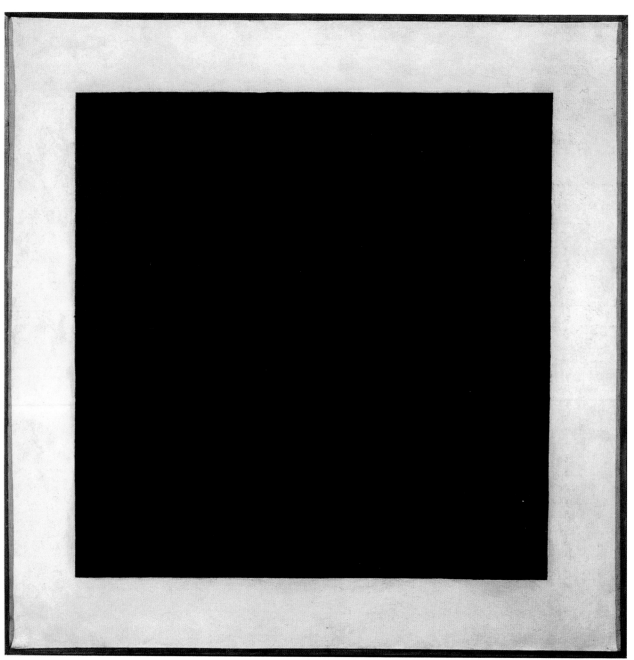

Kasimir Malevich, *Black Square*, c. 1929,
oil on canvas, 106 x 106 cm, Russian
Museum, St. Petersburg

1914–1918 World War I
1917 November Revolution in Russia
911 Kandinsky's *Über das Geistige in der Kunst* (On the Spiritual in Art)

1932 Aldous Huxley publishes *Brave New World*
1945 Beginning of Cold War
1937 "Degenerate Art" exhibition in Munich
1939–1945 World War II

1989 Massacre in Tiananmen Square, Beijing

1920 1925 1930 1935 1940 1945 1950 1955 1960 1965 1970 1975 1980 1985 1990 1995 2000 2005

KASIMIR MALEVICH

Russian painter Kasimir Malevich wanted to pry art away from real-life objects. When his Black Square, *a symbol of his doctrine of Suprematism, was exhibited in 1915, he became a pioneer of the Russian avant-garde, and of abstract art more generally.*

Severinovich Kasimir Malevich was born to a peasant, proletarian family in 1878 as the eldest of 14 children. He began his work with paints as an autodidact; it was only in 1895 that he became a student at art schools and studios in Kiev, Kursk, and Moscow. Before World War I, the Russian art scene was vibrant and outward-looking, influenced by the avant-garde movements that spread abroad from the art capital of Paris. As a student with an eye to what was going on in the international art world, Malevich tried his hand at Impressionism, Fauvism, Cubism, and Futurism, before eventually developing his own style.

Black Square on a White Background

Malevich first showed paintings with radically reduced forms in the Futurist "0.10" exhibition in Petrograd (now St. Petersburg) in December 1915. (The "0" stood for point zero in painting and the desire to destroy what had happened before and start over again. The "10" referred to the expected participation of ten artists.) Malevich came up with a work that would put a temporary end to representational painting. In a manifesto, he declared his *Black Square* (comprised of a black square on a white background) to be the "bare icon of my time" and the founding work of his new artistic religion of Suprematism. He proclaimed a new "painterly realism" comprised of "pure sensation"; he argued that, liberated from the "ballast of objects," this style of painting would lead to a more humane world. Generations of abstract artists would refer to his painting as an "icon of the new art."

Malevich gained a reputation as an artist and theorist not only in Russia but also internationally. He worked as an art official and head of the artistic workshops and schools in Petrograd, Moscow, and Vitebsk, and as director at the Institute of Artistic Culture in Petrograd. In 1927, he made a single trip to the West, to Berlin, to attend the "Great Berlin Art Exhibition." He hoped for a professorship at the Dessau Bauhaus, but this was not forthcoming. After his return, his influence in the new Soviet Union was increasingly eroded by accusations of formalism.

Radical Change of Style

At the end of the 1920s, the Russian artist returned to representational painting, which caused confusion and sustained controversy in the art world. Shortly before his death in 1935, a seriously ill Malevich had himself photographed with his stylistically varied works. The photo shows him lying on his deathbed, with the *Black Square*, a realistic self-portrait, and late-period paintings of peasant workers arranged together in the background.

1878 Born on February 23 near Kiev
1895–96 Studies at the Kiev School of Art
1898–1901 Studies in Kursk
1902 Attends the Moscow School of Painting, Sculpture and Architecture
1912 Travels to Paris, where he becomes involved with Cubism; invited to take part in the second "Blaue Reiter" exhibition
1916 Publication of the essay "From Cubism to Suprematism"
1917 Appointed to the Moscow Art School; member of the Fine Arts Department of the Commission for Popular Education
1918 Professor at the State Art and Technology Workshops in Moscow
1922–29 Heads the Institute of Artistic Culture in St. Petersburg
1935 Dies on May 15 in St. Petersburg

Kasimir Malevich, Self-Portrait, 1933, oil on canvas, 70 x 66 cm, Russian Museum, St. Petersburg

below
Kasimir Malevich, *Taking in the Rye*,
c. 1912, oil on canvas, 72 x 74.5 cm,
Stedelijk Museum, Amsterdam

right page
Kasimir Malevich, *Suprematism*, 1915,
oil on canvas, 44.5 x 35.5 cm, Stedelijk
Museum, Amsterdam

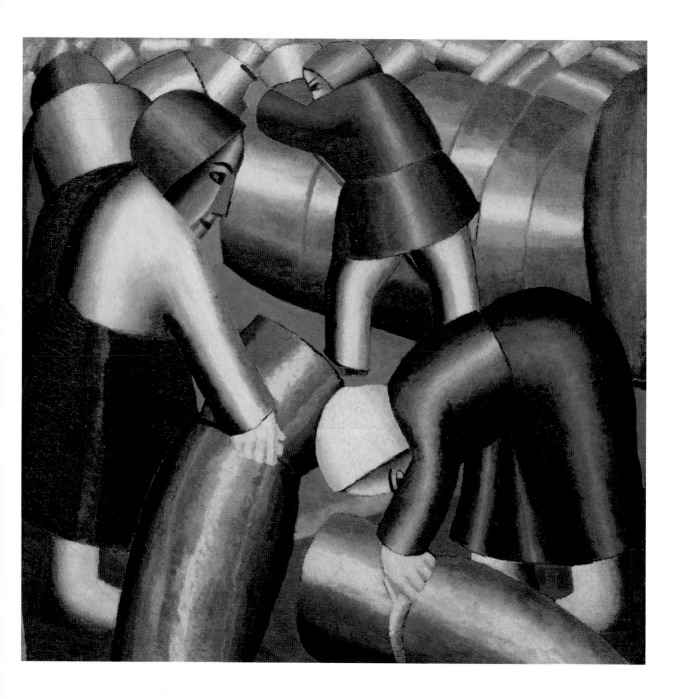

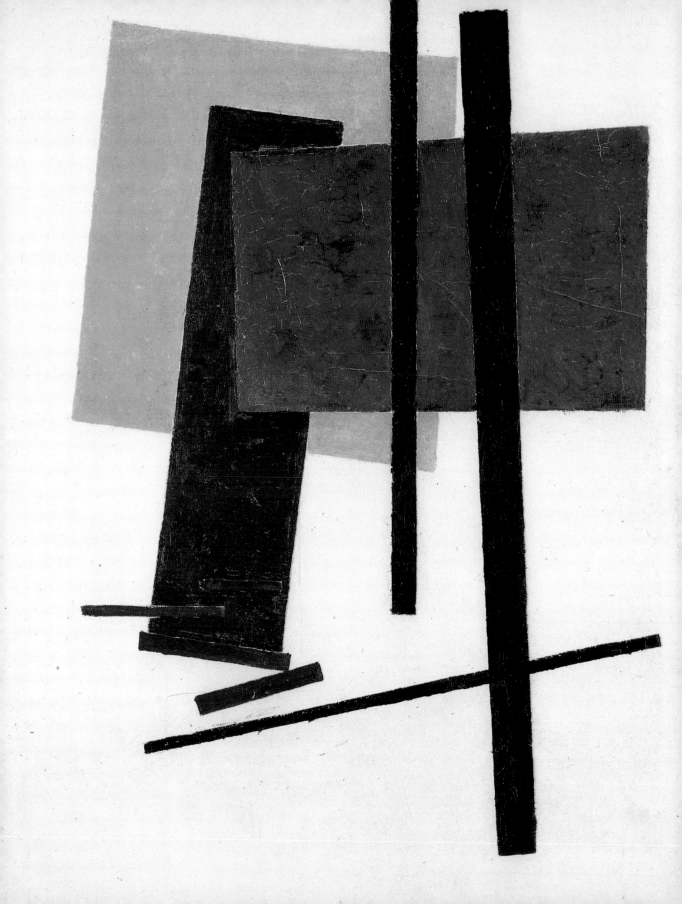

1905/11 Founding of "Die Brück
and "Der Blauer Reiter"
groups of artists

1900 Freud's *Die
Traumdeutung*
(Interpretation
of Dreams)

1911 Kandinsky's *Über das
Geistige in der Kunst*
(On the Spiritual in A

| 1830 | 1835 | 1840 | 1845 | 1850 | 1855 | 1860 | 1865 | 1870 | 1875 | 1880 | 1885 | 1890 | 1895 | 1900 | 1905 | 1910 | 1915 |

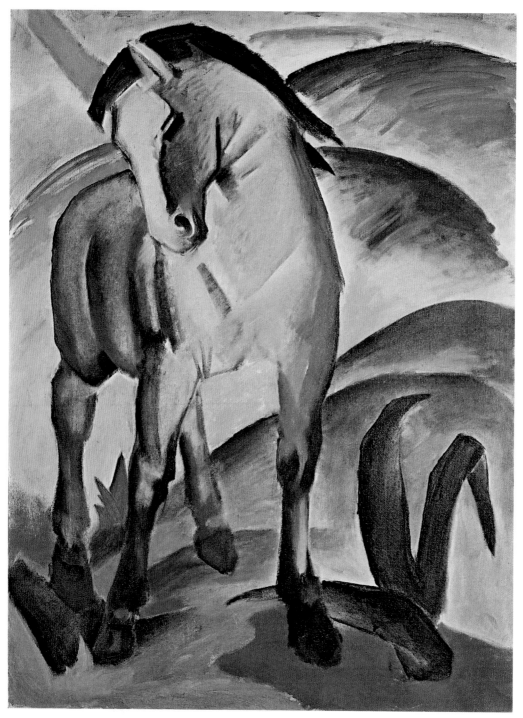

Franz Marc, *Blue Horse I*, 1911,
oil on canvas, 112 x 84.5 cm,
Städtische Galerie im
Lenbachhaus, Munich,
Bernhard Koehler-Stiftung

FRANZ MARC

Along with Vasily Kandinsky, Franz Marc was a founder of the Blaue Reiter group of artists. He is considered one of the most important German Expressionist painters.

Marc was born in 1880 in Munich, the second son of Wilhelm, who worked as a painter and academy professor, and Sophie, who was from Alsace and had been brought up a strict Calvinist. Both parents exerted an influence on their son's career: painting and an interest in religious questions would be a constant thread throughout his life. As a shy and pensive boy, Franz had a penchant for philosophy. At secondary school, he read the vivid, visionary writings of philosopher Friedrich Nietzsche with growing enthusiasm and succumbed to the intoxicating music of Richard Wagner. Even then, he was looking for a new spiritual alternative beyond traditional religion.

Study and Travel through France
In 1900, Marc enrolled at the Academy of Fine Arts in Munich. His aim was to get a good grounding in the fundamentals of art, but he soon found academicism too constraining. He abandoned formal studies and traveled throughout France; during his travels he was particularly fascinated by Paris, and he was overwhelmed by the pre-Expressionist works of Vincent van Gogh and Paul Gauguin. In 1904, after his travels, Marc left home and set up a studio in Schwabing.

Der Blaue Reiter
Marc made the acquaintance of Vasily Kandinsky, Aleksei von Yavlensky, and Gabriele Münter through the New Artists' Association group of artists. When the jury rejected Kandinsky's almost completely abstract *Composition V* for the third association exhibition, Kandinsky, Münter, and Marc resigned from the association and founded the Blaue Reiter editorial community. For Marc, this meant a community that would pursue the spiritual in art. He was convinced that the image per se was not enough; the painter had to produce signs in which reality was contained as an extract. Marc envisaged a better, purer world, which he saw pre-formulated

in the rawness of animals. His expressive, color-saturated pictures were intended to mediate between representation and abstraction.

Little Yellow Horses
One of his key works, *Little Yellow Horses*, is dominated by three yellow horses against a hilly landscape. The main theme is the color yellow, indicating the passive female element, while the sensual and powerful red of the edges contrasts with the blue background. The bright colors, combined with the animals as symbols of vitality and a projection of Marc's artistic ideas, make the picture one of his key works, and at the same time a representative example of the principles of the Blaue Reiter.

1880 Born on February 8 in Munich
1900–03 Trains at the Munich Academy
1902 Travels to Italy
1904 Stays in France
1907 Travels to Paris
1910 Moves to Sindelsdorf in Upper Bavaria; joins the New Artists' Association in Munich; befriends August Macke and Vasily Kandinsky
1911 Leaves the New Artists' Association; with Kandinsky founds the "Blaue Reiter" group
1912 Co-publisher of the "Blaue Reiter Almanac"; travels to Paris with Macke; visits the Futurist exhibition in Cologne
1913 Takes part in first German Autumn Salon in Berlin
1914 Drafted into military service
1916 Killed in action in World War I on March 4 at Verdun

Franz Marc in Sindelsdorf, 1913, photograph

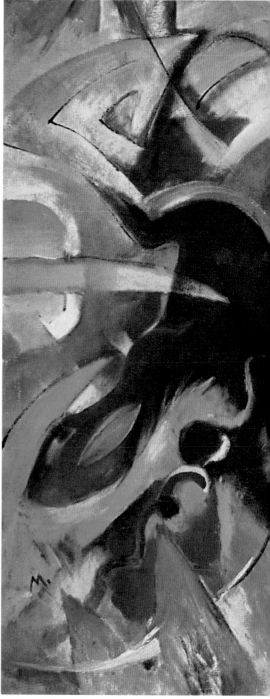

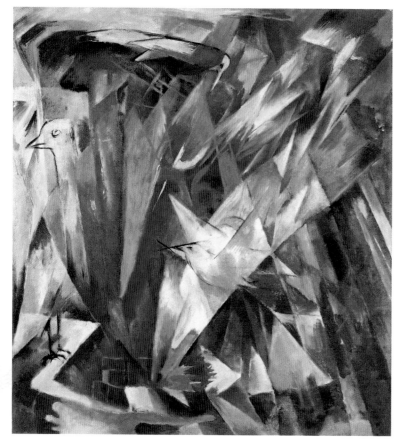

Franz Marc, *Birds*, 1914, oil on canvas,
109 x 100 cm, Städtische Galerie im
Lenbachhaus, Munich

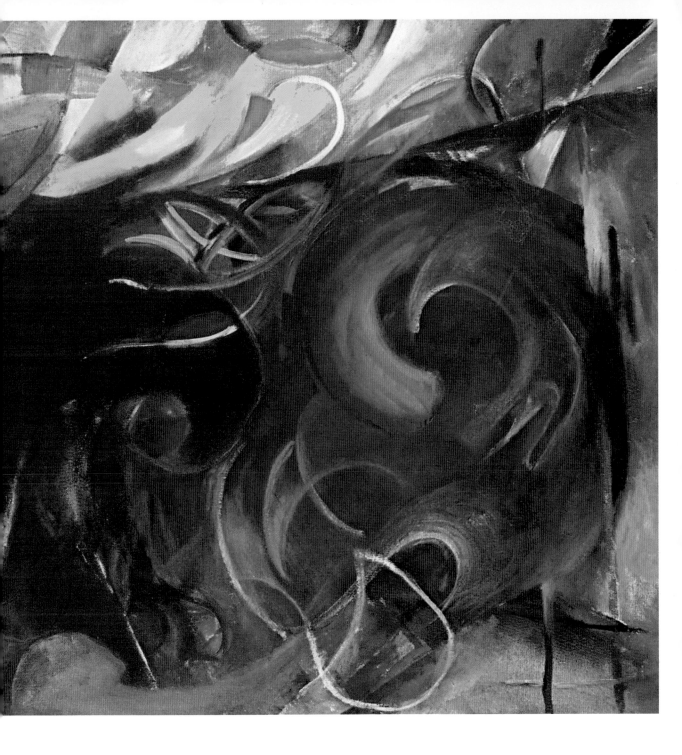

Franz Marc, *Fighting Forms*, 1914, oil on canvas, 91 x 131 cm, Bayerische Staatsgemäldesammlung, Munich

1905/11 Founding of "Die
Brücke" and "Der Blauer
Reiter" groups of artists

1900 Freud's *Die
Traumdeutung*
(Interpretation
of Dreams)

1911 Kandinsky's *Über das
Geistige in der Kunst*
(On the Spiritual in A

| 1830 | 1835 | 1840 | 1845 | 1850 | 1855 | 1860 | 1865 | 1870 | 1875 | 1880 | 1885 | 1890 | 1895 | 1900 | 1905 | 1910 | 1915 |

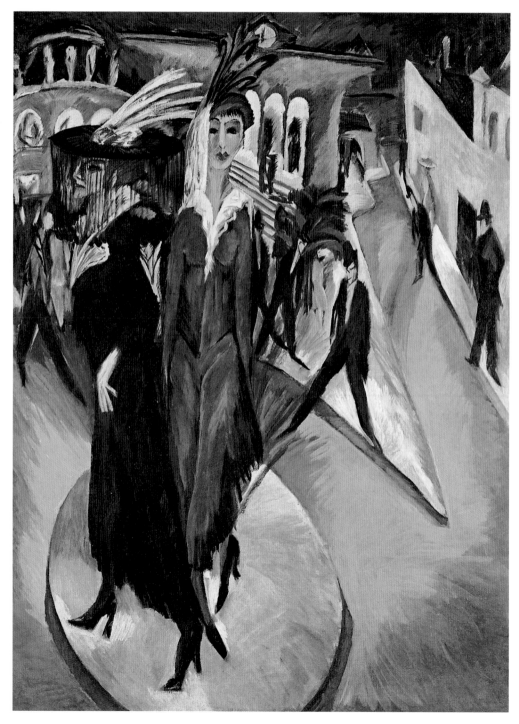

Ernst Ludwig Kirchner, *Potsdam
Platz*, 1914, oil on canvas,
200 x 150 cm, Staatliche Museen
zu Berlin, Nationalgalerie

1937 "Degenerate Art" exhibition in Munich

1914–1918 World War I **1930** Marlene Dietrich becomes **1942** Peggy Guggenheim opens Art of
a star with the *Blue Angel* This Century Gallery in New York

1939–1945 World War II

1927 Founding of Comedian Harmonists
ensemble in Berlin

| 1920 | 1925 | 1930 | 1935 | 1940 | 1945 | 1950 | 1955 | 1960 | 1965 | 1970 | 1975 | 1980 | 1985 | 1990 | 1995 | 2000 | 2005 |

ERNST LUDWIG KIRCHNER

One of Ernst Ludwig Kirchner's most famous images examines big-city life in Berlin: his Potsdamer Platz is a painting that captures the bustle of the metropolis. Based on the power of works such as this, he is often considered the main representative of German Expressionism.

Kirchner was born in Aschaffenburg, Germany, in 1880. In 1901, he enrolled as a student of architecture at the Technical University in Dresden. In June 1905, Kirchner and Erich Heckel, Karl Schmidt-Rotluff, and Fritz Bleyl founded a group of artists know as Die Brücke (The Bridge). Thereafter, he devoted himself to paintings, drawings, and prints. The typical characteristics of Expressionism cultivated by the artists in Die Brücke were sensually vibrant coloration, dramatic compression, and angular outlines. The artists in the group admired Edvard Munch's woodcuts and Vincent van Gogh's bright impasto colors, using these two artists as influences as they created their own inimitable Expressionist style. Aiming to achieve a conscious reflection of their current lifestyle and truth in art, Brücke artists wanted to destroy the old world so as to build a new one from its ruins.

Female Nudes
In 1906, Kirchner made the acquaintance of Doris Grosse, who would be his favorite model until 1911. From 1907 to 1911, he and various Brücke artists spent the summer holidays in Goppeln, the Moritzburg lakes, and Fehmarn. At this time, Kirchner's work focused on portraying female nudes in nature, expressed in boldly colored, impulsive paintings.

Move to Berlin
After 1911, Kirchner and his fellow artists moved to Berlin. Here he would paint one of his most famous images. In the painting *Potsdamer Platz* (1914), two slender women can be seen in the center of the painting. One wears a black dress and turns toward the left edge of the picture, while the other, wearing a dove-gray dress, looks directly at the viewer. The two are surrounded by a hectic rush of passersby and the urban outlines of Potsdamer Platz. With his angular shapes, Kirchner succeeded in capturing the essential elements of the big city. Pace, anonymity,

and crowds of people are brought together in his brushstrokes. Street scenes show the artist as a fascinating portraitist of a feverish urban world.

Die Brücke Breaks Up
In 1913, Kirchner wrote a "chronicle" of Die Brücke, which by overemphasizing his own role led to the dissolution of the group. His first solo exhibition at the Folkwang Museum established his work on the contemporary art scene. In 1914, Kirchner volunteered for military service. After a nervous breakdown, by late 1915 he had already been discharged. He suffered from tuberculosis, and from 1917 lived in Switzerland for health reasons. In 1937, the Nazis confiscated his work, declaring it "degenerate." The following year, Kirchner committed suicide.

1880 Born on May 6 in Aschaffenburg, Germany
1901–03 Studies architecture in Dresden
1903–04 Attends the Debschütz Art School in Munich
1905 Joins with Erich Heckel, Fritz Bleyl, and Karl Schmidt-Rottluff on June 7 to form "Die Brücke"
1911 Moves to Berlin; founds the MUIM Institute (Modern Instruction in Painting) with Max Pechstein
1913 Solo exhibition in Hagen; chosen by the other "Brücke" artist to write a chronicle of the group, but the other members do not accept his version of events; "Die Brücke" is dissolved
1914 Military service
1915 Following a physical collapse, recuperates in a sanatorium in the Taunus hills
1917 Moves to Davos
1937 A large portion of his work is seized by the Nazis
1938 Commits suicide on June 15 in Davos, Switzerland

Ernst Ludwig Kirchner, Self-Portrait, c. 1919, photograph

1886 First gasoline-fueled internal combustion engines

| 1830 | 1835 | 1840 | 1845 | 1850 | 1855 | 1860 | 1865 | 1870 | 1875 | 1880 | 1885 | 1890 | 1895 | 1900 | 1905 | 1910 | 1915 |

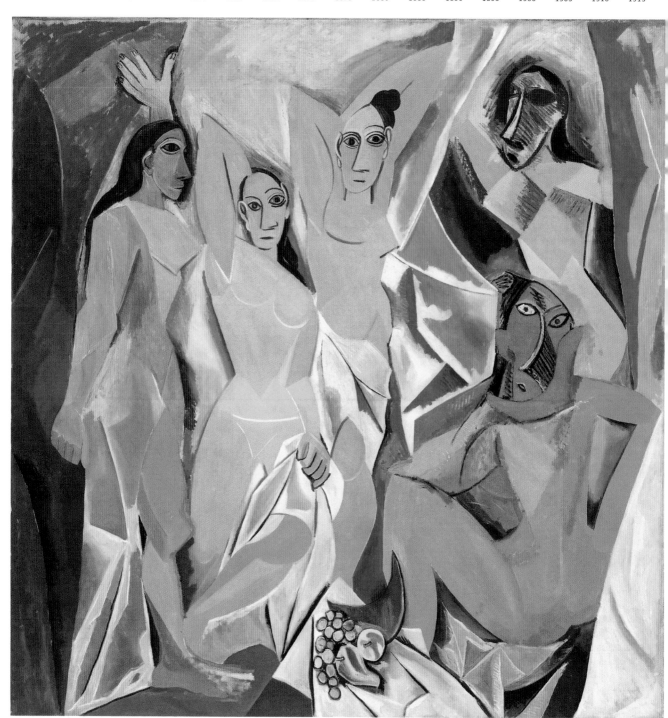

1914–1918 World War I

1939–1945 World War II

1945 Atom bombs dropped on
Hiroshima and Nagasaki

1955 Beginnings of Pop Art

1960 John F. Kennedy becomes
U.S. president

1965–1975 Vietnam War

1969 Moon landing (United States)

1981 First *Columbia* space flight

1990 Reunification of
Germany

1920 1925 1930 1935 1940 1945 1950 1955 1960 1965 1970 1975 1980 1985 1990 1995 2000 2005

PABLO PICASSO

"I wanted to be a painter, and I became Picasso."—Pablo Picasso

As a teenager, Pablo Ruiz Picasso was considered highly gifted. At 15, he was admitted to the art college in Barcelona, and a year later he followed the suggestion of his teachers and transferred to the Academy of Fine Arts in Madrid, where he could learn something new and get more appropriate teaching. Even during his student days, he was able to show his work successfully in exhibitions.

During a trip to Paris, Picasso came into contact with the work of the Impressionists. His special interest became depicting people marginalized by society, in works with ultra-reduced palettes and shapes. Between 1901 and 1904 (his Blue Period), Picasso did paintings in blue-green tones, while in the ensuing Rose Period (until 1906) he focused mainly on scenes from the circus. Henceforth calling himself only by his mother's maiden name, Picasso settled in Paris permanently. Here art dealer Ambroise Vollard bought all the pictures of the artist's Rose Period in 1906, which at last brought Picasso financial security (for the time being).

The Founding Work of Cubism

A year later, Picasso caused a stir with a work that totally undermined traditional notions of pictorial representation. It was not the subject matter of *Les Demoiselles d'Avignon* that shocked critics, but rather the geometric style of the figures and the distortion and fragmentation of pictorial space. The painting started a new art movement—Cubism—that finally made straightforward representation a secondary function of art. Picasso's basic ideas on form coincided with his newly discovered interest in archaic and "primitive" sculptural works in which the body is reduced to simple forms. This interest was also the inspiration for the mask-like faces of the *Demoiselles*.

While fragmented, Picasso's work was never purely abstract. He liberated the real-life object from its original meaning, broke it into pieces, and put it together again, with each component following its own set of autonomous rules. In addition to the Cubist works, in which he eventually integrated newspaper cuttings and other elements as collages, he also painted representational and figurative works. *Guernica* was commissioned in 1937 for the Spanish Pavilion at the Exposition Universelle in Paris. In this work, Picasso depicts fear and horror following the destruction of the Basque town of Guernica during bombing raids by the German Condor Legion. The artist adopted a political stance, saying, "Painting was not invented to decorate homes. It is a weapon of attack and defense against the enemy."

In his later output, Picasso devoted himself primarily to graphic work. He also took works by other painters—such as Diego Velázquez's *Las Meninas*—as models, recreating them in his own style. The artist died at the age of 91 in southern France. He left 15,000 paintings, nearly 660 sculptures, and numerous drawings, prints, and ceramics.

1881 Born on October 25 in Málaga, Spain
1901 Start of the "Blue Period"
1904 Moves to Montmartre artists' quarter. Start of the "Rose Period."
1907 Develops Cubism with Georges Braque
1918 Picasso marries the dancer Olga Koklowa
1921 Their son Paolo is born
1927 Meets Marie-Thérèse Walter and leaves Olga
1935 His daughter Maya is born
1936 Dora Maar becomes Picasso's mistress
1946 Francoise Gilot becomes Picasso's partner; he has two children with her: Claude and Paloma
1953 Picasso meets Jacqueline Rocque, whom he marries in 1961
1973 Dies on April 8 in Mougins near Cannes, France

left page
Pablo Picasso, *Les Demoiselles d'Avignon*, 1906/07, oil on canvas, 244 x 234 cm, The Museum of Modern Art, New York

above
Pablo Picasso, photograph

1861–1865 American Civil War **1891** End of the Indian Wars in the United States

1883 First skyscraper in Chicago

| 1830 | 1835 | 1840 | 1845 | 1850 | 1855 | 1860 | 1865 | 1870 | 1875 | 1880 | 1885 | 1890 | 1895 | 1900 | 1905 | 1910 | 1915 |

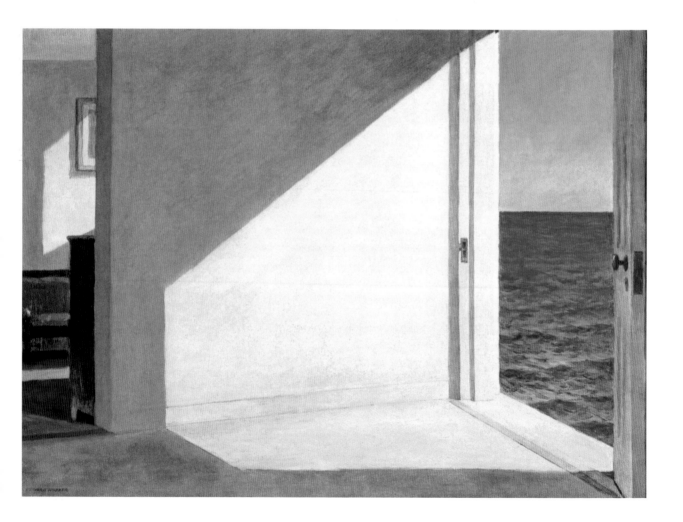

Edward Hopper, *Rooms by the Sea*,
1951, oil on canvas, 37.7 x 101.9 cm,
Yale University Art Gallery, New Haven

1945 Atom bombs dropped on
Hiroshima and Nagasaki

1963 Assassination of
John F. Kennedy

1914–1918 World War I

1939–1945 World
War II

1952 Elvis Presley hits the headlines

1950 Abolition of racial segregation in the United States

1981 First *Columbia* space flight

1920 1925 1930 1935 1940 1945 1950 1955 1960 1965 1970 1975 1980 1985 1990 1995 2000 2005

EDWARD HOPPER

To many people, one name above all represents American modernism—Edward Hopper. His timeless paintings of isolated houses, of movie theaters and diners, and of solitary travelers in hotels and motels characterize the melancholic side of midcentury America.

Hopper came to painting via commercial art and illustration. He studied commercial art from 1899 at the Correspondence School of Illustrating in New York, switching subsequently to the New York School of Art. After a successful gallery exhibition in 1924, he gave up the commercial work he disliked and devoted himself henceforth entirely to painting.

The Melancholy of Modern Life

Hopper moved around between the sundry controversial art movements of his time, including the Urban Realism associated with his teacher Robert Henri and the group later known as the Ashcan School, and the modernism associated with photographer Alfred Stieglitz and his 291 Gallery. In contrast to the followers of the Ashcan School, who saw the pulsating vitality of the city and the possibility of interpersonal encounters, Hopper's works manifest a detached view of the city. They tell of the experience of alienation, loneliness, anonymity, and the inability to establish contact. The pictures seem silent and motionless, looking almost spectral, just because we suspect that, even after the recorded moment, nothing will happen.

Déjà vu

Hopper's works are distinguished by a remarkable stylistic and thematic continuity. He found subject matter not only in the city itself, but also at the periphery and in the suburbs. He managed to give his pictures such intensity that viewers instinctively feel they have already somehow experienced the scene themselves. Yet for all the factual correctness, Hopper always sought an inner expression. In his view, art should be a "fact seen through the personality." He therefore dispensed with all superfluous detail in his paintings. Especially in his late work, compositions seem to get increasingly clear, consisting first and foremost of a contrast between light and shadow over large areas.

As an avid moviegoer, Hopper acquired the eye of a film director, while his art in turn influenced many directors. A well-known example is his painting *House by the Railroad*, which provided Alfred Hitchcock with the idea for his house of horror in *Psycho*. The Photo-Realists and American Pop artists of the 1960s likewise drew from his work. With his detached, coolly objective approach to his subject matter, Hopper was an icon of the American painting of his time.

1882 Born on July 22 in Nyack, New York
1899 Enrolls in the New York Correspondence School of Illustrating
1906 Attends the New York School of Art
1906–10 Makes three trips to Europe
1907–25 Works as a freelance commercial illustrator
1913 Moves into Greenwich Village studio; sells his first painting at the Armory Show
1915 Learns etching
1923 Sells *The Mansard Roof* for $100 to the Brooklyn Museum of Art
1924 Sells all his paintings at his first solo exhibition at the Frank K. M. Rehn Gallery in New York City
1928 Stops making prints
1934 Builds a summer house in Truro, Massachusetts
1937 Featured in a *Life* magazine profile with the title "Hopper Is a Realist"
1941 Takes a trip to the West Coast
1966 Receives an honorary doctorate of fine arts from the Philadelphia College of Arts
1967 Dies on May 15 in New York City

Edward Hopper in Cape Elizabeth, Maine, 1927, photograph, Private collection

1887–1889 Construction of Eiffel Tower in Paris

1914–1918 World War I

1835 1840 1845 1850 1855 1860 1865 1870 1875 1880 1885 1890 1895 1900 1905 1910 1915 1920

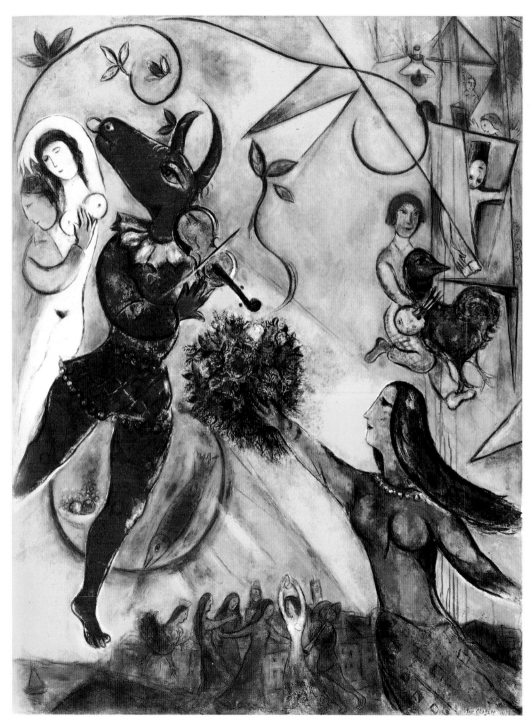

Marc Chagall, *The Dance*,
1950/52, oil on canvas,
238 x 176 cm, Musée national
d'art moderne, Centre
Georges Pompidou, Paris

1937 "Degenerate Art" exhibition in Munich
1939–1945 World War II
1933 Hitler becomes Führer and Chancellor of Germany
1961 Berlin Wall constructed
1962 Cuban Missile Crisis
1973 First oil crisis
1991 Soviet Union breaks up

1925 1930 1935 1940 1945 1950 1955 1960 1965 1970 1975 1980 1985 1990 1995 2000 2005 2010

MARC CHAGALL

In his work, Marc Chagall combined aspects of the stylistic achievements of the Paris avant-garde with naive, poetic memories of his Hasidic Jewish background in Belarus. In his paintings, the conscious and unconscious, reality and dream fuse to convey narratives from a unique fantasy world.

Born in 1887 in Vitebsk, Belarus (then part of the Russian Empire), the first of nine children, Chagall went first to St. Petersburg, then, with the help of a scholarship, to Paris in search of artistic training. "The soil that had nourished the roots of my art was Vitebsk," he later wrote in retrospect. "But my art craved for Paris, like a tree thirsts for water." In France, he was influenced by the works of the Post-Impressionists, Fauves, Cubists, and Surrealists, though he never lost touch with his roots. His paintings are full of memories of his Jewish childhood and the simple rural life in his hometown, which made a deep impression on his visual memory. As a painter, he turned these images into fantastic, naive visions, as in his early masterpiece *I and the Village*, in which the painter himself appears with a green face.

Fantasy and Poetry

In Chagall's works, animals and brides float through the air, clocks hang in the sky, and cows sit on a roof. The laws of time, space, and gravity are suspended, while fantasy and reality appear in rationally incomprehensible combinations. Recurring motifs in his fairy-tale imagery include the figures of the *shtetl*, lovers, bouquets, or the crescent moon. With this imagery, Chagall was looking beyond purely autobiographical content and expressing universal emotions such as happiness, joy, and melancholy.

In addition to working on his paintings, Chagall illustrated books, ranging from Gogol's satirical novel *Dead Souls*, to the fables of La Fontaine, to the Bible; for the latter he traveled to Egypt, Syria, and Palestine to see the Holy Land with his own eyes. He did murals, costumes, and stage curtains (for example, for the Jewish Theater in Moscow), etchings, ceramics, and mosaics. He was also known for his outstanding work in the field of stained glass. The artist designed windows for the cathedrals in Metz and Reims, in France, and for the synagogue at the University Hospital in Jerusalem.

Chagall's works were already under attack from the Nazis in 1933, and in 1938 they were categorized as "degenerate art" and confiscated from public collections. The artist responded to the German onslaught and genocide of the Jews with paintings such as *The White Crucifixion*, a depiction of great suffering. In 1941, he immigrated to New York. After the war he settled in the south of France, where he continued working as productively as ever, with a late oeuvre notable for its vibrant color and narrative wealth of detail. Artistically active to the end, Chagall died in Saint-Paul-de-Vence, France, in 1985.

1887 Born on July 7 in Liosno, near Vitebsk, Belarus
1910 Goes to Paris
1915 Marries Bella Rodenfeld and returns to Russia
1917 Founds a modern art school in Russia
1921 Teaches war orphans near Moscow
1922 The family moves to Berlin, then to Paris a year later
1937 Chagall's pictures are included in the "Degenerate Art" exhibition
1941–47 Chagall marries Valentina Brodsky, his second love
1985 Dies on March 28 in Saint-Paul-de-Vence, France

Franz Hubmann, Marc Chagall, photograph

1910 Futurist Manifesto in Italy

1887–1889 Construction of Eiffel Tower in Paris

1914–1918 World War I

1895 First public film screenings

1835　1840　1845　1850　1855　1860　1865　1870　1875　1880　1885　1890　1895　1900　1905　1910　1915　1920

1939–1945 World War II

1931 *The Persistence of Memory* (Salvador Dalí)

1955 Beginnings of Pop Art

1969 Moon landing (United States)

1986 Chernobyl disaster

1990 Reunification of Germany

| 1925 | 1930 | 1935 | 1940 | 1945 | 1950 | 1955 | 1960 | 1965 | 1970 | 1975 | 1980 | 1985 | 1990 | 1995 | 2000 | 2005 | 2010 |

MARCEL DUCHAMP

French artist Marcel Duchamp is remembered as being a stimulus to the fast-developing American art scene of the early 20th century. His ideas significantly expanded the concept of art. In particular, his conversion of everyday objects into "art objects" represented a spectacular challenge to conventions.

Duchamp became internationally known based on a few controversial works. His first celebrated work, dated 1912, was his take on Cubism and Futurism. This painting, *Nude Descending a Staircase*, manages to capture the movement of a nude figure as a series of snapshots, like a multiple-exposure photo. Seen as the epitome of avant-garde modernism, in 1913 the picture was the center of attention at the Armory Show in New York, where many artists of the European avant-garde were represented alongside contemporary American colleagues.

Ennobled into Art

After the excitement his picture aroused at the Armory Show, Duchamp moved further and further away from traditional painting. In 1913 he designed his first "ready-mades"— mass-produced industrial products that he left unchanged or only slightly modified, but which he signed and sometimes inscribed. For example, he exhibited the front wheel of a bicycle mounted on a stool, a signed bottle rack, and a urinal that he signed "R. Mutt" and entitled *Fountain*. By making these works, Duchamp expressed an overt indifference to all aesthetic categories. His aim was to produce "works of art" that were nothing of the kind, devoid of any creative involvement or personal style. What counted for the artist was simply the act of choosing, as well as the way this "newfound idea" would be treated in a gallery setting. Duchamp was also cavalier in his treatment of traditional art. His work *L.H.O.O.Q.* is a reproduction of Leonardo's famous *Mona Lisa*, but with a goatee and moustache daubed on it.

In 1915 Duchamp began years of work on an enigmatic glass picture called *The Bride Stripped Bare by Her Bachelors, Even*, which he declared "finally incomplete" in 1923. After this last major statement, he retired from the art world, much admired by the Dadaists and Surrealists, and lived as a chess player mainly in New York. Only after more than ten years had passed did he return to art, ready to fire salvos questioning the greatness and uniqueness of works of art and the traditional concept of museums. He collected reproductions of his works and models of his ready-mades in hinged boxes; he exhibited one of these "portable museums"—which he called a *Boîte-en-Valise* (Box in a Suitcase)—at the opening of Peggy Guggenheim's Art of This Century Gallery in 1942.

After a few more works and numerous exhibitions in the United States, where his early artistic productions were shown, Duchamp died unexpectedly in Neuilly-sur-Seine, France, in 1968. His gravestone bears an inscription written by the artist himself: "Anyway, it's always the others who die."

1887 Born on July 28 in Bainville-Crevon, France
1904 Moves to Paris
1913 His *Nude Descending a Staircase* creates a great stir at the Armory show in New York
1915 Creates *The Bride Stripped Bare by Her Bachelors, Even*
1915 Goes to New York, where he influences the Dada artists. Lives partly in Paris, partly in the United States
1923 Abandons art for ten years, out of boredom
1936 Begins work on *Boîte-en-Valise*
1947 Organizes a Surrealist exhibition in Paris
1968 Dies on October 2 in Neuilly-sur-Seine, France

left page
Marcel Duchamp, *Bottle Rack*, 1914/1964, galvanized iron, h: 64.2 cm, Musée national d'art moderne, Centre Georges Pompidou, Paris

above
Ugo Mulas, Marcel Duchamp, 1956, photograph

1912 *Titanic* disaster

1903 Kraft Foods
founded

1882 * Virginia Woolf

1918–1920 Spanish flu
epidemic kills
over 20 million
people worldwide

1835 1840 1845 1850 1855 1860 1865 1870 1875 1880 1885 1890 1895 1900 1905 1910 1915 1920

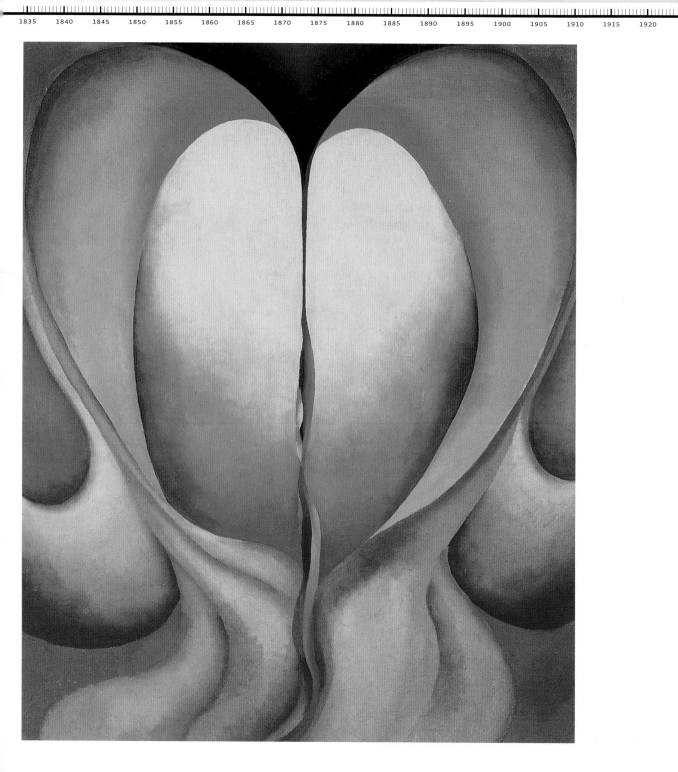

1929 Wall Street crash

1945 Atom bombs dropped on Hiroshima and Nagasaki

1965–1975 Vietnam War

1989 Fall of Berlin Wall

1920–1933 Prohibition in the United States

1940 Charlie Chaplin's *Great Dictator*

1925　1930　1935　1940　1945　1950　1955　1960　1965　1970　1975　1980　1985　1990　1995　2000　2005　2010

GEORGIA O'KEEFFE

The first time the Museum of Modern Art, New York, dedicated a retrospective to the work of a woman was in 1946, when the museum featured the work of Georgia O'Keeffe. The artist had launched a veritable revolution in still-life painting in the 1920s in the United States with her outsized, magnified flower pictures.

O'Keeffe's artistic breakthrough came in 1916, when she found herself socializing with the avant-garde artists associated with photographer Alfred Stieglitz in New York. A year later, Stieglitz organized the first exhibition of her works in his avant-garde 291 Gallery. O'Keeffe began her career with clear, mini-malist paintings of cityscapes and skyscrapers that describe the growth of the metropolis. In the 1920s, floral motifs came to the fore in her oeuvre, and it is for these works that she is especially known. These greatly magnified, open calyxes of orchids, lilies, or callas often arouse erotic associations, though O'Keeffe dismissed this interpretation of them. Rather, she said her aim was to simplify shapes so as to bring out the true essence of things. She painted around 200 close-up pictures of flowers that filled the frame, making use of aspects of the then-very-new field of photo optics. Particularly notable are a series of jack-in-the-pulpit pictures, which are at once very realistic, but which became increasingly abstract as she "zoomed in" to a single stamen.

Great 20th-Century Realist

The photographs of Stieglitz, whom she married in 1924, had a perceptible influence on O'Keeffe's work. He in turn did countless photo portraits of her, many of them nude, which created a public persona for O'Keeffe as a liberal, emancipated woman. For a long time, these photos were better known than her paintings. O'Keeffe's successful career and her independent lifestyle after the death of her husband, who was 23 years her senior, boosted the ideas of feminist art criticism in the 1970s and 1980s.

After Stieglitz's death in 1946, O'Keeffe moved to New Mexico, where the vast, unspoiled landscape provided a rich source of inspiration for her art. Here she led a frugal, solitary life doing pictures of animal bones and skulls in the desert landscapes and a series of paintings, drawings, and photographs of her *hacienda* courtyards. As in most of her pictures, she started from the exact perception of the object

and then became increasingly abstract. In her later work, she once again took up new subject matter, as frequent travel inspired her to do aerial views from an airplane. The artist's last major series—*Sky above Clouds*, dated 1963–65—involved huge landscapes that were up to 7 meters (23 feet) wide. The series manifests a certain kinship with the works of the postwar Abstract Expressionists. O'Keeffe died in Santa Fe, New Mexico, in 1986, at the age of 98. In the summer of 1997, a museum was opened there in her honor.

1887 Born on November 15 near Sun Prairie, Wisconsin
1905–06 Enrolls at the School of the Art Institute of Chicago
1907–08 Studies at the Art Students League in New York City
1912–14 Becomes the supervisor of art and penmanship in the public schools of Amarillo, Texas
1915 Teaches art at Columbia, South Carolina
1916 Begins a correspondence with Alfred Stieglitz
1917 Has her first solo show at the 291 Gallery in New York City; takes her first trip to New Mexico
1918 Moves to New York City
1924 Marries Alfred Stieglitz
1929 Begins to spend her summers in New Mexico
1934 Makes her first visit to the Ghost Ranch, near Abiquiu, New Mexico
1946 Stieglitz dies
1949 O'Keeffe leaves New York City for New Mexico
1971 Loses her central field of vision
1984 Stops making art; moves to Santa Fe
1986 Dies on March 6 in Santa Fe
1989 The Georgia O'Keeffe Foundation is founded in Abiquiu

left page
Georgia O'Keeffe, *Series I*, 1919, oil on canvas, 50.8 x 40.6 cm, Städtische Galerie im Lenbachhaus, Munich

above
Alfred Stieglitz, Georgia O'Keeffe, 1932, photograph

1907 *The Kiss* (Constantin Brâncuşi) **1920–1933** Prohibitio
the United State

1895 First Venice
Biennale **1909** Marinetti's Futurist
Manifesto **1923** Russian
Empire
becomes
Soviet Unic

1840 1845 1850 1855 1860 1865 1870 1875 1880 1885 1890 1895 1900 1905 1910 1915 1920 1925

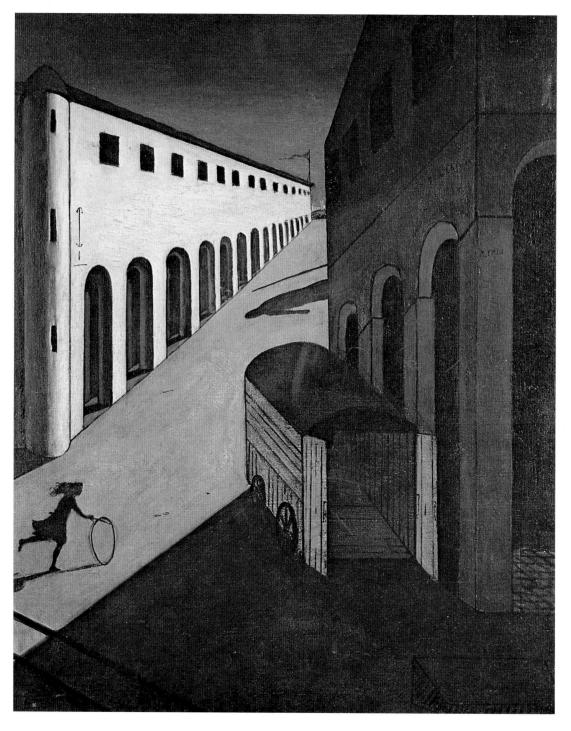

1925 New Objectivity exhibition at
the Kunsthalle in Mannheim

1941 Japanese attack Pearl Harbor **1965–1975** Vietnam War **1989** Fall of Berlin Wall

1938 Discovery of atomic fission by
Otto Hahn and Fritz Strassmann

1930 1935 1940 1945 1950 1955 1960 1965 1970 1975 1980 1985 1990 1995 2000 2005 2010 2015

GIORGIO DE CHIRICO

"If a work of art is to be truly immortal, it must go beyond all bounds of human nature. It can have neither reason nor logic."—Giorgio de Chirico

Giorgio de Chirico was born in Volos, Greece, in 1888, the son of Italian parents. After studying engineering in Athens in 1906, he enrolled at the Academy of Fine Arts in Munich. While there, he discovered the poetic and philosophical paintings of Max Klinger and Arnold Böcklin, which became indispensable sources of ideas. From 1911 to 1915, he lived and worked in Paris, where he socialized with representatives of the literary and artistic avant-garde, before returning to Italy. During these early years of his career, de Chirico joined a number of artists who, despite recent trends toward abstraction, shared an interest in representational art.

The Magic of Objects

De Chirico became perhaps the most important representative of the *Pittura Metafisica* (Metaphysical Painting) style, in which objects became the principle feature. Artists working in this style found a new pictorial poetry based not on formal innovations, but rather on a new way of looking at things, and on tracking down the hidden "soul" beneath the visible shell. A major impetus for the development of Metaphysical Painting came with de Chirico's reading of the writings of Nietzsche, with their suggestive and mysterious visual metaphors, as well as Schopenhauer's texts. "You have to paint all the phenomena of the world like a puzzle," de Chirico declared in 1913, which meant giving ordinary things a new symbolism in his pictures.

Although the objects are real and soberly depicted in de Chirico's work, the connection between them is apparently random and inexplicable, since the scene shown follows no narrative logic. What remains is an unsettling—indeed, disconcerting—impression of a strangely silent world, such as in his most famous series of works, called *Piazzas of Italy*. The pictures are of empty squares, always with the same motifs, such as statues, arcades, or railroads. At one remove from them manichini appear; these mannequins were inspired by the Surrealist texts of his brother,

Alberto Savinio. Extreme contrasts of light and shadow and exaggerated perspectives leave an impression of mysterious dreamworlds. With the introduction of irrational contexts into his work, especially the paintings he did between 1910 and 1920, de Chirico particularly inspired later Surrealists such as Salvador Dalí. Metaphysical Painting was also a major influence on art movements such as Magic Realism and New Objectivity.

De Chirico's later works were inspired by the world of antiquity. His style became more facile, whereupon he was attacked as a traitor by Breton and the Surrealists. From 1930, he was attracted mainly to the work of 17th-century masters such as Peter Paul Rubens. Almost 30 years later, at the age of 80, the artist did an about-face and surprisingly returned to the Metaphysical Painting of his early career. He died in Rome in 1978; his apartment in the Piazza di Spagna is now a museum.

1888 Born on July 10 in Volos, Greece
1906–09 Studies at the Academy of Fine Arts, Munich
1911–15 Stays in Paris; befriends Pablo Picasso, André Derain, Constantin Brâncuși
1916/17 Founds *Pittura Metafisica* with his brother and Carlo Carrà
1920 Publication of the journal *Pittura metafisica*
1924 Co-founder of the journal *La Révolution Surréaliste*
1930 Turn away from *Pittura Metafisica*
1944 Moves to Rome
1978 Dies on November 20 in Rome

left page
Giorgio de Chirico, *Mystery and Melancholy of a Street*, 1914, oil on canvas, 87 x 71.5 cm, Private collection

above
Herbert List, Giorgio de Chirico in his studio, Piazza di Spagna, Rome, c. 1952, photograph

JOAN MIRÓ

1888 *Sunflowers* (Vincent van Gogh) **1914–1918** World War I

1879 Edison invents **1891-1916** Construction of Trans-Siberian Railway **1921** Einstein
carbonized awarded
filament bulb **1897** Founding of Vienna Secession Nobel Prize
for Physics

1886 Statue of Liberty erected on Liberty Island in New York Harbor

| 1840 | 1845 | 1850 | 1855 | 1860 | 1865 | 1870 | 1875 | 1880 | 1885 | 1890 | 1895 | 1900 | 1905 | 1910 | 1915 | 1920 | 1925 |

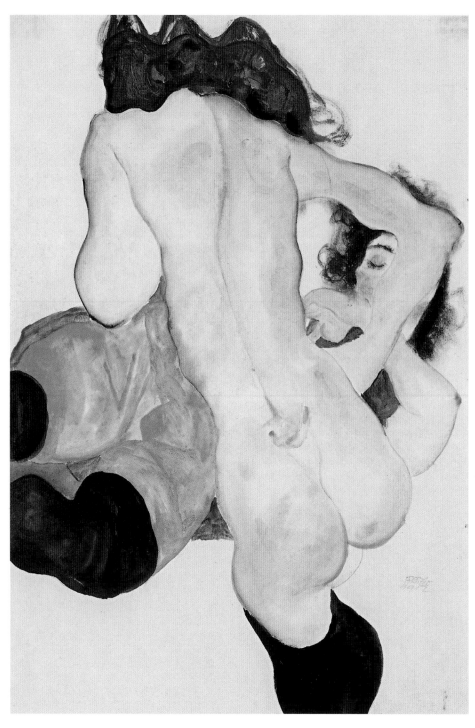

Egon Schiele, *Reclining Woman with Red Underpants and Standing Female Nude*, 1912, watercolor, gouache, and pencil, 45.2 x 32 cm, Serge Sabarsky Collection, New York

EGON SCHIELE

Egon Schiele's daring nudes, unusual at the time for their frankness, shocked many of his contemporaries. But according to his champion, Gustav Klimt, Schiele was one of the most important painters in Vienna.

Schiele was born in an Austrian railroad station in 1890. The world of railroads and steam would leave their mark on his childhood. His father was a stationmaster in Tulln, a small town near Vienna. Egon's boyhood was overshadowed by the progressive insanity of his syphilitic father, who died when Egon was a teenager. This traumatic experience would later characterize the artist's somber, often melancholy imagery.

Acceptance into the Art World

Although Schiele's family had trouble understanding his passion for art, he nonetheless pursued a career from early on. After his father's death, Schiele was admitted at age 16 to the Arts and Crafts School in Vienna, before transferring to Vienna's Academy of Arts. Finding the teaching there rather conservative, he looked for models outside the Academy. He tried his hand at Impressionism and made contact with other artists he met in coffeehouses.

His encounter with artist Gustav Klimt, whom he met by 1907, would exert a decisive influence on Schiele and his work. As the main representative of Viennese Art Nouveau and a member of the Vienna Secession, Klimt became the much-younger Schiele's mentor. He bought Schiele's drawings, introduced him to members of the Wiener Werkstätte, and helped the young artist make connections with influential art critics and collectors. Stylistically, Schiele emancipated himself from Klimt in 1910, as flat patterns gave way to angular lines and outlines in his work.

No Taboos: Schiele's Self-Portraits and Nudes

Schiele's work includes more than 100 self-portraits, in which he recorded the alien and dark side of himself. The depiction of unclothed humans was central to Schiele's entire oeuvre, and there was no other theme that he pursued with such intensity. Unlike many past artists, Schiele's tendency was to make bodies look ugly. He focused less on the idea of the femme fatale than on obsessive sexual desire and the mortality of the body.

For his life models, Schiele went into the working-class district of Vienna and looked for girls who were on the verge of adulthood. As a result, skinny, generally unhealthy-looking teenagers feature in these pictures. Schiele had intense relationships with his nude models, including 17-year-old Wally Neuzil, who inspired highly erotic drawings. Because of his relationship with her, the artist spent a few weeks in jail in 1912, when he was accused of statutory rape and child abduction. The weeks behind bars were a shocking experience for him. But the last few years of Schiele's short life were very productive and successful, including a brief but happy marriage. Both he and his wife, Edith, succumbed to the flu epidemic in 1918, when he was just 28 years old.

1890 Born on June 12 in Tulln, Austria
1906–09 Studies at the Academy of Visual Art in Vienna
1907 Becomes friends with Gustav Klimt
1909 Founds the New-Art Group with Anton Faistaner, Franz Wiegele, and Albert Paris Gütersloh; takes part in the Internationale Kunstschau Wien and in the New-Age Group exhibition at the Salon Pisko
1912 Charged with corrupting a minor, he is arrested; the charge is dropped, but he is sentenced to three days' detention for negligent custody of "indecent" drawings
1914–18 Military service
1918 Successful exhibition at the Vienna Secession; dies on October 31 in Vienna

Anton Josef Trcka, Egon Schiele, 1914, photograph

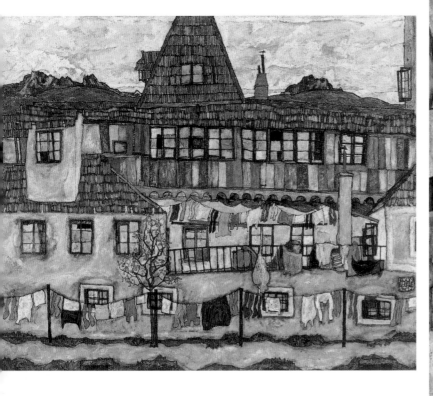

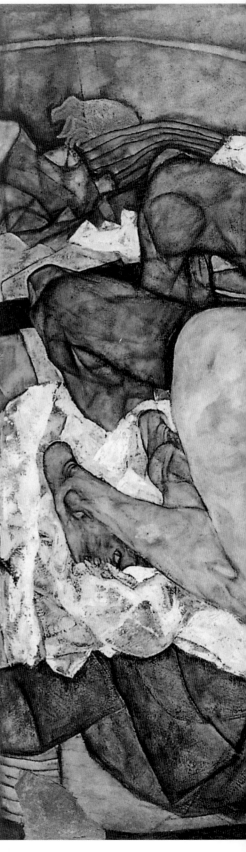

above
Egon Schiele, *House with Drying Laundry*,
1917, oil on canvas, 110 x 140.4 cm,
Private collection

right page
Egon Schiele, *Man and Woman I*
(Lovers I), 1914, oil on canvas,
121.3 x 140.5 cm, Private collection,
New York

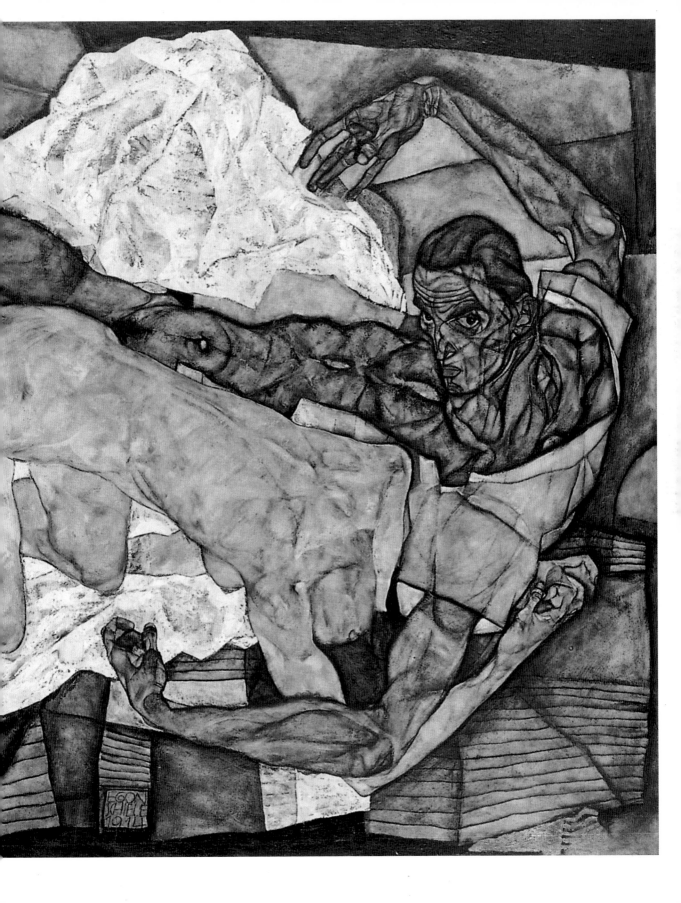

1905/11 Founding of "Die Brücke" and
"Der Blauer Reiter" groups of artists

1914–1918 World War I

| 1840 | 1845 | 1850 | 1855 | 1860 | 1865 | 1870 | 1875 | 1880 | 1885 | 1890 | 1895 | 1900 | 1905 | 1910 | 1915 | 1920 | 1925 |

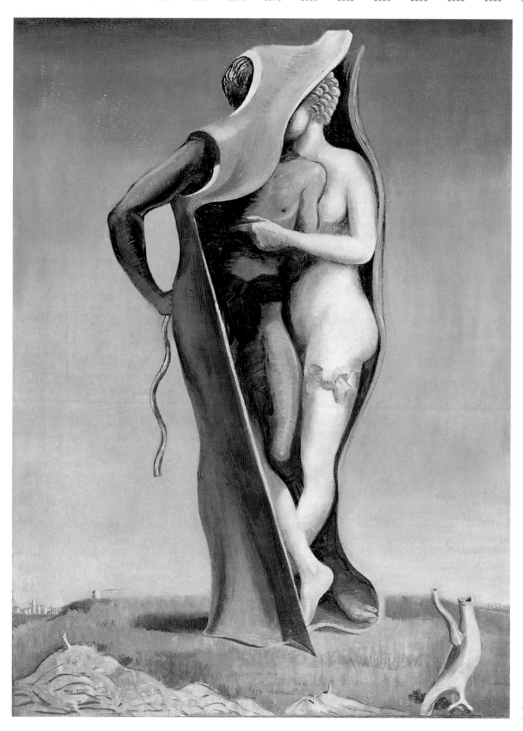

Max Ernst, *Long Live Love or Pays charmant*, 1923, oil on canvas, 131.5 x 98 cm, St. Louis Art Museum

1933 Hitler becomes Führer and 1950 Korean War
 Chancellor of Germany
 1939–1945 World War II 1960 John F. Kennedy becomes U.S. president 1991 Soviet Union breaks up
 1937 *Guernica* (Pablo Picasso) 1973 First oil crisis
 1937 "Degenerate Art" exhibition in Munich

1930 1935 1940 1945 1950 1955 1960 1965 1970 1975 1980 1985 1990 1995 2000 2005 2010 2015

MAX ERNST

Painter, sculptor, draftsman, and poet Max Ernst was one of the most important representatives of Dadaism and a key player in the development of Surrealist painting. In many of his works, he created an ironic world that was an alternative to the reality of his time.

Ernst was born in Brühl, near Cologne, Germany, in 1891, the third of nine children. Before the outbreak of World War II, he studied philosophy, psychology, and the history of art at the University of Bonn, but he already considered himself principally a painter. In 1913, he met August Macke, who enabled him to take part in the exhibitions of the Rhenish Expressionists, with whom he showed works featuring strong colors and dynamic brushstrokes.

Dada
During World War I, Ernst served in the German Army as a volunteer in the field artillery; his war experiences made a deep impression on him. He then embarked on his first Dadaist experiments. Together with the spiritual founders of the movement—Jean Arp, Tristan Tzara, André Breton, and Sophie Taeuber—he used art to shock and attack the civilization he held responsible for the war. In 1919, Ernst, Johannes Theodor Bargeld, and Hans Arp jointly founded the "Zentrale W/3," a Cologne-based Dada group. It searched for truth beyond what could be achieved in traditional painting, which the Dadists rejected due to its pseudo-reality.

Innovative Pictorial Inventions
In 1922, Ernst moved to Paris and published the first of his collage books, in which he challenged the notion of "high art" and the "brilliant" creative achievements of artists in general. In the French capital, he became one of the main figures in the Surrealist movement, whose membership he managed to get to pose almost in toto for his famous picture *Rendezvous of Friends*. In search of new forms of expression in art, he invented several semi-automatic techniques. In "*frottage*," he rubbed a pencil on paper to bring out the patterns on the material beneath. Similar procedures for painting included "*grattage*" (scraping paint over a canvas) and "*decalcomania*" (pressing paint between two surfaces). With his inexhaustible delight in experimentation,

and under the influence of Freudian psychoanalysis, Ernst created pictures with subject matter that eludes rational explanation; in combination with their often-cryptic titles, these works are thoroughly enigmatic.

Ernst's work was declared "degenerate" by the Nazis, and in 1941, with the help of art collector and patron Peggy Guggenheim, he escaped to the United States. The magazine *VVV*—published jointly by exiles Ernst, David Hare, André Breton, and Marcel Duchamp—became the starting point of a Surrealist movement in the United States. During this period, Ernst produced some of his finest Surrealist paintings, including *Vox Angelica* and *The Temptation of St. Anthony*. From 1944 he devoted himself increasingly to his sculptural work. In 1953 Ernst returned to Paris, where his reputation grew, making him a major international success. He remained in Paris until his death, shortly before his 85th birthday, in 1976.

1891 Born on April 2 in Brühl, near Cologne
1912 Decides to become a painter
1914 Has to serve as a soldier in World War I
1919 Founds a Dada artists' group in Cologne
1922 Goes to Paris
1925 Develops *frottage* as a Surrealist technique
1929 His collage novel *Die Frau mit den 100 Köpfen* is published
1939 Is jailed in Paris as an "enemy alien"
1941 Moves to the United States
1976 Dies on April 1 in Paris

Max Ernst in Amboise, 1968, photograph

1886 First gasoline-fueled internal
combustion engines

1914–1918 World War I

| 1845 | 1850 | 1855 | 1860 | 1865 | 1870 | 1875 | 1880 | 1885 | 1890 | 1895 | 1900 | 1905 | 1910 | 1915 | 1920 | 1925 | 1930 |

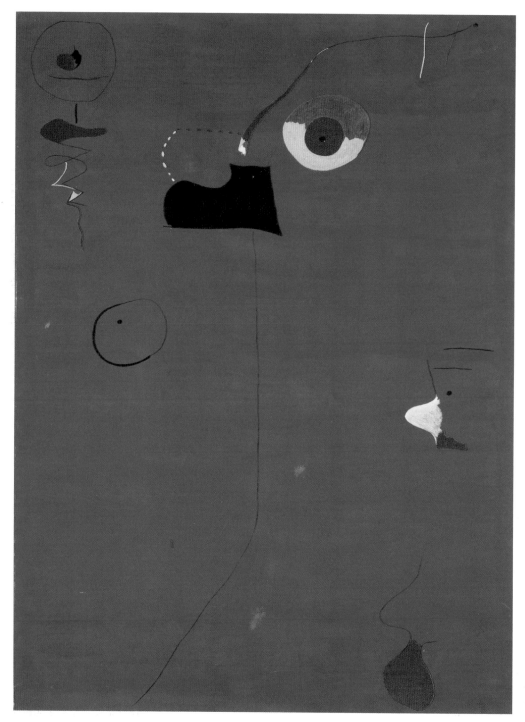

Joan Miró, *Painture (Fratellini)*,
1927, oil on canvas,
130.2 x 97.1 cm, Philadelphia
Museum of Art

1945 Atom bombs dropped on
Hiroshima and Nagasaki

1969 Woodstock music festival

1960 John F. Kennedy becomes
U.S. president

1981 First *Columbia* space flight

1939–1945 World War II

1965–1975 Vietnam War

1995 Christo and Jeanne-Claude
wrap the Reichstag

| 1935 | 1940 | 1945 | 1950 | 1955 | 1960 | 1965 | 1970 | 1975 | 1980 | 1985 | 1990 | 1995 | 2000 | 2005 | 2010 | 2015 | 2020 |

JOAN MIRÓ

Joan Miró was an extremely versatile, imaginative, and productive artist. Although he adopted several avant-garde innovations, his work cannot be easily be classified as belonging to any of the major modernist art movements. Rather, his art conveys idiosyncratic themes and symbols, belonging to a style that was all his own.

During his training at art academies in Barcelona, at the time the key art center in Spain, Miró became familiar with various progressive art movements. Of great influence on his work were exhibitions of the Fauves and Cubists in the Dalmau Gallery, where he himself finally had his first solo exhibition in 1918, at age 25. In early paintings such as *The Farmyard* of 1921–22, he recorded his memories of rural Catalonia in precise detail. The landscape of his native Catalonia would be an enduring inspiration.

Painted Poetry
At the time of his first exhibition, Miró was already living in Paris, which artists of the time saw as the only city that promised success and recognition. Here he met the Surrealists, whose conception of art had a decisive impact on his style of painting. From them, he learned to use the unconscious as a source of inspiration for his work. He gradually abandoned representational painting, creating a new pictorial world with strong colors, countless symbols, mysterious signs, and archetypal elements such as stars, birds, eyes, heads, and ladders. His resulting pictures look naive and almost child-like.

Delight in Experimentation
After a trip to Holland in 1928, Miró did a series of *Dutch Interiors* using postcard reproductions of 17th-century Dutch genre paintings, in which he gaily distorted and then reassembled the pictorial elements of the originals. His collages and sculptures made from waste materials such as pasteboard, rusty nails, or springs reflect that the artist had little time for conventional modes of representation.

In response to the growing unrest in his homeland before the outbreak of the Spanish Civil War in 1936, Miró painted pictures that he called *peintures sauvages*, the hallmarks of which are turbulent shapes, distortions, and menacing-looking fantasy creatures. His dismay at the horrors of World War II is illustrated by the lithographs of his *Barcelona* series.

In 1944, Miró ventured into a new field of art by exploring ceramics. However, he continued to receive numerous international commissions for wall decorations—for example from Harvard University in Cambridge, Massachusetts; the Solomon R. Guggenheim Museum in New York; and the UNESCO headquarters in Paris. Miró continued working tirelessly until his death in 1983, still delighting in experimenting—for example, with objects such as umbrellas integrated into graphic works and textile sculptures (one of his most unusual contributions to modern art).

1893 Born on April 20 near Barcelona
1911 Stops working as a bookkeeper and becomes a painter
1920 Pablo Picasso receives him in his Paris studio
1924 The Surrealists take an interest in him
1926 Miró works on a stage set with Max Ernst
1930 His only daughter, Dolores, is born
1933 Miró meets Vasily Kandinsky
1941 His first major retrospective is shown in New York
1959 Takes part in Documenta in Kassel
1983 Dies on December 25 near Palma de Mallorca

Joan Miró in his studio, 1931, photograph

RENÉ MAGRITTE
GIORGIO DE CHIRICO
SALVADOR DALÍ

1880 First issue of *Science*

1874 First Impressionist exhibition in Paris

1887–1889 Construction of Eiffel Tower in Paris

1907 *Les Demoiselles d'Avignon* (Pablo Picasso)

1917 United States enters World War I

1927 Lindbergh flies solo across the Atlantic

1925 New Objectivity exhibition at the Kunsthalle in Mannheim

1850 1855 1860 1865 1870 1875 1880 1885 1890 1895 1900 1905 1910 1915 1920 1925 1930 1935

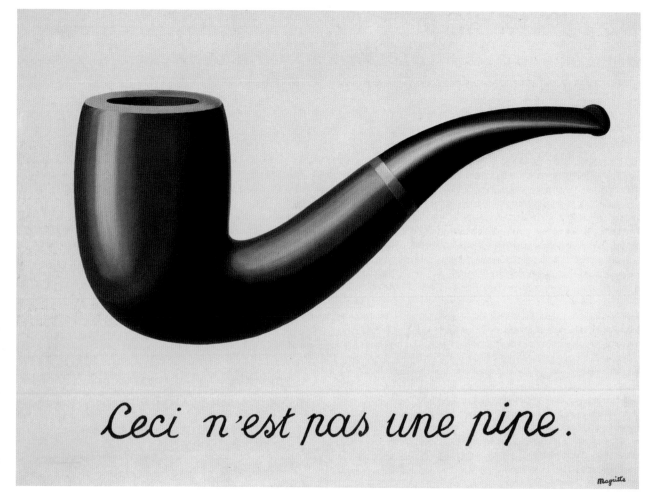

René Magritte, *The Treachery of Images*,
1929, oil on canvas, 60 x 81 cm,
Los Angeles County Museum of Art

1948 Founding of the COBRA group
of artists in Paris

1938 Discovery of atomic fission by
Otto Hahn and Fritz Strassmann

1961 First man in space (Soviet Union)

1989 Fall of the Berlin Wall

1965–1975 Vietnam War

1940 1945 1950 1955 1960 1965 1970 1975 1980 1985 1990 1995 2000 2005 2010 2015 2020 2025

RENÉ MAGRITTE

The influence of René Magritte on contemporary imagery cannot be ignored. His Surrealist paintings are an ironic reversal of the usual order of things, bestowing a lost magic onto modernity.

Magritte grew up in Chatelet, Belgium. He began painting and drawing at the age of 12. One night in 1912, for reasons unknown, his mother committed suicide by drowning herself in the Sambre River, which had traumatic effects on the young Magritte. In 1913, he became acquainted with Georgette Berger, his junior by two years, who became his model. Much later, after graduating from the Brussels Academy of Fine Arts, he happened to meet her again in the botanical gardens; in 1922 he set up a household with her, with the idea of leading a joint bourgeois life. However, he retained his contacts with his artistic friends André Breton, Paul Eluard, Joan Miró, Hans Arp, and Salvador Dalí. He began his career as a commercial artist, which would be reflected in the intellectual sharpness and clarity of his pictures.

Belgian Surrealism

When starting a work, Magritte did basic sketches—for example, of a piano, leaf, or bird. He then added other elements that were generally incompatible with those. That is what gave his pictures their underlying tensions, as relationships are set up between the objects. The most common reactions when people look at Magritte's paintings are astonishment, surprise, amusement, or even bewilderment. His works have no message, and yet they are eloquent. Links are established between objects by means of association—for example, a baguette might fly past an aperture in a castle dungeon, apparently completely naturally.

Commenting on his work, Magritte spoke of "inspiring thoughts." He was a painter-philosopher who thought in images, moving from fantastic idea to fantastic idea with apparently playful light-heartedness. His works belong to Surrealism, in that they tell stories. He did not bring hyperrealism into the pictures, but rather made puzzles out of reality itself, which is shown in all its absurdity. Magritte's picture puzzles are mental games and a radical challenge to reality. His aim was to make us ponder and think about reality, but also to think about art and perception.

The Treachery of Images

One of Magritte's most famous works is called *The Treachery of Images*. In this and other works, he seemed to contradict reality by giving names to well-known things that do not need them, while simultaneously denying their existence. For example, in this famous painting, when he wrote beside a picture of a pipe, "This is not a pipe," he was drawing our attention to the fact that the image of an object should not be confused or even equated with the real thing. Nothing is what it claims to be, Magritte seemed to say. Pictures challenge our defined society and subvert familiar ways of seeing and thinking.

1898 Born on November 21 in Lessines, Belgium
1916–18 Studies at the Academy of Fine Arts in Brussels
1922 Marriage with Georgette Berger
1925 First Surrealist painting: *Le Jockes perdu*
1927 First solo exhibition at the Le Centaure Gallery
1927–30 Stays in Paris and befriends André Breton, Paul Éluard, Joan Miró, Hans Arp, and later Salvador Dalí
1956 Wins the Guggenheim Prize of Belgium
1967 Dies on August 15 in Brussels

Richard de Grab, René Magritte, photograph

1891 End of Indian Wars in the United States **1914–1918** World War I **1929** Wall Street crash

1850 1855 1860 1865 1870 1875 1880 1885 1890 1895 1900 1905 1910 1915 1920 1925 1930 1935

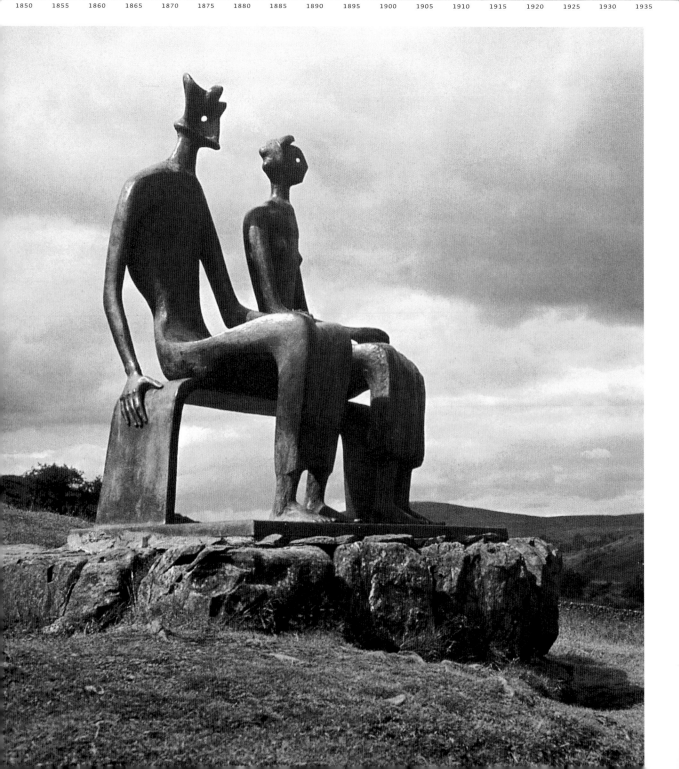

1973 Watergate scandal

1939–1945 World War II **1960** John F. Kennedy becomes U.S. president **1979** Soviet troops invade Afghanistan **2001** 9/11 terrorist attacks in the United States

1969 Moon landing (United States)

1940 1945 1950 1955 1960 1965 1970 1975 1980 1985 1990 1995 2000 2005 2010 2015 2020 2025

HENRY MOORE

English sculptor Henry Moore set new standards for 20th-century sculpture with his bronze, wooden, and stone figures. Today, he is primarily known for his large-scale sculptures in the open air, works in which he brought the analytical formal experiments of Cubist and Surrealist object art into nature.

After working as a teacher and serving on the front line in World War I, from 1919 Moore studied at Leeds School of Art and then at the Royal College of Art in London. From the start of his artistic career, he broke away from the traditional Western canons of sculpture in terms of form, proportion, and composition. Inspired instead by ancient Egyptian, pre-Columbian, African, and Polynesian art, he believed that sculptures evolved from working directly on the block of material. Moore also learned much from fellow contemporary artists such as Constantin Brâncuşi, Alexander Archipenko, Pablo Picasso, and representatives of the Surrealist movement.

"The observation of nature is part of an artist's life, it enlarges his form [and] knowledge, keeps him fresh and from working only by formula, and feeds inspiration," Moore once said. And, indeed, the study of natural objects like bones, stones, and rocks helped him design his sculptures. But it was the human figure that principally interested him. Throughout his career, Moore focused on a few key themes, which included mother and child images and, from the 1930s, reclining figures. Over a long creative period from 1938 to 1983, the latter subject cropped up again and again, as he experimented with various materials such as stone, wood, plaster, and bronze. In 1960, he did his first multipart reclining figures, which seem to mutate back into matter and are reminiscent of rock formations. Famous reclining figures by Moore are found outside the UNESCO building in Paris and Lincoln Center in New York.

"Landscaping of the body"

The late work of Moore is particularly notable for a close dialogue with architecture and the open countryside, which he regarded as the ideal place to erect his works. The artist said: "Sculpture is an art of the open air. Daylight, sunlight, is necessary to it, and for me its best setting and complement is nature. I would rather have a piece of my sculpture put in a landscape, almost any landscape, than in, or on, the most beautiful building I know." With bulging curves and hollow shapes integrated into the material, he managed to incorporate the broad vistas of the countryside into his sculptural forms. This meant that, as his career progressed, his works became more and more monumental.

In addition to his sculptural work, Moore worked on a wide range of graphic series. In the *Transformation Drawings*, he drew found objects such as shells or pebbles from nature, subsequently transforming them into figures and people. In the early 1940s, as an official "war artist," he did his *Shelter Drawings*, which show people grappling with the reality of war—taking shelter, sleeping, or stoically enduring in London Underground stations.

1898 Born on July 30 in Castleford, Yorkshire, England
1916 Works as a teacher at Temple Street School in Castleford
1917 Is wounded in a gas attack in World War I
1921 Begins to study art at the Royal College of Art in London
1926–39 Teaches at the Royal College of Art
1929 First major public commission, *West Wind*, for the London Underground headquarters
1940 Is appointed England's official war artist
1948 Shows work at the 24th Venice Biennale and wins the Grand Prize for sculpture
1958 UNESCO sculpture unveiled in Paris
1986 Dies on August 31 in Much Hadham, Hertfordshire

left page
Henry Moore, *King and Queen*, 1952–53, bronze, 163.8 cm, W. J. Keswick Collection, Glenkiln, Shawhead, Dumfriesshire, Scotland

above
Henry Moore in his studio in Herford-shire, photograph

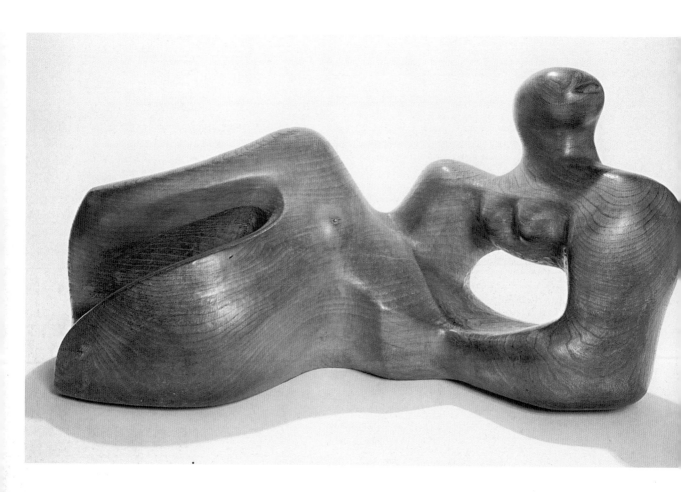

Henry Moore, *Reclining Figure*, 1935–36,
wood, 93.3 cm, Albright-Knox Art
Gallery, Buffalo, New York

Henry Moore, *Two-Piece Reclining Figure No. I*, 1959, bronze, 193 cm, Chelsea School of Art, London

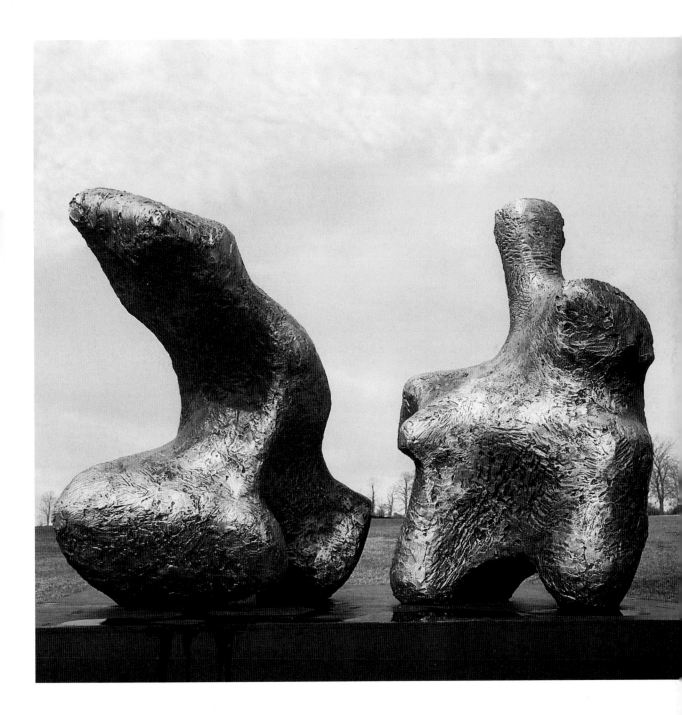

KASIMIR MALEVICH

MARK ROTHKO

JOAN MIRÓ

1928 Alexander Fleming dis-
covers penicillin

1921 Einstein awarded Nobel Prize for Physics

1855 1860 1865 1870 1875 1880 1885 1890 1895 1900 1905 1910 1915 1920 1925 1930 1935 1940

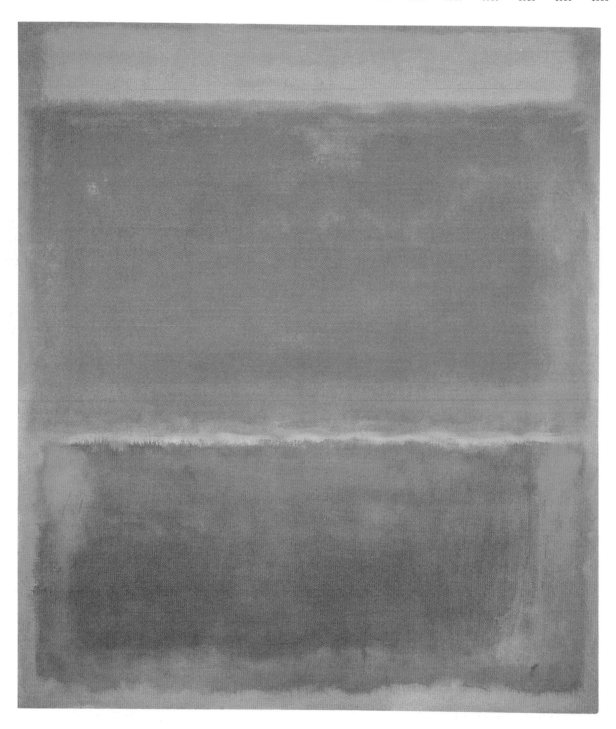

1945 Start of Cold War 1965–1975 Vietnam War

 1948 UN Declaration of Human Rights 1968 Assassination of Martin Luther King, Jr. 1989 Massacre in Tiananmen Square in China

 1969 Moon landing

1941 Japanese attack Pearl Harbor 1961 Founding of Amnesty International

1945 1950 1955 1960 1965 1970 1975 1980 1985 1990 1995 2000 2005 2010 2015 2020 2025 2030

MARK ROTHKO

Mark Rothko is one of the pioneers of Color Field Painting and one of the most important representatives of Abstract Expressionism. His colored rectangles earned him a notable place in art history, and they still move viewers today.

Rothko was born Marcus Rothkowitz in 1903 in Dvinsk (Daugavpils), Latvia, then part of the Russian Empire. For fear of pogroms, in 1913 his family immigrated to New York, before moving the following year to Portland, Oregon. From 1921 to 1923, Rothko attended Yale University, in New Haven, Connecticut. In 1940, he changed his name to Mark Rothko.

Matisse as Inspiration

In search of inspiration, Rothko visited the museums of New York, where he lived after college. He was particularly taken with the work of Joan Miró and with Henri Matisse's *Red Studio* at the Museum of Modern Art. For months, he studied the latter painting every day; later, he saw it as the source of all his abstract paintings. Rothko felt that when one looks at this picture, "You are entirely lost in color, you are completely suffused by it, as if it were music." He displayed his admiration by later calling one of his paintings *Homage to Matisse*. Over time, Rothko became increasingly obsessed with the vibrations of color, even writing articles on the subject. In terms of the content of his work, in one of his essays he said, "I see my pictures as dramas, their figures as actors. They arose from the need for a group of actors who can move on the stage without inhibitions or shame."

The Multiforms

The year 1946 marked a turning point in Rothko's work. He came up with a new series of pictures called "multiforms." They can be seen as a transition toward his classic abstract paintings. The artist gradually abandoned his existing themes and motifs, such as myth and symbolism, landscape and people, and instead evolved his work toward an increasingly abstract visual idiom. Biomorphic shapes became blurred patches of color without solidity and weight, seeming to grow organically out of the picture itself. Rothko gave them transparency and luminosity by applying multiple superimposed, thin layers of paint on the canvas. His works, using the portrait format and sometimes standing over 300 centimeters (118 inches) high, were intended to give viewers the impression of being right inside the picture's color space.

Color Field Painting

Today, Rothko is best known for his large-format pictures of colored rectangles arranged one above the other, which create an illusion of movement with their blurred outlines. Using the technique known as Color Field Painting, the artist made colored rectangles run to the edges of the canvas, conjuring up an illusion of spatial infinity, or a symbol of cosmic worlds. The purist arrangement of his non-representational rectangles, light, and space generate something sublime that viewers can also sense. For Rothko, a close connection between viewers and a work of art was always essential. As the artist said: "I'm interested only in expressing basic human emotions—tragedy, ecstasy, doom, and so on. And the fact that a lot of people break down and cry when confronted with my pictures shows that I can communicate those basic human emotions."

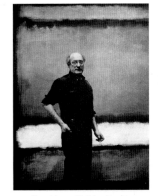

1903 Born Marcus Rothkowitz on September 25 in Dvinsk, Russia (now Daugavpils, Latvia)
1913 Immigrates to the United States with his mother and sister; they join his father and two older brothers in Portland, Oregon
1921–23 Attends Yale University; moves to New York City
1929 Begins teaching art part-time to children at the Brooklyn Jewish Center
1935–40 Belongs to the Ten, an independent group of painters
1938 Becomes American citizen
1958 Becomes contracted to paint murals for the Four Seasons restaurant in the Seagram Building in New York City
1959 Cancels the commission and returns the money
1964–67 Paints murals for chapel planned for University of St. Thomas in Houston
1969 Receives an honorary doctorate from Yale University
1970 Commits suicide on February 25 in New York City
1971 The Rothko Chapel is dedicated in Houston

left page
Mark Rothko, *Untitled*, 1960, oil on canvas, 235.9 x 205.7 cm, Adriana and Robert Mnuchin estate

above
Mark Rothko photographed in front of No. 7, photograph

PABLO PICASSO ━━━━━━━━━━━━━━━━━━━━━━━━━━━━━━━━━━

SALVADOR DALÍ ━━━━━━━━━━━━━━━━━━━━━━━━━━━━━━━━━━

ANDY WARHOL ━━━━━━

1914–1918 World War I

1929 Wall Street crash
in New York

| 1855 | 1860 | 1865 | 1870 | 1875 | 1880 | 1885 | 1890 | 1895 | 1900 | 1905 | 1910 | 1915 | 1920 | 1925 | 1930 | 1935 | 1940 |

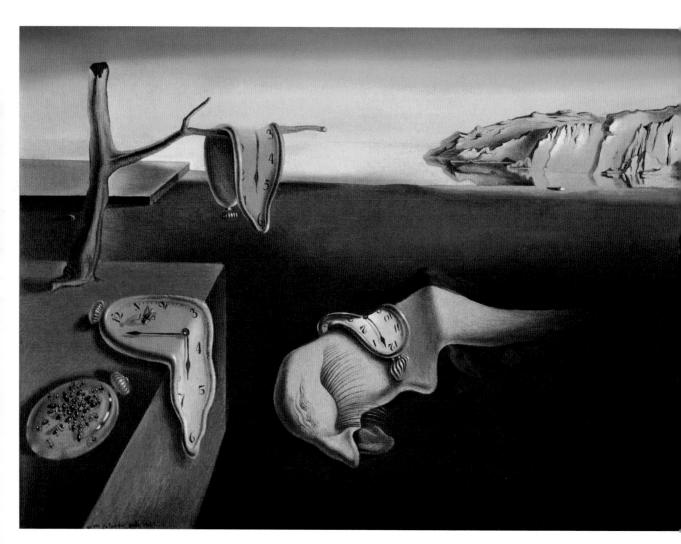

Salvador Dalí, *The Persistence of Memory*,
1931, oil on canvas, 24 x 33 cm,
The Museum of Modern Art, New York

1939–1945 World War II

1952 Elvis Presley hits the headlines

1969 Moon landing (United States)

1972 Terrorist attacks at Munich Olympics

1991 Soviet Union breaks up

2003 U.S. invasion of Iraq

2001 9/11 terrorist attacks in United States

1945 1950 1955 1960 1965 1970 1975 1980 1985 1990 1995 2000 2005 2010 2015 2020 2025 2030

SALVADOR DALÍ

"I believed in Surrealism as if it constituted the Tables of the Law."—Salvador Dalí

Spanish artist Salvador Dalí joined the Surrealists in 1927, an act that launched him toward the most important phase of his painting. In his work, he processed fears, dreams, and visions; in particular, the writings of Sigmund Freud represented an inexhaustible source of ideas for the artist. Dalí did exactly what the Surrealists had asked for in their manifesto: he abandoned himself to the psychic automatism of unconscious associations. This process led to meticulously executed, often sexually coded mental landscapes that were obsessively focused on Dalí's own state of mind. Soon after he joined the Surrealists, Paris's leading artists regarded him as one of their most original representatives.

Obsessions of an Artist

In the summer of 1930, the Spaniard invented what he called the "paranoiac-critical" method, a "spontaneous method of irrational knowledge based on systematic objectification and fantasizing interpretations." Dalí enthusiastically used this "paranoia" for artistic processes so he could implement his often "obsessively dangerous ideas" creatively. His aim was to transport the viewer into the same delirious state as the artist, to "systematize the confusion and contribute to the complete discrediting of the world of reality."

After initial successes in Barcelona and Paris, Dalí's international breakthrough came in 1934 in the United States, where he was hailed as "Mr. Surrealism." In particular, many Americans were impressed by *The Persistence of Memory*, perhaps the best-known Surrealist picture ever painted, in which Dalí introduced his famous soft watches into his work. But he did not just create paintings. He saw himself as a universal genius, turning out numerous three-dimensional objects, writing and illustrating books, making advertisements, working in films, and designing costumes and sets for the ballet and theater. Even when the Surrealists threw him out because of political differences, it did not affect his growing recognition.

Facets of a Unique Artist

Dalí was primarily interested in psychology up until World War II, but at that point he switched to science for his subject matter. Alongside Freud, Albert Einstein became one of his icons. Following the atomic bomb explosions in Hiroshima, Nagasaki, and New Mexico, Dalí entered into an "atomic" or "nuclear" phase in his art, during which his paintings included models from nuclear physics. In 1951, Dalí proclaimed his return to Catholicism and the attendant attractions of mysticism. This was all thematic grist for his paintings, allowing him to introduce Christian traditions and their symbols, including birth, love, and death, as well as elements from Greek mythology and classical literature. The new appreciation of tradition went hand in hand with the application of structural concepts such as the Golden Ratio and symmetry in his oil paintings. Finally, in the 1960s, the chameleon-like artist experimented with the latest laser technology, on a quest for three- and four-dimensional art. The result was what the artist himself called "Dalí's Pop Art," inspired by the current trend in the United States.

Dalí the man was as enigmatic as his various artistic productions. Even his funeral in January 1989 was a spectacular piece of staging. He was buried in the crypt of the Dalí Museum in Figueres, Spain, which had been established while he was still alive.

1904 Born on May 11 in Figueres, Spain
1921 Begins to study art in Madrid, but does not complete the course
1928 The Surrealists André Breton, René Magritte, Paul Éluard, and Éluard's wife, Gala, pay a visit
1930 Dalí and Gala settle in Lligat
1935 Breton excludes Dalí from the Surrealist group
1940 Dalí and Gala go into exile in the United States for eight years
1958 The couple marries
1971 The Dalí Museum in Cleveland opens; it moves to Florida in 1982
1972 Dalí designs wall and ceiling paintings for Gala's palace in Púbol
1974 The Teatro-Museo Dalí opens in Figueres
1982 Gala dies in Púbol
1989 Dies on January 23 in his hometown, Figueres

Salvador Dalí, 1963, photograph

1898 * George Gershwin **1918** * Leonard Bernstein **1937** *Guernica*
 (Pablo Picasso)

1914–1918 World War I

1855 1860 1865 1870 1875 1880 1885 1890 1895 1900 1905 1910 1915 1920 1925 1930 1935 1940

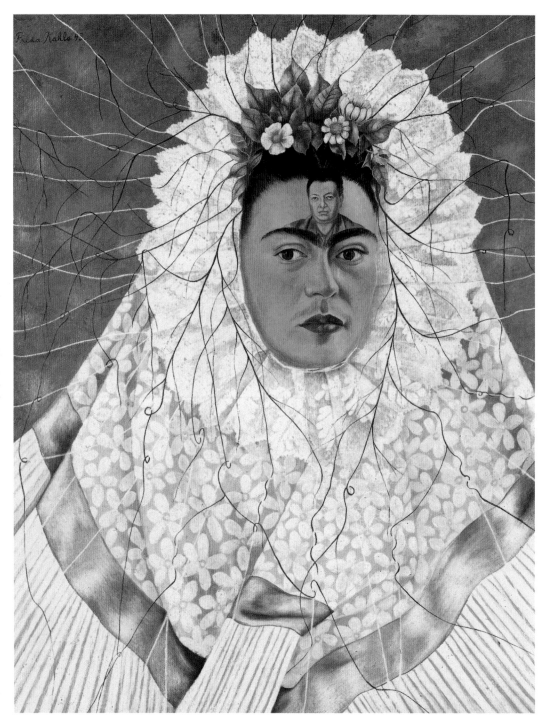

Frida Kahlo, *Self-Portrait as a Tijuana or Diego in My Thoughts or Thoughts of Diego*, 1943, oil on board, 76 x 61 cm, Jacques and Natasha Gelman Collection, Mexico City

FRIDA KAHLO

"They thought I was a Surrealist, but I wasn't. I never painted dreams. I painted my reality."—Frida Kahlo

Mexican artist Frida Kahlo's eventual cult-like status is in some ways connected to her tragic life story. Born in Coyoacán, a suburb of Mexico City, in 1907, she had a serious accident when she was 18. A school bus she was on collided with a tram, driving an iron rail into her pelvis. All her life she struggled with the consequences of her injuries, having to undergo numerous operations and often lying in a plaster cast for months at a time. (Kahlo had actually wanted to study medicine, but began to draw and paint while lying in the hospital.) At the age of 22, she married 43-year-old Diego Rivera, one of post-revolutionary Mexico's best-known painters. It was a rocky marriage, and they divorced and then remarried. Both had extramarital affairs, which was noticeably hard on Kahlo, especially Rivera's affair with her younger sister.

Biographical Art

Over the course of her career, Kahlo created nearly 200 works, mostly in small formats. Self-portraits comprised at least a third of her output. Many self-portraits feature the deeply felt physical and emotional suffering arising from her long illness. *The Broken Column* (1944), for example, shows her in a steel brace, with a spine (broken many times) in the form of a column. The failure of her attempts—against medical advice—to have children is addressed in works such as the oil painting *My Doll and I* (1937) and the lithograph *Frida and the Miscarriage* (1932).

Haunting images like these gave Kahlo a reputation for pathos ("My painting carries with it the message of pain," she once said), drawn mainly from her own experiences. However, her works should be seen not just as illustrations of her personal history of suffering, but also as allegorical representations of gender roles and sociopolitical opinions. *A Few Small Stabs* (1935), for example, depicts a man who has killed his unfaithful wife, firmly believing he had a right to do so. Inspiration for her paintings can also

be found in Mexican folk art, as is evident in her small pictures painted on zinc, which were based on religious votive tablets that are often attached to Mexican church walls. Her work cannot be defined by a single style—even though André Breton, a founder and leading theorist of Surrealism, considered Kahlo a Surrealist, describing her work as "a belt round a bomb." Kahlo rejected the label, believing that she did not completely detach herself from reality in her works, but rather transformed her own life experiences into visual metaphors.

Kahlo's first successful solo exhibition was held in New York in 1938. The next major stop was Paris, where the Louvre bought a self-portrait from her in 1939. In 1946 she was awarded the Mexican National Prize for Painting for *Moses* (1945). She did not get a solo exhibition of her works in her native country until 1953, the opening of which she was able to attend only on a stretcher. A year later she fell ill with pneumonia, from which she never recovered. After a brief but extraordinary life, she died at the age of 47.

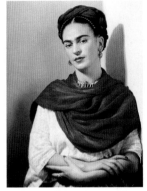

1907 Born July 6 in Coyoacán, near Mexico City
1925 Is severely injured in a bus accident, and spends the rest of her life dominated by the effects of her injuries. She begins to paint while in the hospital.
1929 Marries painter Diego Rivera
1930 Accompanies Rivera on his lengthy working trips to the United States
1932 Hospitalized in Detroit after a miscarriage
1937 Meets Trotsky and has a brief affair with him
1939 Divorces and then remarries Rivera (1940) in San Francisco
1953 First solo show of her works in Mexico City
1954 Dies July 13 in Coyoacán

following double page, left
Frida Kahlo, *Self-Portrait Sitting on the Bed* or *My Doll and I*, 1937, oil on metal, 40 x 31 cm, Jacques and Natasha Gelman Collection, Mexico City

following double page, right
Frida Kahlo, *The Broken Column*, 1944, oil on canvas, mounted on hardboard, 40 x 30.7 cm, Dolores Olmedo Patiño Museum, Mexico City

Nickolas Muray, Frida Kahlo, 1938/39, photograph

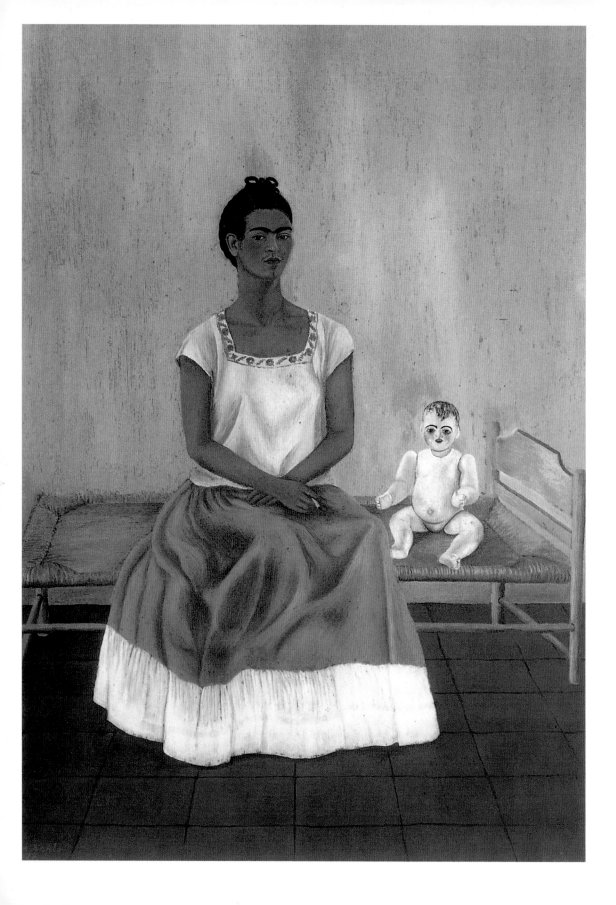

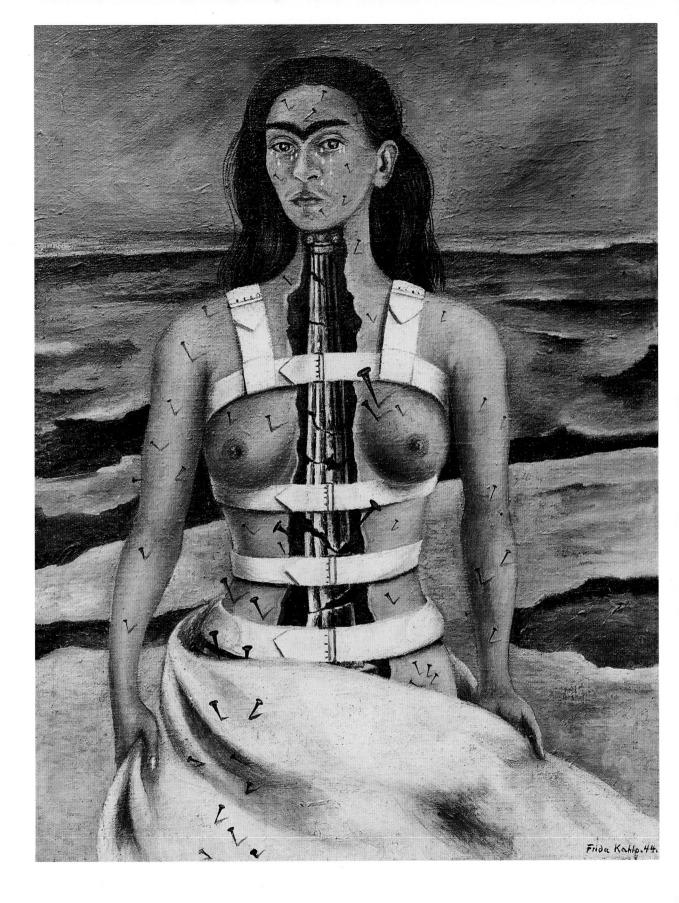

1933 Hitler becomes Führer and
Chancellor in Germany

1914–1918 World War I

1939–1945 World
War II

1860 1865 1870 1875 1880 1885 1890 1895 1900 1905 1910 1915 1920 1925 1930 1935 1940 1945

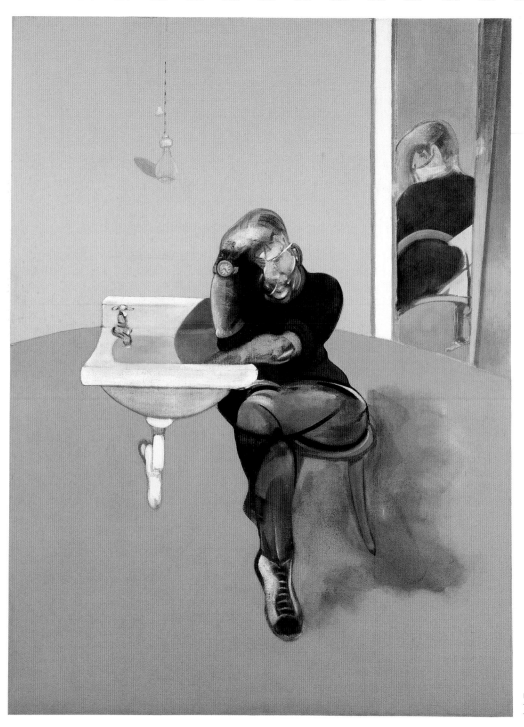

Francis Bacon, *Self-Portrait*,
1973, oil on canvas,
198 x 147.5 cm, Private collection

1945 Founding of
United Nations

1957 Albert Camus awarded
Nobel Prize for Literature

1986 Chernobyl disaster

1947 India gains independence
from Britain

1973 Watergate scandal

2001 9/11 terrorist attacks in the United States

1969 Moon landing (United States)

1996 First cloned mammal (Dolly the Sheep)

1950 1955 1960 1965 1970 1975 1980 1985 1990 1995 2000 2005 2010 2015 2020 2025 2030 2035

FRANCIS BACON

When Francis Bacon went public with his expressionist paintings in the 1950s, the international art scene's first reaction was shock. His vivid images depicted fear, suffering, and violence, reflecting the horrors of the 20th century as much as individual psychological fears. They led to a rethinking of contemporary views of representational painting.

Born in Dublin in 1909, Bacon became a leading innovator in figurative painting after World War II. While the Abstract Expressionists in the United States and representatives of Art Informel in Europe were pursuing abstraction, Bacon focused on the human figure. He worked continuously to find ways of showing modern man in his existential torments, a lonely and desperate, violent and cruel, but also yearning and vulnerable being. He translated extreme mental suffering into physical deformities and distortions. Along with isolated single figures, which are often trapped in cages or empty rooms without windows, his pictures feature bodies painfully writhing, struggling, and intertwined. Bacon shows human figures who can no longer find a foothold in the world in which they live, but who—despite their unsparing, frightening presentation—nonetheless fascinate the viewer as works of art.

Major Metaphors of Human Existence

In most cases, the figures of Bacon's works can clearly be discerned, even though he always put them through a transformation. In addition to the slow-motion photography of Eadweard Muybridge (which showed human bodies in motion) and illustrations in medical books, Bacon was inspired above all by reproductions of famous works of art. Examples included his series of "screaming popes," which he based on a Velázquez portrait of Pope Innocent X, and *Studies for a Portrait of Van Gogh*, an homage to a kindred spirit and fellow painter. These were followed by a whole series of self-portraits as well as portraits of friends and colleagues, like Lucian Freud and Frank Auerbach, that were mostly based on photographs. In describing his aims in such works, Bacon said: "Great art is always a way of concentrating, reinventing what is called fact, what we know of our existence—a reconcentration … tearing away the veils that fact acquires through time. … Really good artists tear down those veils." With his disturbing representations of deformed

bodies and idiosyncratic, expressive use of color, the artist set himself radically apart from the traditional canons of portraiture.

After the tragic suicide of his partner, George Dyer, in 1971, the theme of mortality dominated Bacon's paintings. Only in his late years did the works become more conciliatory, the colors brighter, and the paint application smoother. In these later works, people tend increasingly to vanish behind misty veils, although the unsettling effects remain. Bacon died in Madrid in 1992.

1909 Born on October 28 in Dublin
1929 Works as interior decorator
1933 Produces several main works, which are shown in the Mayor Gallery, London
1937 Participates in the "Young British Painters" exhibition
1944 Becomes a professional painter
1954 Represented in the British pavilion at the Venice Biennale
1962 Retrospective in the Tate Gallery, London
1992 Dies on April 28 in Madrid

following double page, left
Francis Bacon, *Study after Velázquez' Portrait of Pope Innocent X*, 1953, oil on canvas, 153 x 118 cm, Des Moines Art Center, Iowa, Coffin Fine Arts Trust Fund

following double page, right
Francis Bacon, *Portrait of George Dyer Staring into a Mirror*, 1967, oil on canvas, 198 x 147.5 cm, Private collection

John Deakin, Francis Bacon, 1965, photograph

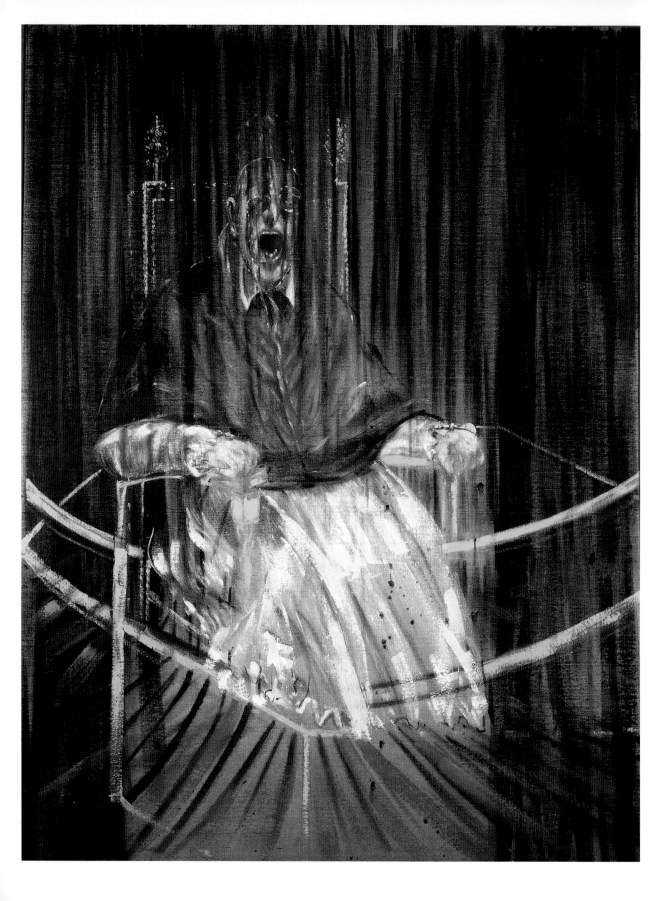

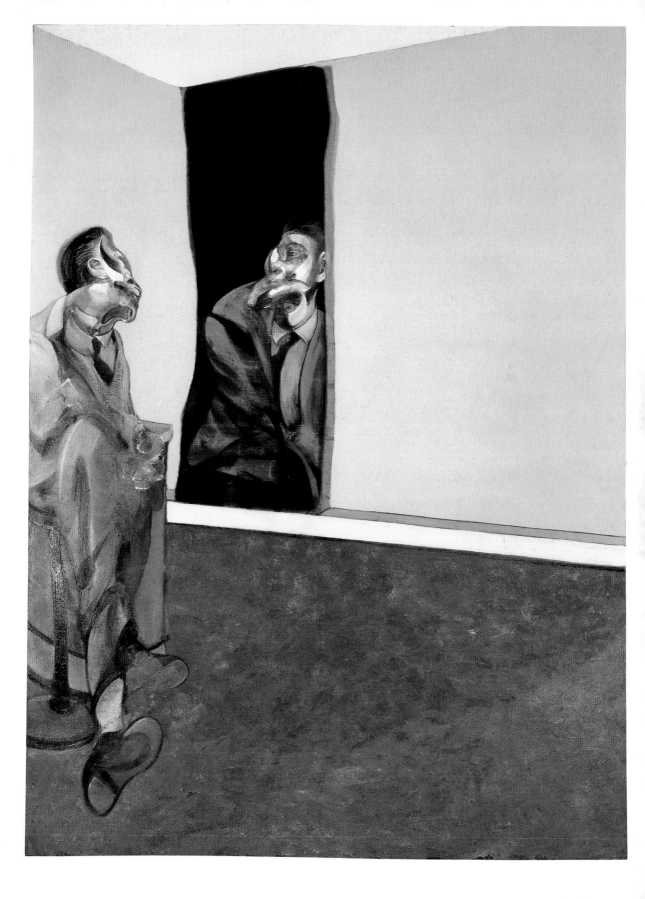

LOUISE BOURGEOIS

HENRY MOORE

JEAN TINGUELY

1877–1880 *The Age of Iron* (Auguste Rodin)

1897 Founding of the Vienna Secession

1914 *Bottle Rack* (Marcel Duchamp)

1923 Freud writes *The Ego and the Id*

1938 Kristallnacht (November pogrom in Germany)

| 1860 | 1865 | 1870 | 1875 | 1880 | 1885 | 1890 | 1895 | 1900 | 1905 | 1910 | 1915 | 1920 | 1925 | 1930 | 1935 | 1940 | 1945 |

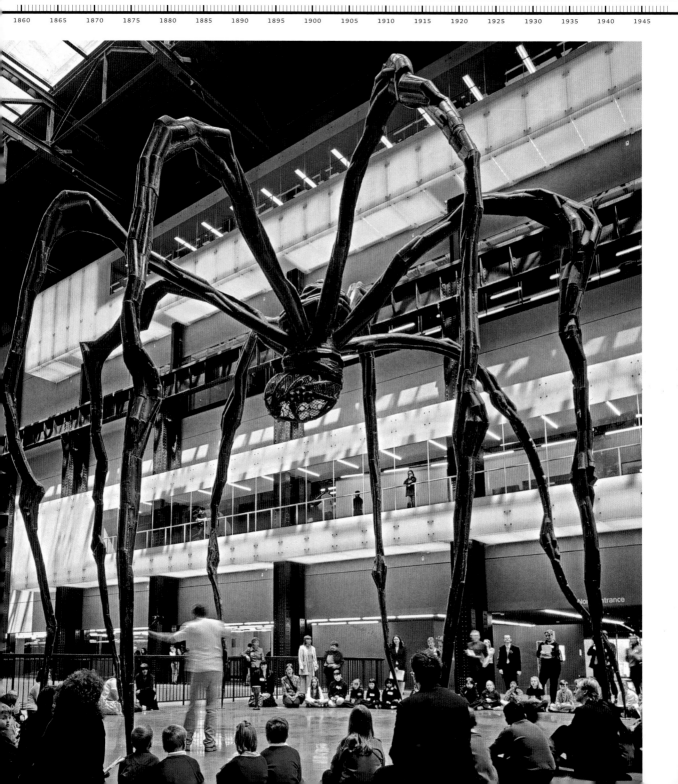

1996 First cloned mammal
(Dolly the Sheep)

1968 Premiere of Stanley Kubrick's
2001: A Space Odyssey

1986 *Rabbit* (Jeff Koons)

2005 Hurricane Katrina devastates
New Orleans

| 1950 | 1955 | 1960 | 1965 | 1970 | 1975 | 1980 | 1985 | 1990 | 1995 | 2000 | 2005 | 2010 | 2015 | 2020 | 2025 | 2030 | 2035 |

LOUISE BOURGEOIS

"All my work in the past 50 years, all my subjects have found their inspiration in my childhood. My childhood has never lost its magic, it has never lost its mystery, and it has never lost its drama."—Louise Bourgeois, 1994

The viewer looks in vain for stylistic rigor in Louise Bourgeois's work. The artist was less concerned with questions of form, since content—that is, what she was trying to express in a work—always took precedence. The starting point for her oeuvre was her own life, as she processed a conflict-ridden past and the injuries inflicted on her in childhood. She was convinced that only by working autobiographically and sticking entirely to herself and her own feelings could she truly be universally understood.

Bourgeois studied mathematics before she enrolled at various art schools, first in Paris and, after her marriage to American art historian Robert Goldwater, at the Art Students League in New York. She worked as a painter, but later switched to sculpture. A theme of her early pictures is the *femmes maisons*: women whose minds are trapped in houses, a metaphor for the social status of women and what she saw as their cramping confinement to the domestic sphere.

Ambiguities

Bourgeois tried out a wide range of materials in her sculptural work. Her early work included pillar-like wooden figures, but in the 1960s she was one of the first artists to experiment with amorphous materials such as latex and synthetic resin. She created women, hybrid creatures, and goddesses modeled on ancient fertility idols, exploring sexual themes and taboos with unaccustomed directness for the time. The impish irony with which Bourgeois went about her works is clear from a now-famous photograph by Robert Mapplethorpe, in which the then-70-year-old artist is shown roguishly smiling with her sculpture *Fillette* (1968) loosely tucked under her arm. Though the title of the work refers to a "little girl," it is obviously a giant phallus with testicles. Bourgeois later took great pleasure in denying any sexual innuendo in her works, saying, "Oh, do they see something erotic about it? Then they're putting it in themselves."

Expression of Memories

One of Bourgeois's best-known works dates from 1974. In it, she was settling a score with her own father, who had cheated on her mother for years with his daughter's governess. It is an installation called *Destruction of the Father*, a red-lit cave with female forms in which all that is left of a cannibal feast is bones. Beginning in the mid-1980s, she created numerous mysteriously furnished, cage-like installations called *Cells*, which tell of other inner realities. From 1994 she worked up her memories of her mother with various versions of the spider motif; a giant steel version called *Maman* was shown in 2000 at the opening of the Tate Modern in London. Though the artist's explanations sound simple, her works are not easy to interpret. That does not, however, make the works of Bourgeois, whose national and international breakthrough came only in old age, any less fascinating.

1911 Born on December 25 in Paris
1920 Helps her parents restore tapestries
1933–38 Studies art in Paris
1936 After studying at the Sorbonne, she switches her focus to art at the École des Beaux-Arts
1938 Marries Robert Goldwater and moves to New York City
1941 Begins making *Personages*, life-size wooden sculptures
1945 Has her first solo show in New York City
1955 Becomes an American citizen
1960 Starts to experiment with malleable materials
1977 Receives an honorary doctorate in fine arts from Yale University
1982 Publishes the autobiographical article "Child Abuse" in *Artforum*
1999 Commissioned to create an inaugural installation for the Turbine Hall in the Tate Modern in London
2001 Display *Maman*, a 9-meter (30-foot) bronze spider, in Rockefeller Plaza, New York City
2010 Dies on May 31 in New York

left page
Louise Bourgeois, *Maman*, 1999, steel, marble, 9.27 x 8.91 x 10.23 m, Private collection, courtesy Cheim & Read, New York

above
Louise Bourgeois in her studio, 1988, photograph

1898 * George Gershwin **1914–1918** World War I **1939–1945** World War II

1860	1865	1870	1875	1880	1885	1890	1895	1900	1905	1910	1915	1920	1925	1930	1935	1940	1945

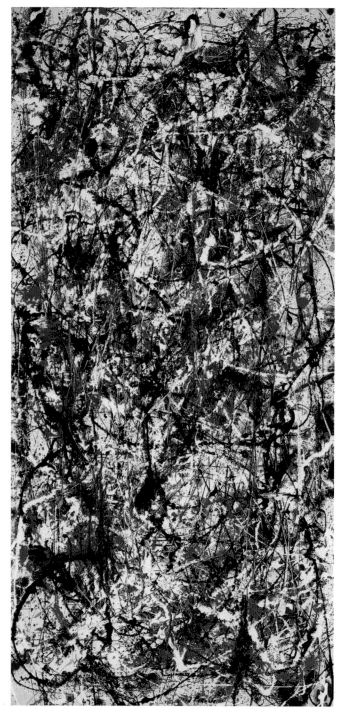

Jackson Pollock, *Cathedral*, 1947, enamel and aluminium
paint on canvas, 181.6 x 89 cm, Dallas Museum of Art,
Gift of Mr. And Mrs. Bernard J. Reis

1950 Abolition of racial segregation in the United States

1963 Assassination of John F. Kennedy

1962 Cuban Missile Crisis

1973 Watergate scandal

1990 Reunification of Germany

1952 Elvis Presley hits the headlines

1969 Moon landing (United States)

2001 9/11 terrorist attacks in the United States

1950 1955 1960 1965 1970 1975 1980 1985 1990 1995 2000 2005 2010 2015 2020 2025 2030 2035

JACKSON POLLOCK

As the history of modern art developed, the individual personalities of artists were reflected more and more clearly in their work. That was particularly the case with American Abstract Expressionist Jackson Pollock's gestural paintings. Using the technique of "action painting," Pollock made the canvas his field of action.

From the beginning of his short but unusual career, Pollock worked with various techniques, such as pencil, ink, watercolor, gouache, and collage. In 1936, he worked in the New York studio of Mexican painter David Alfaro Siqueiros, from whom he learned new techniques with a spray gun and synthetic paints. Particularly important for his artistic development were his encounters with New York School artists Robert Motherwell, Willem de Kooning, and Roberto Matta, as well as with a variety of immigrant European artists, particularly the Surrealists. The Surrealists' influence helped lead him to his guiding belief that the origins of art lay in the subconscious.

Tissues of Color

The first high point in Pollock's output came with a large wall painting of 1943 called *Mural*, which he created in a single night for the home of art collector Peggy Guggenheim, who the same year put on Pollock's first solo exhibition at her Art of This Century Gallery. His artistic breakthrough finally came in 1947 with his abstract "drip paintings." In these, he not only abandoned traditional figurative representation, but also moved away from standard painting and drawing equipment and traditional techniques. He dripped, sprayed, poured, or hurled the various paints directly from the tube at the canvas—often in extreme portrait or landscape formats—that he had laid out on the floor. Pollock applied the paint in controlled yet spontaneous motions, as chance dictated; the creative act was paramount. One of his outstanding works—and a masterpiece of Abstract Expressionism—is the painting *Number 32*, dating from 1950. In his later

works, Pollock began to avoid colors, returning to figurative elements in "pourings" done in black and white, mainly by hurling the paint.

Although Pollock became famous as a result of his work ("Is he the greatest living painter in the United States?" asked a rhetorical headline in *Life* magazine in 1949), he had grave problems in his personal life. Deep personal crises and alcoholic binges were followed by periods of sobriety and psychotherapy. A sustained period of depression in 1955–56 put an end to his creative work. On August 11, 1956, Pollock was killed in a car crash in East Hampton, Long Island, at the age of 44. The Museum of Modern Art in New York put on the first retrospective of his work that same year.

1912 Born on January 28 in Cody, Wyoming; later that year, he moves with his family to California
1930–32 Studies art with Thomas Hart Benton at the Art Students League
1935 Joins the mural division of the Works Progress Administration's Federal Art Project
1943 Commissioned by Peggy Guggenheim to create a mural for her Manhattan townhouse
1945 Marries painter Lee Krasner
1947–48 Begins to paint off the easel, with his canvas on the floor
1949 Featured in *Life* magazine
1956 Dies on August 11 in a car crash in East Hampton, New York

right
Jackson Pollock, *There Were Seven in Eight*, c. 1945, oil on canvas, 109.2 x 259.1 cm, The Museum of Modern Art, New York

above
Jackson Pollock, c. 1955/56, photograph

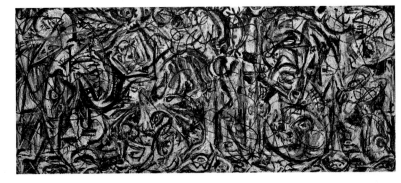

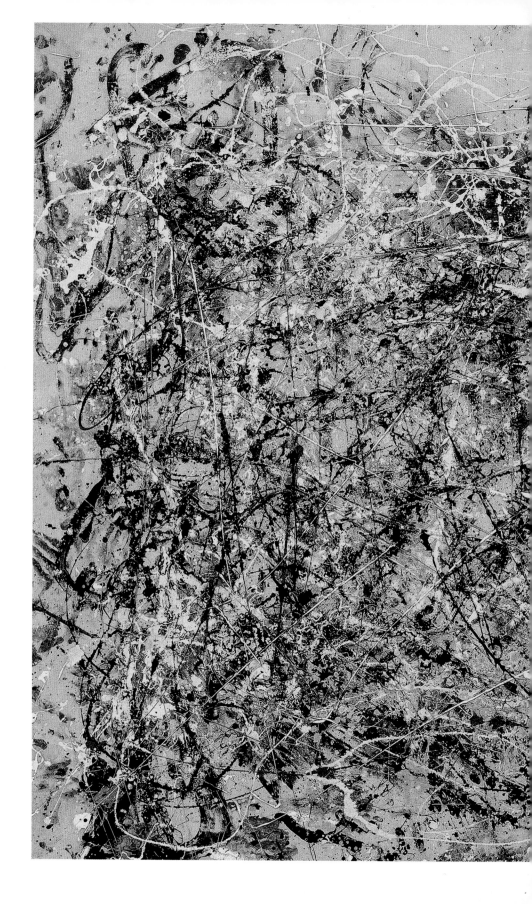

Jackson Pollock, *Number 1A*, 1948,
oil and enamel on canvas,
172.7 x 264.2 cm, The Museum of
Modern Art, New York

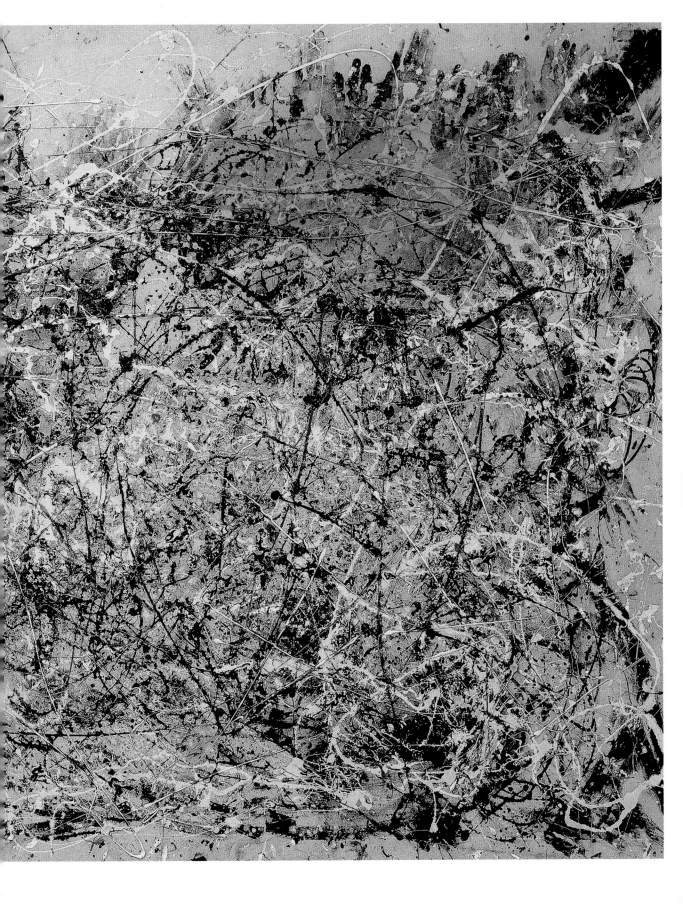

1914–1918 World War I **1939–1945** World War II

1929 Wall Street crash in New York

| 1870 | 1875 | 1880 | 1885 | 1890 | 1895 | 1900 | 1905 | 1910 | 1915 | 1920 | 1925 | 1930 | 1935 | 1940 | 1945 | 1950 | 1955 |

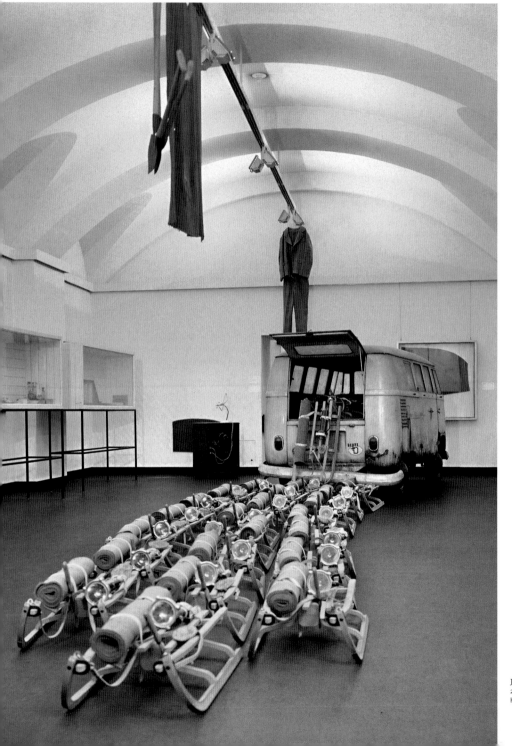

Joseph Beuys, *The Pack*, 1969, van,
24 sleds, fat, felt, Museumslandschaft
Hessen Kassel, Neue Galerie Kassel

1955 First Documenta exhibition
in Kassel

1973 First oil crisis

1995 Christo and Jean-Claude wrap
the Reichstag

1961 Construction of Berlin Wall

1980 Ronald Reagan becomes U.S. president

2003 U.S. invasion of Iraq

1972 Terrorist murders at
Munich Olympics

1990 Reunification of Germany

1960 1965 1970 1975 1980 1985 1990 1995 2000 2005 2010 2015 2020 2025 2030 2035 2040 2045

JOSEPH BEUYS

The artistic legacy of Joseph Beuys is a complex mix of installations, sculptural works, watercolors, drawings, multiples, and writings, all of which blur conventional boundaries between genres. His performance art made him one of the best-known and most controversial artists in Germany. A tall, gaunt man who often wore a hat, Beuys drew no line between life and art. For him, art included thinking, talking, and debating.

Beuys was born in Krefeld, Germany, in 1921. After leaving school, he volunteered for the Luftwaffe, and in 1941 he began military training as a radio operator and later as a pilot. As a fighter pilot, he was stationed in southern Italy, Croatia, and Ukraine, and he became a paratrooper on the Western Front. While still in uniform, he decided to become a sculptor, enrolling in 1947 at the Düsseldorf Academy of Art.

"Every man is an artist"

In his first years of study, Beuys followed the usual curriculum, but he was already somewhat unconventional in his attitude—for example, using materials with visible signs of use on them. In 1955, he lapsed into a long-term period of depression, which he afterward described as a kind of purification process. As a result of it, he strove subsequently for an art and "social sculpture" that would have the potential to educate people to be free, creative individuals and to improve the world.

As professor of monumental sculpture at the Düsseldorf Academy of Art from 1961, Beuys taught his students about artistic and sociopolitical utopias. He put his students to the test in public "actions," which earned him a reputation as a provocateur. Beuys's appearance at the Festival of New Art in Aachen on July 20, 1964—the 20th anniversary of the failed attempt to assassinate Adolf Hitler—made him famous overnight. Reports in the media showed photos of Beuys with a bloody face, holding a cross in a Nazi salute. The blood was the result of being hit by a spectator, who found Beuys's artistic experiments to be too much. This appearance turned the art professor into a martyr who sacrificed himself for his outlook and philosophy of art.

A Political Force

In the 1970s, Beuys became increasingly political. He repeatedly tried to get the official Academy admissions panel to admit more students; Beuys and rejected students "occupied" university offices as a sign of protest. As a result, he was dismissed from the Academy in 1972. Beuys regarded the incident as an "action" and produced a piece about it called *Democracy Is Funny*.

In 1980, Beuys stood in the North Rhine–Westphalia state elections as a candidate for the newly formed Green Party. In 1982, he dreamed up an ambitious project for planting 7,000 oaks in Kassel as a "work" for Documenta 7. It was another step toward his objective of "really changing the world." As he once said, "Art is in my opinion the only evolutionary force. That is, only people's creativity can change the situation."

Beuys's showmanship soon earned him an international reputation. In one of his performances, he explained pictures to a dead hare. Another famous work was *Fat Chair*, a sculpture that bestowed respectability on fat as an artistic material. By later in his career, he surpassed American artists Robert Rauschenberg and Andy Warhol at the top of lists of bankable artists. After doctors had diagnosed a severe form of pneumonia, Beuys died in 1986 in Düsseldorf.

1921 Born on May 12 in Krefeld, Germany

1940 Joins the German air force

1943 His plane crashes in the Crimea; is rescued by nomadic Tartars

1947–52 Studies at the Düsseldorf Academy of Art

1963 First "fat" exhibition is held in Cologne gallery

1974 Founds the Association for the Promotion of Free College for Creativity and Interdisciplinary Research in Düsseldorf, with the writer Heinrich Böll

1980 Stands for the Green Party in the state elections in North Rhine-Westphalia

1982 Starts the 7,000 *Oaks Campaign* in Kassel. Beuys's son Wenzel plants the last tree in 1987.

1986 Dies on January 23 in Düsseldorf, Germany

Joseph Beuys, photograph

1945 Beginning of Cold War

1939–1945 World War II

1870 1875 1880 1885 1890 1895 1900 1905 1910 1915 1920 1925 1930 1935 1940 1945 1950 1955

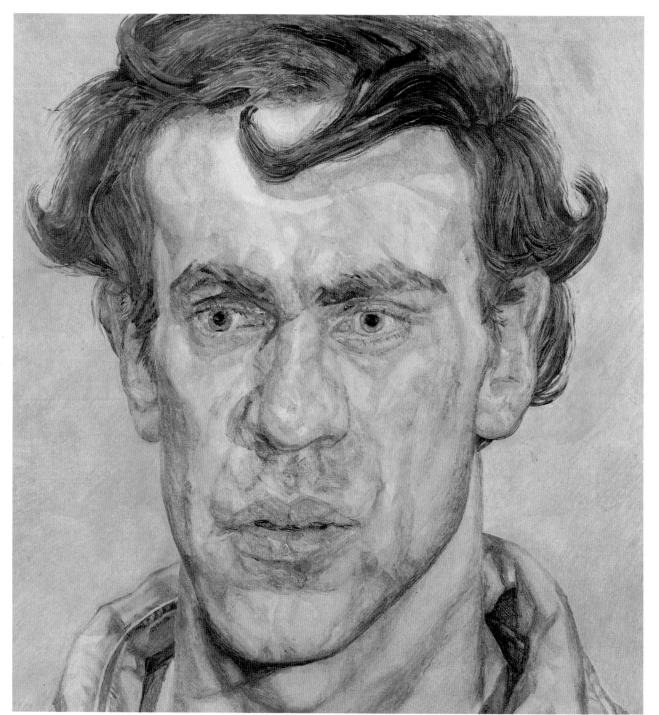

1955 First Documenta exhibition **1973** First oil crisis
 in Kassel

1998 Founding of International Court in The Hague
 2001 War in Afghanistan

1961 Construction of Berlin Wall **1980–1988** Iran–Iraq War
 2007–2010 Global financial crisis

1990 German re-
 unification

1966 Who's Afraid of Red, Yellow and Blue?
 (Barnett Newman)

2004 Eastern European countries
 admitted to the EU

1960 1965 1970 1975 1980 1985 1990 1995 2000 2005 2010 2015 2020 2025 2030 2035 2040 2045

LUCIAN FREUD

Abstraction was the dominant art form when Lucian Freud started his career, yet he chose a path in figurative painting. Among his masterly portraits and nudes is a small-format, yet monumental-looking, portrait of Queen Elizabeth II, painted in 2001.

Freud was born in Berlin in 1922, the son of architect Ernst Freud and grandson of Sigmund Freud, the founder of psychoanalysis. In 1933, the family immigrated to England. In London, Freud went to the Central School of Arts and Crafts, before moving on to the East Anglian School of Painting and Drawing in Dedham, and finally to Goldsmiths College in London.

One of his fellow students was painter Francis Bacon, who became a close, life-long friend. After World War II, Freud and Bacon, part of the London School, were passionate believers in placing the human figure at the center of their work. In 1952, Freud did a portrait of Bacon in the Magic Realist style, meticulously reproducing every fold of skin and strand of hair. Today, he still mainly uses relatives, friends, and acquaintances as his models.

Haunting Images of People

In the late 1950s, Freud's painting style moved toward the style for which he is known today. He began to paint more expressively, using a coarser brush, with which he could apply intense, saturated color in dynamic brushstrokes. Besides self-portraits, he did group and individual portraits, plus nudes in large and small formats. Freud works straight from the model, who is presented with unsparing candor. Often his pictures show opulent nude bodies scarred by age; the artist is uninterested in portraying what is considered "beautiful." Freud himself describes the way he puts things into the picture as "clumsy and unwieldy, like life itself." In terms of paint, he says, "As far as I am concerned the paint is the person. I want it to work for me just as flesh does." He works slowly, exploring his models with empathy over time, saying, "I would wish my portraits to be of the people, not like them. Not having a look of the sitter, being them." Yet despite the often-shocking intimacy portrayed, Freud always allows sitters their personal freedom.

In many pictures, they appear with their eyes closed or an averted gaze.

Among Freud's outstanding works are a series of portraits of his mother from the late 1970s as well as portraits of performance artist Leigh Bowery and of London benefits officer Sue Tilley ("Big Sue"). In addition to human portraits, he has painted many portraits of horses and dogs. Since 1982, he has also done etchings, which have a complex, reciprocal relationship with his paintings. Freud lives and works in London.

1922 Born on December 8 in Berlin
1933 Immigrates to England
1938–43 Studies at the Central School
 of Arts and Crafts in London
1939 Attains British citizenship
1944 First exhibition in Galerie Lefevre
1948 Marries Kathleen Garman
 Epstein. After divorce he marries
 Caroline Blackwood.
1951 Produces *Interior in Paddington*
1954 Represented in the British
 pavilion at the Venice Biennale
2002 Largest retrospective ever at the
 Tate Britain, London

left
Lucian Freud, *A Young Painter*, 1957/58,
oil on canvas, 40.8 x 39.4 cm, The
Directors of Baring Brothers & Co. Ltd.

above
Lucian Freud in Benton End, 1940,
photograph

1901 * Walt Disney **1914–1918** World War I **1952** Elvis Presley hits the headlines

1939–1945 World War II

1875 1880 1885 1890 1895 1900 1905 1910 1915 1920 1925 1930 1935 1940 1945 1950 1955 1960

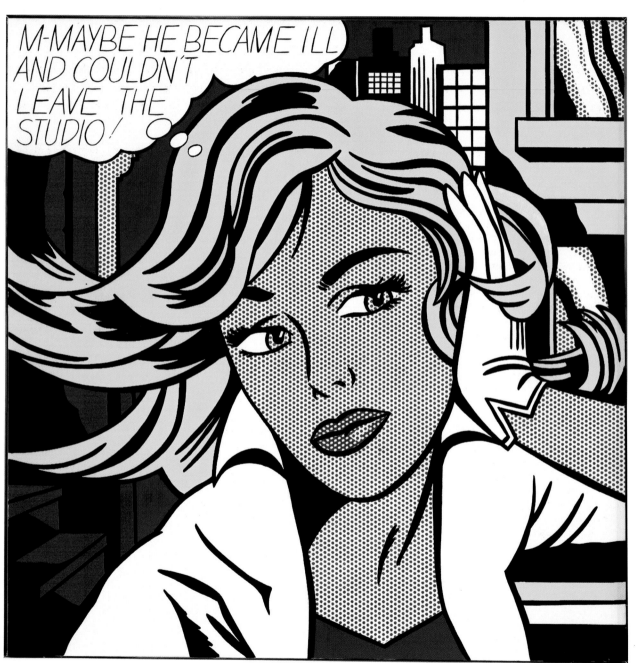

Roy Lichtenstein, *M-Maybe (A Girl's Picture)*, 1965, Magna on canvas, 152 x 152 cm, Museum Ludwig, Cologne

2001 9/11 terrorist attacks in the United States

1969 Woodstock music festival 1988 "Freeze" exhibition in London is Young 2005 Hurricane Katrina devastates
 British Artists' breakthrough New Orleans

1962 Cuban Missile 1973 Watergate scandal
Crisis 1998 Founding of International Court
 in The Hague

1965 1970 1975 1980 1985 1990 1995 2000 2005 2010 2015 2020 2025 2030 2035 2040 2045 2050

ROY LICHTENSTEIN

Like Andy Warhol, Roy Lichtenstein was a key figure in the development of Pop Art. His best-known works focus on subjects from comics, which he portrayed with his distinctive, outsize dot-screen technique. The speech bubbles attached to his protagonists humorously capture the idiom of everyday conversation, highlighting the influence of mass media on his work.

Lichtenstein was born in New York in 1923. He had a middle-class childhood, with a real-estate agent father and homemaker mother. Lichtenstein left high school in 1940 and enrolled at Ohio State University's School of Fine Arts. By then, he already wanted to be an artist, but was persuaded by his parents to train to be a teacher. During Lichtenstein's studies, his teacher Hoyt L. Sherman used a "flash room" as a teaching method: he would darken the room and briefly project images up onto three screens. In the dark, the students had to put down on paper what they had seen on the screens. The technique made an enduring impression on Lichtenstein and his interest in exploring perception in his art.

Teaching and First Exhibitions
Between 1952 and 1955, Lichtenstein focused on typically American subjects. He was interested in expressionism, abstraction, and painted wooden structures. He often deconstructed American paintings with Cubist painting techniques. His first solo exhibitions were in 1949 at the Ten Thirty Gallery in Cleveland and in 1951 at the Carlebach Gallery in New York. To make a living, in 1957 he again took up teaching. Lichtenstein was appointed Assistant Professor of Art at the State University of New York at Oswego, where he taught for a number of years.

Look, Mickey: The Breakthrough
In 1961, Lichtenstein decided to abandon his expressive style, opting instead for industrial printing technology and speech bubbles, which he hoped would increase the impact of his pictures. With these two techniques, he achieved stunning effects in his works, immediately gripping the viewer's attention. *Look, Mickey* was the first large-scale oil painting in which he worked with sharply outlined figures, industrial paints, and imitation half-tone screens (as used in commercial art). It shows an excited Donald Duck, whose fishing hook has gotten caught in his own jacket, making him think he has a big fish on the line.

The Fascination of Dot Screens
Lichtenstein used the imagery of the mass media and industrial products for his work. His comic-strip enlargements, with their primary colors and immediacy, have a powerful visual effect. He faithfully reproduced the original documents but greatly magnified them, with the coarse Ben Day dots imitating the printing techniques used in comic books and newspaper photos. He often satirized pictures by removing them from their original context. The magnification and exaggerated simplification of the sources drew viewers' attention to the everyday realities of 1960s America.

1923 Born on October 27 in New York
1939 Studies at the Arts Students League in New York
1940–43 Studies at Ohio State University
1943–46 Stationed in the military in Europe
1949–51 Teaches at Ohio State University, Columbus
1951 Solo exhibition at the Carlebach Gallery, New York
1962 Takes part in first Pop Art exhibition "New Realists" at Sidney Janis Gallery, New York
1969 Retrospective at the Solomon R. Guggenheim Museum, New York
1995 Awarded the National Medal of Art
1997 Dies on September 29 in New York

Laurie Lamprecht, Roy Lichtenstein, photograph

1939–1945 World War II **1962** Cuban Missile Crisis

1901 * Walt Disney **1914–1918** World War I **1952** Elvis Presley hits the headlines

| 1880 | 1885 | 1890 | 1895 | 1900 | 1905 | 1910 | 1915 | 1920 | 1925 | 1930 | 1935 | 1940 | 1945 | 1950 | 1955 | 1960 | 1965 |

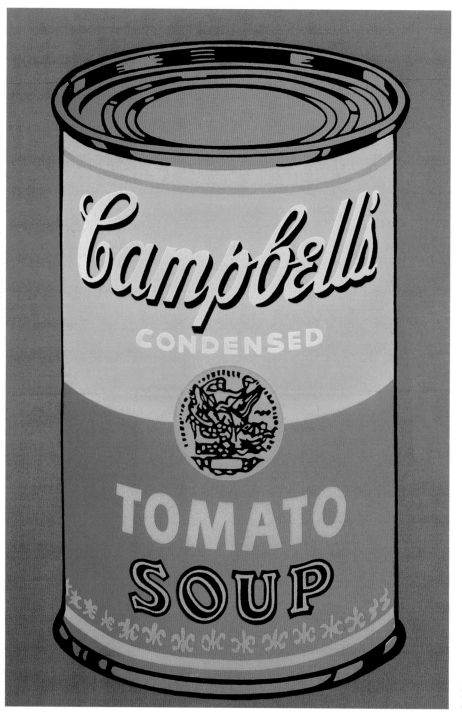

Andy Warhol, *Campbell's Tomato Soup Can*,
1968, screen print on colored paper, 38.1 x 25.4 cm,
Collection José Mugrabi

1969 Woodstock music festival
2001 9/11 terrorist attacks in the United States

1973 Watergate scandal **1986** Chernobyl disaster

| 1970 | 1975 | 1980 | 1985 | 1990 | 1995 | 2000 | 2005 | 2010 | 2015 | 2020 | 2025 | 2030 | 2035 | 2040 | 2045 | 2050 | 2055 |

ANDY WARHOL

American artist Andy Warhol, a key figure of the Pop Art movement, consumed popular culture and adopted its imagery. His serial production method diverted attention away from the subjects portrayed, focusing instead on the way the sources were treated. His work explores the omnipresent, often-manipulative nature of popular culture in the 1960s.

A Method of His Own

While working as a commercial artist, Warhol developed a distinctive "drop and drip" technique that anticipated his later screen prints. He drew angel, *putto*, or cat motifs, and then copied them with blotting paper onto a new sheet. Although Warhol was very successful as a commercial artist—in the late 1950s, he was among the top-earning designers in Manhattan —he opted for a fine art career and sought new ideas for his canvases.

In his early work, Warhol focused on banal subjects. His Campbell's soup cans were the first works he exhibited, in 1962, and they also became his trademark. He also appropriated photographs of stars like Marilyn Monroe or the newly bereaved Jackie Kennedy, as well as comic and cartoon motifs such as Mickey Mouse, Popeye, and Superman, as subjects for his work. Warhol used anything and everything from popular culture that he felt was "glamorous." At the same time, he was not averse to tasteless subjects, as indicated by his *Disaster* series, in which he worked with large newspaper photos of car accidents and suicides.

With these figures taken from the mass media, Warhol deliberately drew a line between himself and the then-popular Abstract Expressionist style. The use of serial images was particularly important in his production of endless silkscreen prints; as he once said, "I like things to be exactly the same over and over again." These works derive their impact from an experimental coloration, in which he consciously relied on the bleaching-out effects that arose from copying the initial print.

The Factory

From the end of 1963, Warhol's workshop—known as the Factory—was where New York's bohemia (dancers, transvestites, actors, painters, and musicians) gathered. The studio was also the setting for his many films. Using an inexpensive Bolex 16mm camera, he started filming visitors, artists, friends, and other celebrities such as Mick Jagger, Bob Dylan, Marcel Duchamp, and Salvador Dalí. But after an assassination attempt by radical feminist Valerie Solanas in June 1968, during which he was almost fatally injured, Warhol no longer gave open access to visitors. He became less social and focused more on his art.

1928 Born on August 6 in Pittsburgh, Pennsylvania
1945–49 Studies design at the Carnegie Institute of Technology (now Carnegie Mellon University)
1949 Moves to New York City to work as a commercial artist
1957 Wins the annual Art Directors Club award for his I. Miller& Sons shoe advertisements
1960 Begins to create paintings based on advertisements and comic strips
1962 Begins to use the photo silkscreen technique
1963 Opens the "the Factory" and begins to film "Screen Tests" and other films
1968 Shot by Valerie Solanas
1969 Founds *Interview* magazine
1974 Begins to assemble "Time Capsules"
1976 Begins to dictate his diaries to Pat Hackett; they are later published in 1989
1980 Publishes *POPism* with Pat Hackett
1985–87 Hosts *Andy Warhol's Fifteen Minutes* on MTV
1987 Has gall bladder surgery; dies in New York on February 22

Andy Warhol, photograph

CY TWOMBLY

LOUISE BOURGEOIS

JASPER JOHNS

1949 Founding of NATO

1920–1930 Harlem Renaissance

1955 "The Family of Man"
exhibition at MoMA
in New York

| 1880 | 1885 | 1890 | 1895 | 1900 | 1905 | 1910 | 1915 | 1920 | 1925 | 1930 | 1935 | 1940 | 1945 | 1950 | 1955 | 1960 | 1965 |

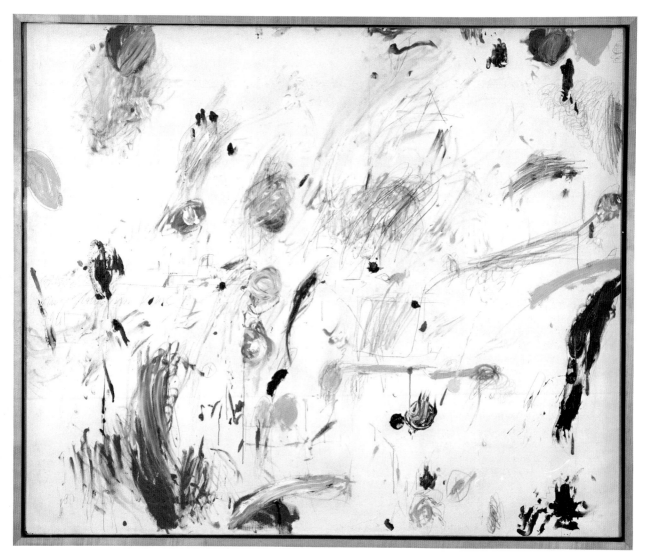

Cy Twombly, *Ferragosto II*, 1961, Oil paint, wax crayon, lead
pencil on canvas, 164.5 x 200.3 cm, Hirschhorn Museum
and Sculpture Garden, Smithsonian Institution, Washington,
Gift of Joseph H. Hirshhorn, 1966

1963 Assassination of John F. Kennedy

1986 *Challenger* space
shuttle disaster

1995 *Everyone I Ever Slept
With* (Tracey Emin)

2003 U.S. invasion of Iraq

2001 9/11 terrorist attacks in the United States

2006 Record price for a work of art ($140m) paid
for Jackson Pollock's *No. 5* (1948)

2009 Barack Obama awarded Nobel Peace Prize

1970 1975 1980 1985 1990 1995 2000 2005 2010 2015 2020 2025 2030 2035 2040 2045 2050 2055

CY TWOMBLY

American painter, draftsman, sculptor, photographer, and object artist Cy Twombly is one of the most important representatives of Abstract Expressionism. His paintings, which at first glance often look like scribbles, have become world famous. In these works, intricate ciphers recall fragments of building walls and graffiti.

Edwin Parker Twombly, Jr., was born in Lexington, Virginia, in 1928. By 1945, he was already producing sculptures. His first assemblages of the 1950s reflect the influence of German artist Kurt Schwitters and Swiss sculptor Alberto Giacometti, as well as the object art of the Surrealists. In 1948, he studied at the School of the Museum of Fine Arts, Boston, and from 1949 at Washington and Lee University. In 1950, a scholarship took him to New York. In the early 1950s, he was drafted into the army for a short time, when he was involved with decoding encrypted messages. Another scholarship took him and his friend Robert Rauschenberg to Europe. From 1955 to 1956, Twombly was head of the art department at Southern Seminary and Junior College in Buena Vista, Virginia. The following year he moved to Rome.

Abstract Expressionism

In the 1950s and 1960s, Twombly helped lay the foundations for a new kind of painting. He used a language of signs apparently borrowed from traditional wall graffiti. The result was an idiom of calligraphic ciphers, in which he painted his canvases graffiti-style with systematized diagrams, figures, symbols, or fragments of words. While in Gaeta, Italy, Twombly created his famous *Poems to the Sea* cycle of paintings. In these works, he covered the canvas with a riot of unexpected imagery—smears, incidental trivia, sexual doodles, pointless smudges, engineering calculations, and columns of figures like those made by local artisans. Twombly's pictures reminded stunned viewers of the walls of Roman houses, with their infinite layers of paint and scribbles. In truth, however, nothing like it had ever been seen before. In these and subsequent works, scrawls, smudges, scratches, and tangles of script are as skillfully composed as objects in a classical still life, creating dramatic tension. In his own inimitable way, he combines painting with structures that seem like written characters—

for example, in his *Blackboard* paintings from the 1960s.

Twombly's work has been exhibited internationally and won numerous awards. In 1994, New York's Museum of Modern Art put on a Twombly retrospective. In 1995, the Menil Collection in Houston erected a special Cy Twombly Gallery, designed by Italian architect Renzo Piano. In 1996, he received the Praemium Imperiale Japanese cultural prize, one of the most prestigious awards in the art world. Twombly lives in the Italian seaside resort of Gaeta, but still has studios in Rome and in Lexington, where he grew up.

1928 Born on April 25 in Lexington, Virginia

1948–49 Studies at Washington and Lee University in Lexington and the School of the Museum of Fine Arts, Boston

1950–51 Studies at the Art Students League, New York

1953 First solo exhibition, at the Kootz Gallery, New York

1957 Settles in Rome

1994 Retrospective at the Museum of Modern Art, New York

2002 Takes part in group exhibition "Art Chicago," in the CAIS Gallery

2008 Awarded the Gerhard Altenbourg Prize

JASPER JOHNS

ANTONI TÀPIES

GEORG BASELITZ

1920–1930 Harlem Renaissance

1895 First public film
screenings

1910 Opening of Los Angeles County
Museum of Art

1910–1929 Mexican Revolution

1953 Merce Cunningham founds
his dance company

1945 Beginning of Cold War

| 1880 | 1885 | 1890 | 1895 | 1900 | 1905 | 1910 | 1915 | 1920 | 1925 | 1930 | 1935 | 1940 | 1945 | 1950 | 1955 | 1960 | 1965 |

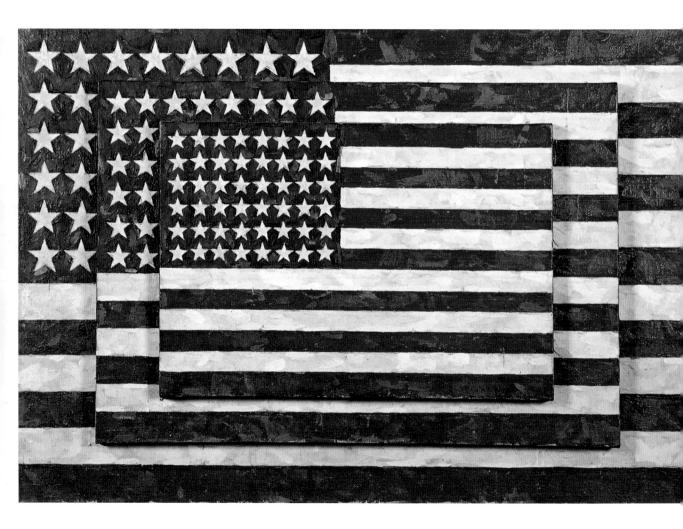

Jasper Johns, *Three Flags*, 1958, encaustic
on canvas, 199.1 x 293.6 x 32.3 cm,
Whitney Museum of American Art

1994 End of apartheid in South Africa

1968 Assassination of Martin Luther King, Jr. **2001** 9/11 terrorist attacks in the United States

1982 Production of the first commercial
CD player

| 1970 | 1975 | 1980 | 1985 | 1990 | 1995 | 2000 | 2005 | 2010 | 2015 | 2020 | 2025 | 2030 | 2035 | 2040 | 2045 | 2050 | 2055 |

JASPER JOHNS

Jasper Johns's pictures of letters, numbers, targets, and flags introduced a new kind of subject matter and clear, simple imagery into art. His work paved the way not only for Pop Art, but also for Minimalism.

Johns was born in Augusta, Georgia, in 1930, but grew up in South Carolina. He left the South when he was 19, settling in New York in order to follow his childhood dream of becoming an artist. In New York, he made the acquaintance of numerous artists, including Robert Rauschenberg, John Cage, and Merce Cunningham, with whom he remained in regular contact over the years.

The American Flag as Subject Matter
Johns's pioneering painting *Flag* (1954–55) consists of layers of paint on top of collaged strips of newspaper. He used encaustic, a technique in which the colors are fused with wax. This gives the surface of the picture the quality of a relief. He took the American flag as a motif not for any patriotic reason—his flag does not wave on official business, nor is it held aloft by victorious GIs. Rather, he was looking for an ordinary image that would be immediately recognizable to everyone.

Focusing on the Ordinary
Throughout this early period, Johns often similarly took his subjects from the realm of the conventional and the ordinary—things that are familiar to everyone, but for that very reason are scarcely noticed. However, the very fact that the artist chose to make a picture of them was enough to revive interest in them for the viewer. The neo-Dadaist technique of introducing tangible everyday objects (for example, newspapers, rulers, wires, forks) was an important element for him as well. External, tangible reality is a disconcerting intrusion into the picture. The boundary is blurred between the reality of the object and the reality of the image, so that the picture itself becomes the subject.

Successful Entry into the Art Market
Johns's breakthrough came in 1958, with his first solo exhibition at the Leo Castelli Gallery in New York. His works were then shown at the Venice Biennale and the Museum of Modern Art, which bought three of them. Suddenly he had the attention of the art world.

After his gallery debut, Johns to some extent abandoned the painting style that had earned him overnight recognition. The process of painting itself was now more important to him than the external signs he chose to use. In the early 1960s, this interest in process led to printmaking. It was a kind of work that suited his delight in experimentation. He went on to introduce major innovations in painting, silkscreen printing, lithography, and etching in subsequent decades.

1930 Born on May 15 in Augusta, Georgia
1947–48 Attends the University of South Carolina in Columbia, South Carolina
1949 Moves to New York City
1951–53 Serves in the U.S. Army
1954 Meets Robert Rauschenberg, John Cage, and Merce Cunningham; begins his first flag painting
1955 Paints his first target picture
1958 Has his first solo show, held at the Leo Castelli Gallery in New York City
1961 Buys a house in Edisto Island, South Carolina
1966 His Edisto Island house and studio are destroyed by fire
1967–78 Becomes the artistic adviser to the Merce Cunningham Dance Company
1972 Introduces the cross-hatching motif to his work
1988 Awarded the Golden Lion at the 43rd Venice Biennale
1990 Receives the National Medal of Arts
2006 The sale of his *False Start* (1959) brings the highest price for the work of a living artist

Jasper Johns in his studio in Pearl Street, New York, photograph

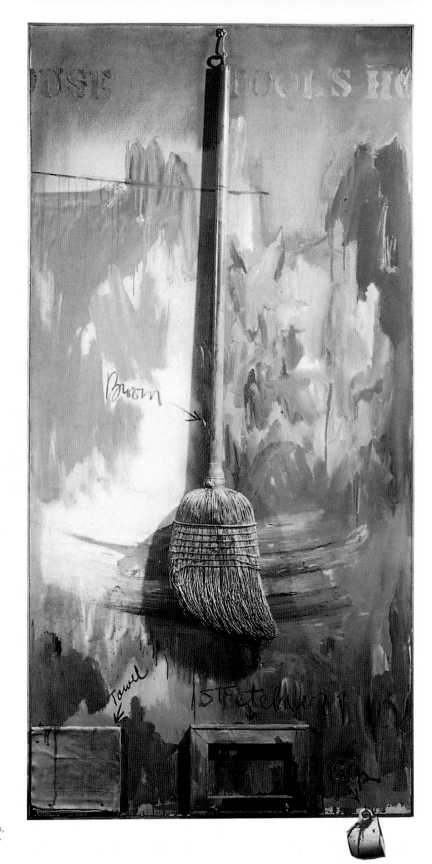

right
Jasper Johns, *Fool's House*, 1962,
oil on canvas, 464.6 x 232.2 cm,
Jean Christophe Castelli Collection

right page
Jasper Johns, *Target with Plaster Casts*,
1955, encaustic and collage on canvas
with objects, 328.9 x 284 x 22.4 cm,
David Geffen Collection, Los Angeles

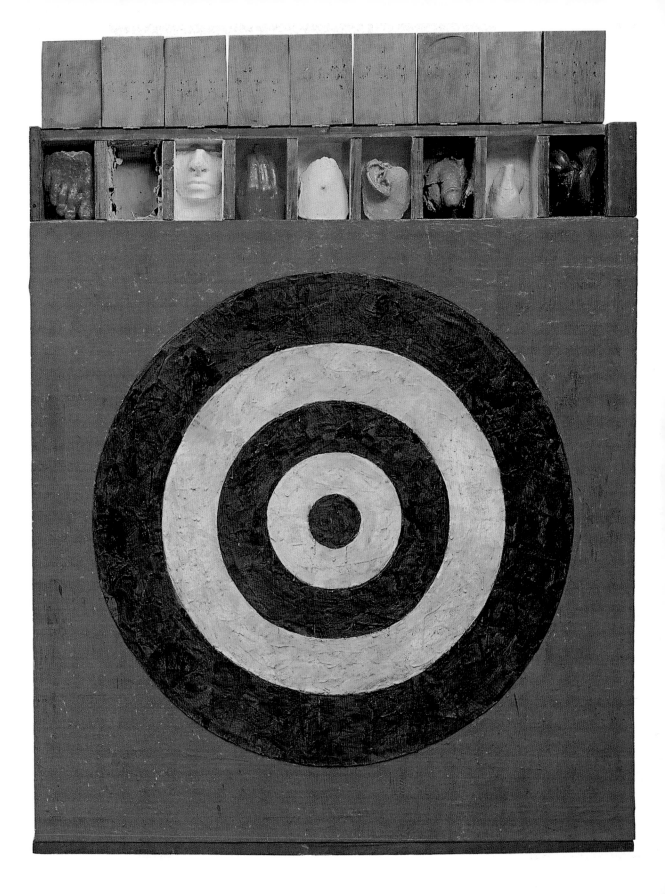

1914–1918 World War I **1939–1945** World War II

1880 1885 1890 1895 1900 1905 1910 1915 1920 1925 1930 1935 1940 1945 1950 1955 1960 1965

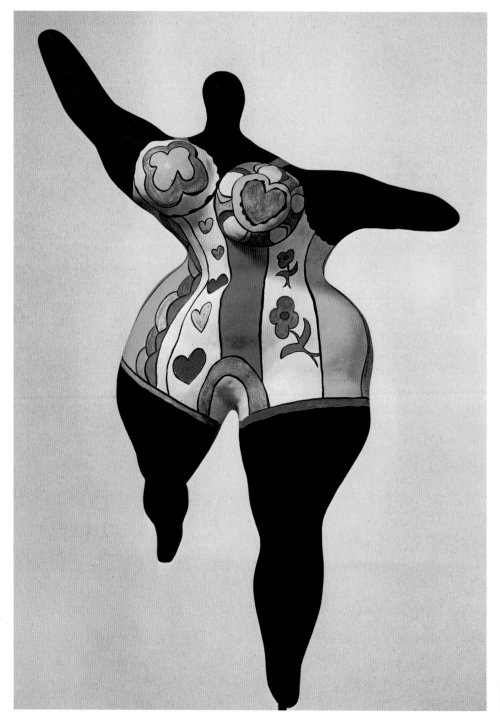

Niki de Saint Phalle, *Grand Danseuse
Negresse*, c. 1968, polyester, h. 200 cm,
Private collection

1969 Woodstock music festival

2003 Human genome decoded

1973 Watergate scandal

2001 9/11 terrorist attacks in the United States

1992 Bill Clinton becomes U.S. president

1967 *A Bigger Splash* (David Hockney)

1998 Founding of International Court in The Hague

| 1970 | 1975 | 1980 | 1985 | 1990 | 1995 | 2000 | 2005 | 2010 | 2015 | 2020 | 2025 | 2030 | 2035 | 2040 | 2045 | 2050 | 2055 |

NIKI DE SAINT PHALLE

"Niki's work demands that we ignore all conventional subdivisions in art, e.g. between painting, sculpture and architecture, sophisticated and unpretentious, permanent and transient, even conventionally appropriate and inappropriate. Instead, it's simply fun."—Excerpt from the citation for the Praemium Imperiale sculpture prize, in 2000

In the early 1960s, a young Parisian artist named Niki de Saint Phalle caused a stir by spectacularly shooting at her own pictures. Her active involvement in art was the result of a nervous breakdown; art had proved a permanent kind of therapy, and a way of life. "I was shooting at myself. At society and its injustices. I shot my own aggression and the violence of the times," she said in explanation of her early dramatic performances. These performances made Saint Phalle a symbol of a new kind of female artist, one who did not care about traditional role models and who was not willing to submit to the established, male-dominated art world.

Nana Power
An alternative to the *Shots* series was the richly varied *Nanas* series that she did subsequently, and with which she has become closely identified. The jolly, colorful, opulent female figures made of polyester and other materials are reminiscent of archaic fertility goddesses, and they embody self-confident femininity and *joie de vivre*. "I see them as heralds of a new matriarchal age, which I believe is the only answer," Saint Phalle said. "They represent the independent, kind, giving and happy mother." In 1966, she completed one of the many ambitious projects she did jointly with Basel-based kinetic artist Jean Tinguely, her partner and later husband: the exhibition of an oversized *Nana* figure at the Moderna Museet in Stockholm. Over 90 feet (28 meters) long, the architectural sculpture *She: A Cathedral* invited visitors in through an opening between spread legs, where a kind of amusement park awaited them inside the figure.

A Garden of Pleasure and Fantasy
In the early 1970s, Saint Phalle began creating a sculpture park of monumental figures based on Tarot cards, which she interpreted in a very personal and spiritual way. The park near Capalbio, in southern Tuscany, is an expressive combination of her artistic and personal philosophy, and it is the apogee of her work. After nearly 20 years of work, much of which she spent on site, the Tarot Garden was officially opened in 1998 and features 22 huge figures.

By then, Saint Phalle had moved for health reasons to California, where the milder winters were kinder to her lungs, which had been damaged by prolonged exposure to polyester. She died in California in 2002. Her legacy is an individualistic oeuvre, eloquent in its belief in utopias, and filled with a sense of necessity.

1930 Born Catherine Marie-Agnès Fal de Saint Phalle on October 29 in Neuilly-sur-Seine, Paris
1933 Moves with her family to Greenwich, Connecticut
1937 Moves with her family to New York City
1950 She marries Harry Mathews
1951 Daughter Laura born
1952 Moves with her family to Paris. One year later Niki de Saint Phalle has a serious nervous breakdown. While convalescing, she begins to paint.
1955 Son Philip is born
1960 Meets Jean Tinguely
1971 Marries Jean Tinguely
1998 Tarot Garden in Garavicchio, Tuscany, opened. Moves to California.
2002 Dies on May 21 in San Diego, California

Niki de Saint Phalle, 1980, photograph

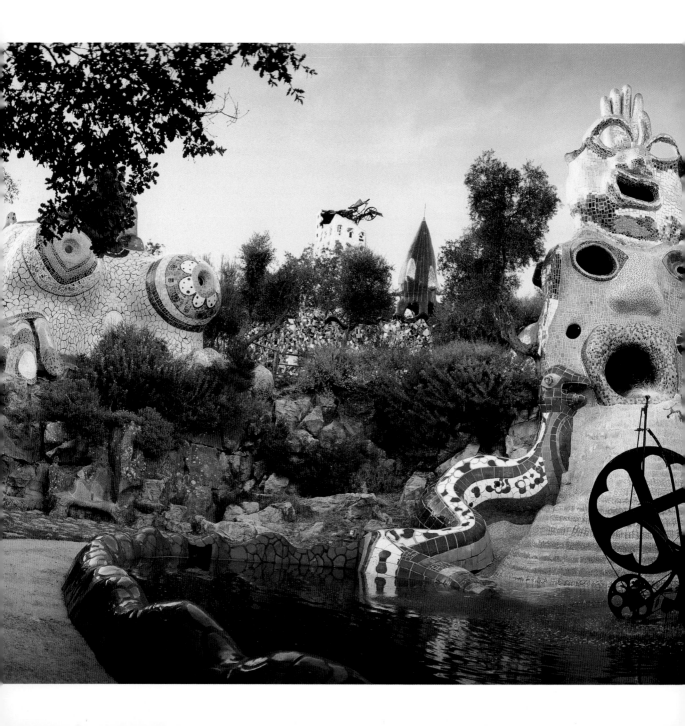

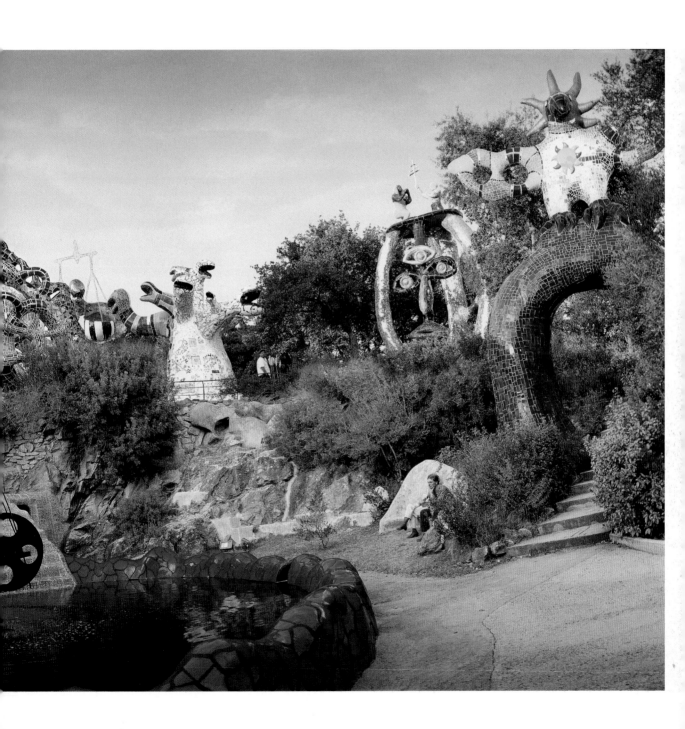

GERHARD RICHTER

LUCIAN FREUD

GEORG BASELITZ

1939–1945 World War II

1955 First Documenta exhibition
in Kassel

1945 Beginning of Cold War

1961 Construction of
Berlin Wall

1885 1890 1895 1900 1905 1910 1915 1920 1925 1930 1935 1940 1945 1950 1955 1960 1965 1970

1980–1988 Iran–Iraq War

2004 Eastern European countries join EU

1977 Red Army Faction/ Baader-Meinhof Gang

1990 German reunification

1986 *Challenger* space shuttle disaster

2007 Al Gore awarded Nobel Peace Prize

1975 1980 1985 1990 1995 2000 2005 2010 2015 2020 2025 2030 2035 2040 2045 2050 2055 2060

GERHARD RICHTER

Gerhard Richter sees his work as an exploration of the traditional medium of painting, questioning its relevance in today's media-dominated society. His work combines both representational and abstract images, and its diversity is a constant source of surprise.

After working as a stage and advertising painter, Richter studied at the Dresden Art Academy. There, East Germany's tight control over artistic freedom, imposing Socialist Realism as a tool of social reconstruction, was too much for Richter to take. Shortly before the construction of the Berlin Wall in 1961, he managed to get out of the Soviet zone, and the same year he continued his studies at the Düsseldorf Academy of Art, which at the time was developing into a center of experimental art in Germany.

Painted Photography

In 1962, Richter adopted a photorealistic style before such a concept even existed. "I was fed up with painting crap, and copying a photo seemed to me the most imbecilic and inartistic thing one could do," he said in retrospect. His sources included photos from family albums, reproductions from the mass media, and his own pictures; from these sources he created his *Atlas*, a thematically diverse volume in which he collected images. Often, the artist opted for banal subjects, which he deliberately rendered out-of-focus in the painted version, so as to create an arm's-length relationship with the subject matter for the viewer. The mood of the work always comes across as reserved and impersonal, underlined by the predominant use of the "non-color" gray. But the austere, realistic images are not simply reproductions in a painted mode. Rather, Richter uses these images to make us aware of our habit of equating reality with the painted picture.

Painterly Diversity

After the pictures based on photographs came Richter's *Color Plates*, which were based on color swatches from a paint shop; monochrome gray-scale pictures; and "blurs" that make their subjects unrecognizable. Richter also worked on numerous heavily impastoed landscapes, modeled from aerial photographs of city centers, planning models from

architectural magazines, and Romantic landscapes, seascapes, and cloudscapes.

Since the mid-1970s, Richter has pursued a radical new approach to abstract works, which he paints without a model. The intrinsic effects of color and shape and the aspect of chance are important parts of his creative process. The artist applies paint to the canvas in numerous layers with "planned spontaneity" and without prior specifications, until he considers the work complete. "I have no intentions, no system, or direction to follow, I have no program, no style, no agenda," he declared. But he also still sticks to the mix of photographic realism and abstract painting. He has caused a public stir with series such as the *48 Portraits*, which showed cultural and scientific celebrities (for the Venice Biennale in 1972), and the Baader-Meinhof series *18th October 1977*, which portrayed members of the student terrorist group.

Although he is known first and foremost as a painter, Richter's work also includes performances, installations, sculptures, watercolors, drawings, photographs, and multiples. He lives in Cologne, where he designed a new window made of about 11,500 pieces of glass for Cologne Cathedral's southern window, which had been destroyed in the war.

1932 Born on February 9 in Dresden, Germany
1948–51 Works as a scene painter and commercial artist in Zittau in the German Democratic Republic
1952–56 Studies at the Art Academy in Dresden
1961–63 Member of the master class at the Düsseldorf Academy of Art
1967 Visiting lecturer at the College of Visual Art in Hamburg
1971–94 Art teacher in Düsseldorf
1972 Represented in the German pavilion at the Venice Biennale
1975–92 Member of the Academy of Art, Berlin
1982 Marries sculptor Isa Genzken
1988 Visiting lecturer at the State Academy of Fine Arts, Städelschule
1997 Awarded the Praemium Imperiale prize
2005 Founding of Gerhard Richter Archive in Dresden
2007 Takes part in Documenta 12, Kassel

left page
Gerhard Richter, *Abstract Painting*, 1977, oil on canvas, 250 x 200 cm, Stedelijk van Abbemuseum, Eindhoven

above
Gerhard Richter, 2002, photograph

DAVID HOCKNEY

JOSEPH BEUYS

ANDY WARHOL

1901 * Walt Disney 1914–1918 World War I

1952 Elvis Presley hits
the headlines

1969 Woodstock
music
festival

1939–1945 World War II

1965–1975 Vietnam
War

1885 1890 1895 1900 1905 1910 1915 1920 1925 1930 1935 1940 1945 1950 1955 1960 1965 1970

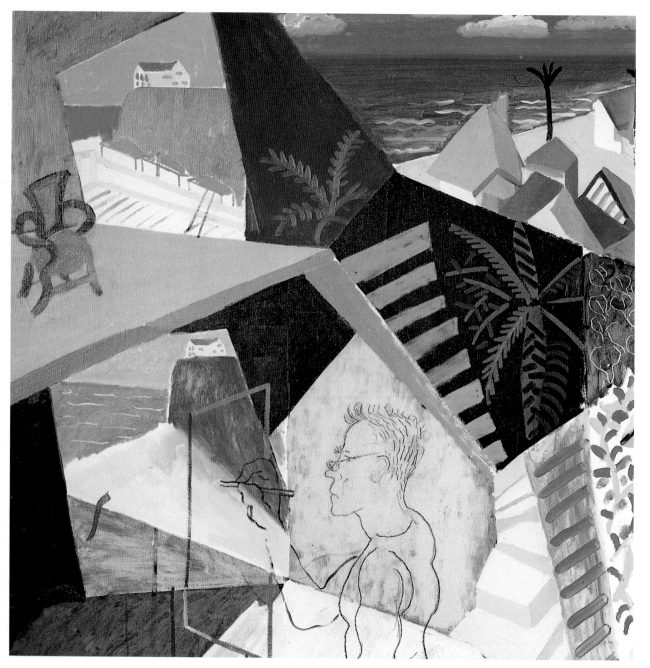

David Hockney, *A Visit with Christopher
and Don, Santa Monica Canyon*, 1984,
oil on two canvases, 183 x 610 cm,
Collection of the artist

1973 Watergate scandal

1986 *Challenger* space
shuttle disaster

2001 9/11 terrorist attacks in the United States

2004 Tsunami catastrophe in Asia

1975 · 1980 · 1985 · 1990 · 1995 · 2000 · 2005 · 2010 · 2015 · 2020 · 2025 · 2030 · 2035 · 2040 · 2045 · 2050 · 2055 · 2060

DAVID HOCKNEY

Even if he does not consider himself a Pop artist, David Hockney is nonetheless often cited as one of the most important artists of this movement. In his naturalistic pictures, he paints his friends, his dogs, his house, the rooms he stays in on his travels, and the scenery that he passes through, often using the traditional genres of portraits, still lifes, and landscapes. Yet Hockney avoids labels for his art, saying he seeks an original kind of perception and a voice of his own.

Hockney was born in Bradford, England, in 1937. He studied at the Bradford School of Art from 1953 to 1957, and then at the Royal College of Art in London, during which time he explored portraiture and familiar scenes. He developed a national reputation early in his career in England, before moving to California in 1964.

California

Hockney lived in Santa Monica, where he was fascinated by the villas, lush prosperity, palm trees, swimming pools, light, and heat. In works inspired by California, he dispassionately observes the good life with decisive linearity and nuanced coloration; he catches the typical leisurely rhythms of doing nothing and the pleasures of a paradise of abundance. In these and other works, Hockney relies on clear colors and simple compositions. He paints the reciprocal effects of exteriors and light, motionless and moving water, and the patterns of fabrics and domestic accessories such as furnishings and household goods.

The Aura of Objects

Hockney also expresses psychic characteristics · through decorative details, the incidence of light and atmosphere, body language, materials, and fabrics. For example, one of Hockney's most famous works is the portrait of designers Ossie Clark and Celia Birtwell posing with their cat, inspired by Jan van Eyck's *Arnolfini Portrait*. Hockney found the job quite taxing, saying "Oh, they sat for many hours. It was a real struggle … But then, at the end, it gets very close to naturalism as I understand it. The source of light—the open French window in the middle—was damn difficult. It had to be airy, and yet the center. But frankly, all the technical problems were caused because my main aim was to paint the relationship of these two people."

As reflected in his approach to this work, Hockney pursues a balance of form and content in his work.

He believes that the formal objectives should not overpower the content—as happened, in his view, in many Abstract Expressionist paintings—nor should content outweigh form. In this way, Hockney articulates an idea that runs like a thread through Pop Art—the idea that all material and formal phenomena in the picture are equivalent, whether it be the shape of a chair, a facial expression, the color of a curtain, the pattern on a rug, or indefinable symbolic elements.

After many years in California, Hockney returned to Bridlington, England, in 2000. In addition to his painting, he has worked as a draftsman, printmaker, stage designer, and photographer.

1937 Born on July 9 in Bradford, England
1948 Wants to become an artist and shows his posters on school bulletin boards
1959 Studies art in London
1960 His pictures are shown in public for the first time
1963 Finally makes a name for himself. Meets Andy Warhol.
1976 Travels across the United States
1980 His hearing declines
1982 Buys a house in Hollywood
1999 Three Hockney exhibitions open in Paris simultaneously

David Hockney, photograph

1927 Premiere of first "talkie,"
The Jazz Singer

1949 Founding of NATO

1962 Cuban Missile Crisis

1940 Frank Sinatra's breakthrough song
I'll Never Smile Again

1890 1895 1900 1905 1910 1915 1920 1925 1930 1935 1940 1945 1950 1955 1960 1965 1970 1975

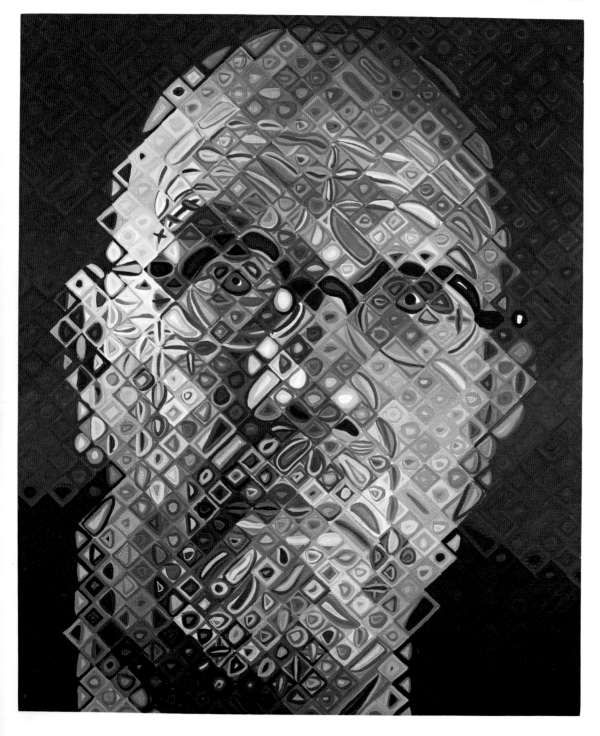

1975 Pol Pot regime comes to
power in Cambodia

1990 German reunification

1999 First e-book reader
on the market

2006 Iraqi court sentences Saddam
Hussein to death

2009 Barack Obama awarded Nobel Peace Prize

1980 1985 1990 1995 2000 2005 2010 2015 2020 2025 2030 2035 2040 2045 2050 2055 2060 2065

CHUCK CLOSE

Chuck Close's huge portraits based on photographs have helped revive the art of portraiture. His absolute focus in his choice of subject matter is paired with an openness in his working approach, as he has explored a wide range of techniques throughout his career. Close is one of the most influential and widely collected artists in the United States.

Born in Monroe, Washington, Close showed an interest in art from early on, asking his parents for an easel at the age of five. His father, who worked for the U.S. Air Force as a mechanic, made him one with his own hands. "It was a really good easel," remembers Close. Close went on to study art at the University of Washington, Seattle; Yale University; and the Academy of Fine Arts in Vienna.

The Heads

Close reinvented the portrait, which in the 1960s had been declared dead. It all began with a self-portrait in 1968, based on a photo of his own face. The painting is striking for the lifelike detail, down to single stands of hair. Close showed himself here unshaven and unkempt, a cigarette stub between slightly parted lips, his neck rising from a bare section of shoulder. The portrait is imbued with an attitude of rebellion.

Since then Close has focused almost exclusively on this genre, saying, "I paint heads because heads matter to everybody. If you paint a face big enough, it's hard to ignore." He started out as a painter of black and white, subsequently adding magenta, cyan, and blue as colors to his canvases.

The Photo-Realist

Close asserts that photography is a worthy object of art, and he ennobles it by translating a source photograph into a monumentally enlarged—that is, weighty—easel picture. He uses traditional screening techniques and follows the technical likeness square by square. However, within these restrictions he plays with magnification, depicting individual parts of the skin like abstract paintings, mountain ranges, or fields. Close creates the blurred areas with an airbrush, a technique that, like photography, was once considered craftwork. The perfection of the technique that Close uses can in turn be interpreted as an affirmation of painting: photography and painting are played off against each other with virtuosity.

In 1988, the total collapse of an artery in his spine left Close severely paralyzed. Despite this setback, he still paints today with the help of braces that stabilize his wrists and brush as he works.

1940 Born on July 5 in Monroe, Washington
1946 Receives his first set of oil paints
1961 Takes his first visit to New York City
1964 Receives a master of fine arts degree from Yale University
1966 Starts working with photographs
1968–70 Creates his "Heads" series in black and white
1970 Begins to experiment with color
1972 Publishes his first mezzotints
1978 Makes his fingerprints drawings
1979 Begins to use a Polaroid camera
1980 Returns to oil painting with a brush
1988 Left with incomplete quadriplegia as a result of a collapsed spinal artery
1997 Receives an honorary doctorate from the Rhode Island School of Design
1999 Begins to produce daguerreotypes
2000 Awarded the National Medal of Arts in Washington, D.C.
2004–09 Uses his daguerreotype and Polaroid photographs to create tapestry designs

left page
Chuck Close, *Self-Portrait I*, 2009, oil on canvas, 182.9 x 152.4 cm

above
Chuck Close, *Self-Portrait*, 2006, jacquard tapestry, 261.6 x 200.7 cm

1955 First Documenta exhibition in Kassel

1939–1945 World War II **1961** Construction of Berlin Wall

1945 Beginning of Cold War

| 1890 | 1895 | 1900 | 1905 | 1910 | 1915 | 1920 | 1925 | 1930 | 1935 | 1940 | 1945 | 1950 | 1955 | 1960 | 1965 | 1970 | 1975 |

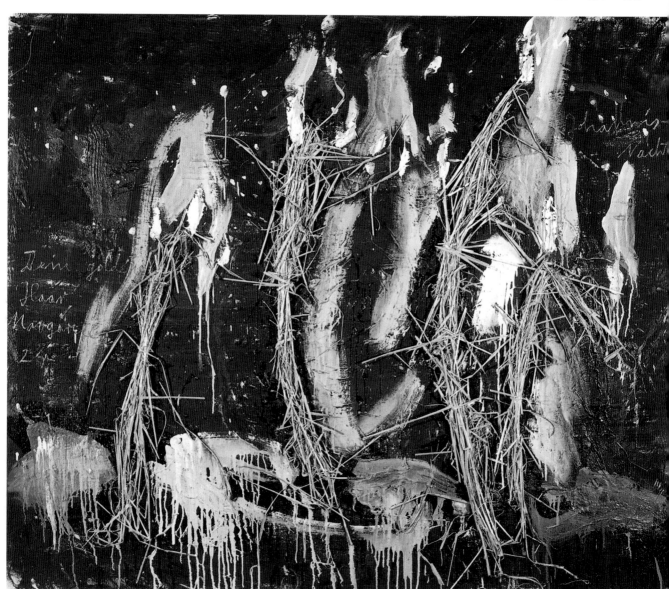

Anselm Kiefer, *Your Golden Hair,
Margarete*, 1981, oil, acrylic, and straw
on canvas, 130 x 160 cm

1983 Discovery of the HIV virus **2004** EU admits East European states

1990 German reunification **2007–2010** Global financial crisis

1979 Margaret Thatcher becomes **1998** Founding of International
British Prime Minister Court in The Hague

| 1980 | 1985 | 1990 | 1995 | 2000 | 2005 | 2010 | 2015 | 2020 | 2025 | 2030 | 2035 | 2040 | 2045 | 2050 | 2055 | 2060 | 2065 |

ANSELM KIEFER

In Anselm Kiefer's art, symbols and myths of German history are recurring motifs, especially the rise of the Nazis and their continued effect after World War II. Ever since his photo series Occupations, *in which he portrayed himself making fascist salutes, he has been one of the best-known and the same time most controversial contemporary artists in Germany.*

Politically Correct?

Initially Kiefer studied law and Romance languages, before switching to art. After studying in Freiburg and Karlsruhe, he became a pupil of Joseph Beuys at the Düsseldorf Academy of Art. When expressive figurative painting was all the rage, Kiefer did large-format landscape pictures, generally in gray and brown earth tones, integrating materials such as wood, fabric, or lead. He added names and terms in writing that refer to German history, principally Nazism. Not infrequently, Kiefer subsequently attacked his own work with an axe or burner, thus creating an appearance of devastation. In these and other works, the artist deliberately encourages viewers to make their own associations; he rarely expresses any public views about his ambivalent works.

Self-Dramatization

The photos in the *Occupations* series were taken in 1969, during a journey through various European countries. Kiefer had himself photographed doing Nazi salutes on the beach, in the mountains, or in front of the throne of Pope Pius XII, who had said nothing in the face of Nazi mass murder. The series of photos, one of the first works by the artist on the subject of the Third Reich, aroused public hostility. Only at a later date was the series appreciated and the courage acknowledged with which Kiefer approached totalitarian attitudes and issues of connivance. In an interview he said that, with these actions, he had wanted to "go part of the way, in order to understand the madness." And, he had to confess, "I felt very clearly the fascination that made it possible for a majority of Germans to believe it for a time."

Kiefer repeatedly triggered political controversy. His exhibition of works at the Venice Biennale in 1980 stirred up a fierce controversy about the artist's intentions, as he further explored themes of German nationalism and Nazism. After his subsequent exhibitions in New York, he was, according to *Time* magazine, "the best artist of his generation on either side of the Atlantic."

In 1992, Kiefer moved to the south of France. After a three-year break from painting and numerous trips to India, Mexico, China, and the United States, he abandoned recent German history to some extent, taking up more universal subject matter, particularly literature and poetry. Besides painting and photography, his oeuvre also includes graphic work, sculptures, installations, and artist books. Kiefer has won numerous awards, including the coveted Praemium Imperiale art prize in 1999 and the German Book Trade's Peace Prize in 2008. It was the first time in the history of the Peace Prize that an artist had been awarded it. The citation said Kiefer "had confronted his time with the disturbing moral message of the ruinous and ephemeral." Kiefer now lives in Paris.

1945 Born on March 8 in Donau-
eschingen, Germany
1966–68 Studies painting in Freiburg
1969–70 Studies at the Karlsruhe Art
Academy
1970–72 Studies at the Düsseldorf
Academy of Art under Joseph
Beuys
1999 Awarded the Praemium Imperiale
2007 Commissioned to create a work
for Louvre in Paris
2008 Awarded the German Book
Trade's Peace Prize

Anselm Kiefer, 1991, photograph

JEFF KOONS

ANDY WARHOL

DAVID HOCKNEY

1969 Woodstock
music festival

1962 Cuban Missile 1973 Water-
Crisis gate
scandal

1890 1895 1900 1905 1910 1915 1920 1925 1930 1935 1940 1945 1950 1955 1960 1965 1970 1975

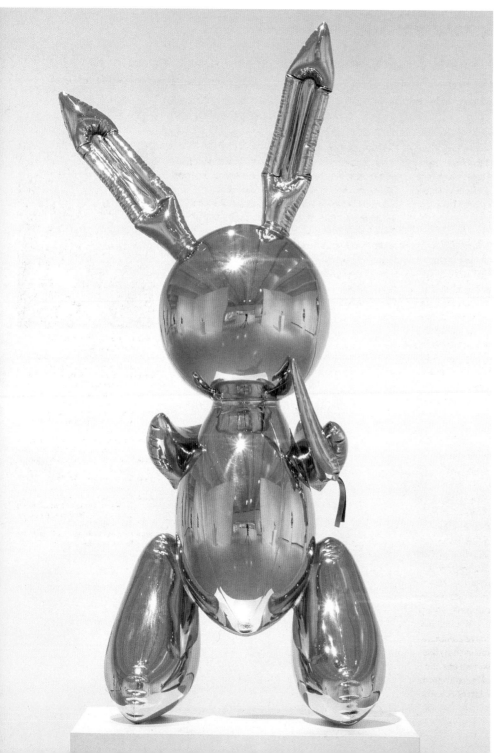

Jeff Koons, *Rabbit*, 1986, stainless steel,
104.1 x 48.3 cm, Private collection

2001 9/11 terrorist attacks in the United States

1999 Littleton, Colorado, school massacre

1993 Bill Clinton becomes U.S. president **2009** Barack Obama awarded Nobel Peace Prize

1988 "Freeze" exhibition in London is **2005** Hurricane Katrina devastates New Orleans
Young British Artists' breakthrough **2007–2010** Global financial crisis

2000 Dotcom bubble bursts

1980　1985　1990　1995　2000　2005　2010　2015　2020　2025　2030　2035　2040　2045　2050　2055　2060　2065

JEFF KOONS

Jeff Koons became famous in the mid-1980s as part of a generation of artists that explored the importance of art in a media-saturated era. With his ambition to "communicate with the masses," Koons draws on the visual vocabularies of the advertising, marketing, and entertainment industries.

Koons was born in York, Pennsylvania, in 1955. From 1972 to 1975, he studied at the Maryland Institute College of Art in Baltimore, before moving on to the School of the Art Institute of Chicago from 1975 to 1976. In 1976, he moved to New York, initially working as a broker on Wall Street.

Between Art and Kitsch

Koons made a stir as a sculptor beginning in the 1980s. He developed his reputation for replicating figures from everyday life and presenting them in a new form. For example, his sculptures have included Hoover vacuum cleaners enclosed in Plexiglas, basketballs in glass aquariums, and porcelain figures of Michael Jackson or the Pink Panther. In these works, he explores the boundaries between popular and elite culture. Koons is thus expanding the legacy of Dada and Marcel Duchamp, while integrating references to Minimalism and Pop Art. He presents his art as a commodity that cannot be pigeonholed into traditional categories.

Professional Production

Due to his complicated techniques, Koons has numerous assistants at work in his New York studio. Before production starts on a work, the sources are initially scanned. Then the elements are arranged on a computer, with someone fixing color values, contrasts, and transitions in great detail. Finally, a digital version of the work is produced. The assistants break the picture down into its component parts again, and enlarge them to make diagrammatic representations specifying the color for each fraction of an inch, in a manner reminiscent of contours on maps. Says Koons: "What I'm aiming for is a particular feeling in the viewer. If I don't have complete control over all the elements involved in that, the reaction is lost. Maybe part of the picture has too much texture, or a sculpture needed more accurate processing somewhere—the credibility of the whole work is gone."

Systematic Self-Marketing

In 1990, carvers of Madonnas from Oberammergau produced a life-size sculpture of the artist, designed by Koons himself. At the Venice Biennale, the naked sculpture was exhibited in a simulation of lovemaking with Hungarian-born porn star Cicciolina. It was good publicity for Koons to make himself an object of art. A year later he married Cicciolina. He then exploited this event, plus the birth of their son, in a media spectacle called *Made in Heaven*, which he intended as a critical take on the rules of the art trade.

1955 Born on January 21 in York, Pennsylvania

1972–75 Studies at Maryland Institute College of Art, Baltimore

1975–76 Studies at School of the Art Institute of Chicago

1976 Moves to New York and works as a commodities broker

1980 First solo exhibition at New Museum of Contemporary Art, New York

1985 Exhibition at the International Monument Gallery in New York

1986 Produces *Bunny* and *Luxury and Degradation*

1990 Represented at the Venice Biennale

1991 Marriage with porn star Cicciolina. The marriage and birth of his son become represented in *Made in Heaven*.

2000 Turns away from art and publicity for several years

Jeff Koons, photograph

1949 Premiere of Arthur Miller's
Death of a Salesman

1973 First
commer
PC

1919–1944 Prohibition in the United States

1905 Constitutional revolution in Iran **1936–1939** Spanish Civil War

1963 James Brown's breakthrough
album Live at the Apollo

| 1890 | 1895 | 1900 | 1905 | 1910 | 1915 | 1920 | 1925 | 1930 | 1935 | 1940 | 1945 | 1950 | 1955 | 1960 | 1965 | 1970 | 1975 |

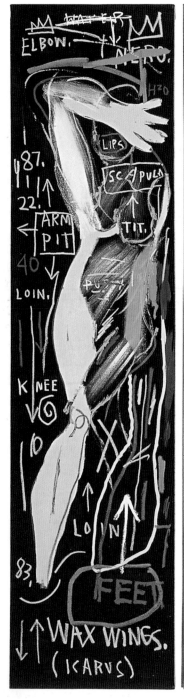

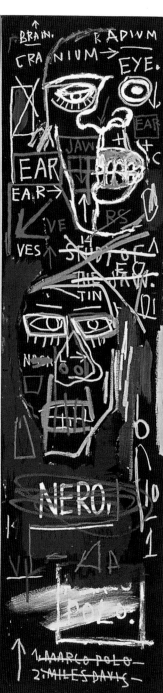

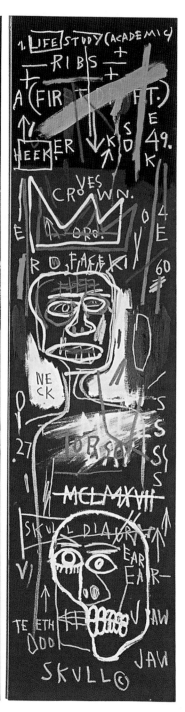

1985 Mikhail Gorbachev comes to
power in the Soviet Union

1994 Genocide of the Tutsi in Rwanda

2003 Darfur conflict erupts in Sudan

| 1980 | 1985 | 1990 | 1995 | 2000 | 2005 | 2010 | 2015 | 2020 | 2025 | 2030 | 2035 | 2040 | 2045 | 2050 | 2055 | 2060 | 2065 |

JEAN-MICHEL BASQUIAT

The Neo-Expressionism of Jean-Michel Basquiat combines African elements with febrile icons of New York's street culture. From the beginning of his career, Basquiat switched with ease between diverse contexts such as the graffiti subculture, the gallery scene, and major exhibition venues.

Basquiat was born to a Haitian father and a Puerto Rican mother in Brooklyn in 1960. At 18, he left home without completing school. His first step in art was undertaken together with his friend Al Diaz. Using the name SAMO (for "same old shit"), they scrawled graffiti all over Lower Manhattan, soon achieving local notoriety. To make a living, Basquiat and his girlfriend at the time, Jennifer Stein, stood outside New York's museums selling postcards and T-shirts they had painted themselves.

Gaining a Reputation

Early on, Basquiat did drawings on paper, metal sheet, T-shirts, or other materials and produced assemblages from scrap metal. His breakthrough came with the use of mixed-media techniques involving colored pens, oil crayons, pastels, watercolors, pencils, charcoal, and acrylics. The supports were canvas or paper, and he added words, grimaces, or the copyright symbol. In these pictures, he mixed African motifs such as masks and figures with signs and symbols he found on the streets of New York. Urban life was featured in images of cars, buildings, policemen, children's street games, and graffiti.

In 1980, Basquiat took part in an exhibition with Jenny Holzer, John Ahearn, and several other artists. The following year the arts periodical *Artforum* ran a major article on Basquiat. It was his breakthrough. Other exhibitions followed and added to his reputation, including the "New York, New Wave" show at PS1 and a 1982 exhibition in Italy. The same year, at age 21, he was the youngest artist ever to be invited to participate in Documenta, in Kassel.

In 1983, Basquiat became acquainted with artist Andy Warhol. Warhol became his mentor and promoter, and the relationship developed into a working partnership with joint exhibitions. By the end of his career, Basquiat's works were in demand among critics, collectors, and artists. The artist died at the age of 27 in 1988, from a heroin overdose.

1960 Born on December 22 in Brooklyn, New York

1967 Creates a children's book with a classmate from St. Ann's School

1968 His parents separate and eventually divorce

1974 Moves with his father to Mira Mar, Puerto Rico

1976 Returns with his family to Brooklyn

1977 Begins his "SAMO" collaboration with Al Diaz

1978 Leaves home

1979 Ends his "SAMO" collaboration

1980 Has his work featured in the "Times Square Show"

1981 Has his work reviewed by René Ricard in *Artforum*

1983 Commissioned by gallerist Bruce Bischofberger to create collaborative work with Andy Warhol and Francesco Clemente

1985 Featured on the cover of the *New York Times Magazine*

1987 Devastated by Warhol's death

1988 Dies on August 12 in New York City

1996 Release of the film *Basquiat*, directed by Julian Schnabel

2000 Release of *Downtown 81*, originally filmed in 1981 and featuring Basquiat

left page
Jean-Michel Basquiat, *Untitled*, 1983, acrylic and oil paint stick on canvas mounted on wood supports, three panels, 243.8 x 182.9 cm, Anette and Udo Brandhorst Collection

above
Lizzie Himmel, Basquiat in Great Jones Studio, New York, 1985, photograph

1962 Cuban Missile Crisis

1945 Beginning of Cold War

1965 Malcolm X is assassinated in New York City

| 1890 | 1895 | 1900 | 1905 | 1910 | 1915 | 1920 | 1925 | 1930 | 1935 | 1940 | 1945 | 1950 | 1955 | 1960 | 1965 | 1970 | 1975 |

Damien Hirst, *The Physical Impossibility of Death in the Mind of Someone Living*, 1991, tiger shark, glass, steel, and formaldehyde solution, 213 x 518 x 213 cm, Saatchi Collection, London

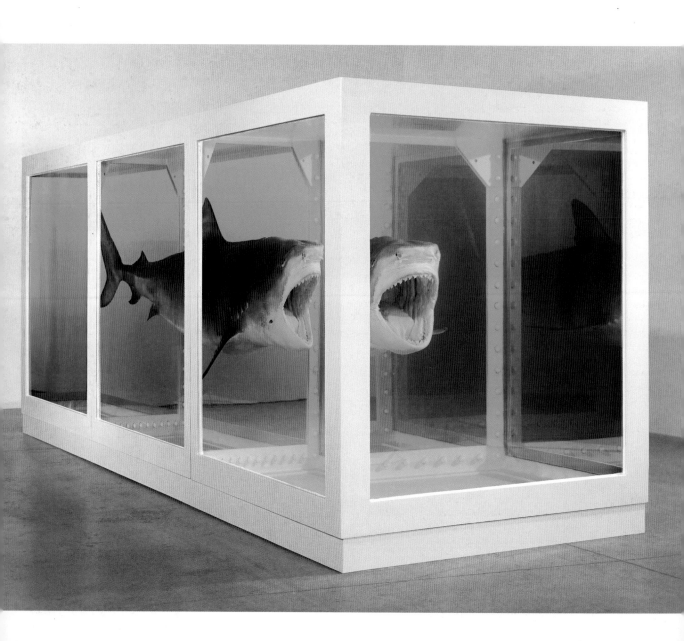

1979–1989 Soviet–Afghan War	2000 Dotcom bubble bursts
1988 "Freeze" exhibition in London is Young British Artists' breakthrough	2007–2010 Global financial crisis
	2009 Barack Obama becomes first African American U.S. president
	2006 Record price for a work of art ($140m) paid for Jackson Pollock's *No. 5* (1948)
1983 Production of first commercial mobile phone	

1980 1985 1990 1995 2000 2005 2010 2015 2020 2025 2030 2035 2040 2045 2050 2055 2060 2065

DAMIEN HIRST

A tiger shark steeped in formaldehyde, a skull studded with thousands of diamonds, a slowly rotting cow's head—eye-catching works have made British artist Damien Hirst rich and famous. His works are provocative to the point of discomfort.

Hirst was born in Bristol, England, in 1965. From 1986 to 1989, he pursued a fine arts degree at Goldsmiths College in London, not wanting to concentrate on a single genre such as painting or sculpture. During this period, he became a leading member of the group known as the Young British Artists. In 1988 he organized an exhibition called "Freeze" in London's Docklands, featuring his own work as well as that of many of his contemporaries. "Freeze" was followed by another show called "Modern Medicine." Both exhibitions made Hirst's name familiar to a wider public, as he began to explore the work—including animals in vitrines—for which he would become famous.

Sharks, Pills, and Ping-Pong Balls

Hirst's work explores themes of life and death, pathology and science, and order and disorder. An early example of this approach was the famous shark, which he pickled in a tank full of formaldehyde and called *The Physical Impossibility of Death in the Mind of Someone Living*. His work often features industrial steel and glass containers—a mix of Minimalist cube structures and forensic showcases. In the work *I Want to Spend the Rest of My Life Everywhere, with Everyone, One to One, Always, Forever*, Hirst suspended a ping-pong ball over a jet of air, seemingly creating a meditation on chaos and the eternal monotony of existence. This is Hirst's populist existentialism, or perhaps boyish humor, or perhaps a Surrealist sense of absurdity.

Hirst is a showman, businessman, and self-publicist as much as an artist. His exhibitions are large-scale spectacles that would seem more at home in a science museum or theme park than in a gallery. Typical of the scale and ambition of Hirst's output are items such as *Hymn* 2000, a 7-meter (22-foot) painted human torso in bronze, the external shell of which can be removed in places to give a view inside the body, like an outsize anatomy model. In *Lullaby Spring*, Hirst presented 3-meter- (10-foot-) long,

mirror-like medicine cabinets filled with colorful rows of pills arranged at precisely calculated intervals, representing the endless diversity of disease and the human drive to conquer it.

The Skull—A Public Relations Stunt?

Hirst's design for a skull made of diamonds—called *For the Love of God*—made headlines. Like much of Hirst's art, the skull was not made by the artist himself. Rather, a Bond Street jeweler created the work, which is studded with 8,601 flawless diamonds covering the entire platinum cast of a real skull. The forehead sports a 52-carat diamond. Acquired through ethically approved sources, the diamonds are estimated to be worth as much as £10 million. Priced initially at £50 million, the "sale" of the work was proclaimed in the papers at the time in 2007, but no evidence has been produced that this was not just a media stunt, perhaps a new kind of "performance" art.

In addition to art, Hirst has made music videos, established a restaurant, and produced pop songs.

1965 Born on June 7 in Bristol, England
1986–89 Studies at Goldsmiths College in London
1988 Organizes the "Freeze" exhibition with other students
1991 First solo exhibition, in the Woodstock Street Gallery, London
1992 Takes part in "Young British Artists" exhibition, in the Saatchi Gallery, London
1995 Awarded Turner Prize
1998 Publishes his autobiography *I Want to Spend the Rest of My Life Everywhere, with Everyone, One to One, Always, Forever, Now*
2000 Has a solo show at the Gagosian Gallery in New York

Damien Hirst in his studio in Chalford, England, September 2006, photograph

1950–1953 Korean War

1968 Premiere of Stanley
Kubrick's *2001:
A Space Odyssey*

1940 McDonald's founded

| 1890 | 1895 | 1900 | 1905 | 1910 | 1915 | 1920 | 1925 | 1930 | 1935 | 1940 | 1945 | 1950 | 1955 | 1960 | 1965 | 1970 | 1975 |

1977–1980 *Untitled Film Stills*
(Cindy Sherman)

2004 Murder of Dutch film director
Theo van Gogh

1987–1993 First Palestinian Intifada **2005** Founding of YouTube

1999 Kosovo War

| 1980 | 1985 | 1990 | 1995 | 2000 | 2005 | 2010 | 2015 | 2020 | 2025 | 2030 | 2035 | 2040 | 2045 | 2050 | 2055 | 2060 | 2065 |

MATTHEW BARNEY

Matthew Barney's oeuvre includes not only his best-known, multi-part Cremaster *films, but also independent videos, drawings, photographs, installations, and sculptures that elude definitive classification. According to the* New York Times, *he is the "most important American artist of his generation."*

Barney was born in San Francisco in 1967 and grew up in Boise, Idaho. After graduating from high school, he enrolled at Yale University to study medicine, while also working as a model. After two semesters, he switched his major to art, eventually graduating in 1989. While at Yale, he began his ongoing *Drawing Restraint* series, which involved physical tests of endurance in a gallery space.

Film Art
Barney's reputation largely rests on the opulent *Cremaster* films (1994–2002), a five-part project in which the plot is supplemented by photographs, drawings, installations, performances, and sculptures. The parts were not produced in chronological order. In the artist's words, they are a meditation on the process of creativity. The cremaster of the title is the male cremaster muscle, which raises and lowers the testicles and is thus part of the process of genesis.

The plots of the films are very complex and operate on several levels. There are numerous symbols alluding to sexual reproduction, especially the development of the embryo in the first weeks, when gender establishes itself. Yet as the films proceed, increasing numbers of biographical, historical, and cultural motifs get mixed in. Barney wrote the screenplays, directed, and acted one of the key roles in each film, while secondary roles have been played by celebrities such as actress Ursula Andress, artist Richard Serra, and writer Norman Mailer. The films feature little dialogue.

Another lavish project that spans nearly two decades (1987–2007) is the 16-part series *Drawing Restraint*. In the art film *Drawing Restraint 9*, the main roles are played by the artist and his wife, Icelandic singer Björk, who also composed the music. The principal location is a whaling ship, and the action involves parallel narratives. One is about the history of whaling and whale oil, while below deck a tragic love story takes place in which the

lovers are transformed into whales and escape into the sea.

Barney sees his work as "narrative sculpture" that he has successfully translated into various media. According to the citation for the Kaiserring Prize, awarded by the German city of Goslar in 2007, Barney is one of the "one of the greatest symbolists of the past fifty years, whose utopian visions have given rise to artistic works that investigate the boundaries between the sexes … His works are operatic in scale and cinematic in form … His works are an incomparable labyrinthine private cosmos in which potential processes responsible for the creation of Man merge with motifs and symbols from mythology, history, geology, and architecture to form a parallel universe."

1967 Born on March 25 in San Francisco, California
1973 Moves with his family to Boise, Idaho
1985 Enrolls as a pre-med student at Yale University
1987 Begins his *Drawing Restraint* series
1989 Graduates from Yale with a degree in the arts; moves to New York City
1990 Has his *Field Dressing* video shown in New York City
1991 Featured as the cover story of the summer issue of *Artforum*; has a solo debut at the Barbara Gladstone Gallery in New York City
1993 Wins the Europe 2000 prize at the 45th Venice Biennale
1994 Begins work on *The Cremaster Cycle*, a five-part film project
2002 Completes *The Cremaster Cycle*
2005 Exhibits his *Drawing Restraint 9* series at the 21st Century Museum of Contemporary Art in Kanazawa, Japan; releases the film *Drawing Restraint 9*

left page
Matthew Barney, *Drawing Restraint 9*, 2005, production still

above
Matthew Barney, 2007, photograph

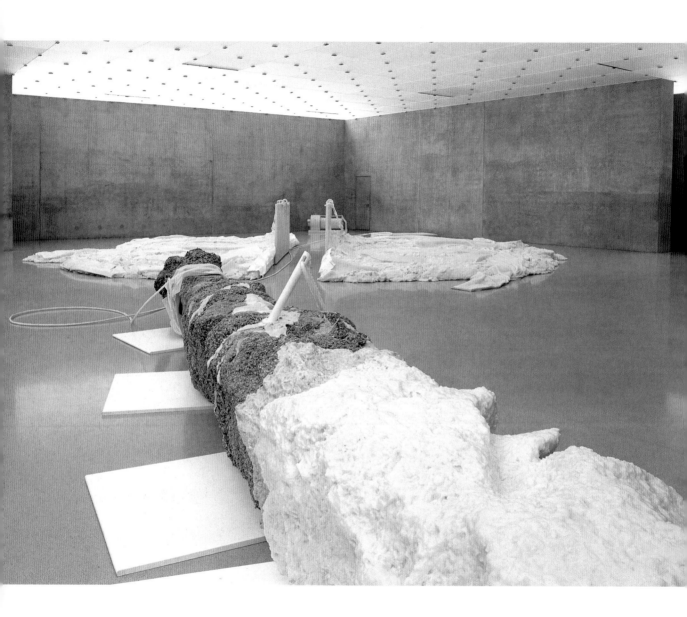

Matthew Barney, "*Mythos*",
June 2–August 9, 2007, Installation
View: Kunsthaus Bregenz, Bregenz,
Austria

Matthew Barney, *Goodyear Field* (detail), 1996, self-lubricating plastic, prosthetic plastic, petroleum jelly, silicone, Astroturf, pearlescent vinyl, cast tapioca, cast polyester, polyester ribbon, costume pearls, speculae, and Pyrex, 8.23 x 6.81 x 1.37 m overall

GLOSSARY

abstract, abstract art, abstract painting
"Abstract" means "nonrepresentational." The term usually refers to a nonrepresentational movement in art that started from 1910. Abstract artists are interested in allowing forms and colors to work in their own right, rather in than depicting things.

Abstract Expressionism
The term "Abstract Expressionism" was first used in European art criticism as early as 1919 to describe the work of Vasily Kandinsky. After World War II, critics applied it to the painters of the New York School—Arshile Gorky, Willem de Kooning, Jackson Pollock, and Mark Rothko—whose abstract aesthetic stood in stark contrast to the realism of the American Regionalist style. Inspired by European modernism and Surrealism, the Abstract Expressionists explored an automatic and even aggressive manner of applying paint that seemed to reflect an artist's psychological turmoil. In the process, they obscured and eventually obliterated the notion of representational art. Throughout the late 1940s and early 1950s, the raw intensity of these paintings attracted widespread international acclaim, effectively making New York City the new epicenter of the art world.

action
"Action," "performance," and "happening" are all terms referring to art that is like an experimental theatrical or musical production. In contrast to works of art in museums, these events exist only in the here and now. Happenings and performances draw the viewers into the action, but an action can also take place without an audience and be viewed later (for example, using photographs).

assemblage
(Fr.: "fitting together") Using the assemblage technique, an artist produces a work of art by fitting various objects together.

avant-garde
The avant-garde, as precursors of a new idea or movement, anticipate a general development, break with traditional forms, and establish something radically new.

biennale
(Ital.: "every other year") Biennales are international events such as art exhibitions or film festivals that take place every two years.

collage
(Fr. *coller*: "to glue") Using the collage technique, an artist creates pictures by gluing together newspaper cuttings, scraps of fabric, wallpaper, cut-up images, and more.

Conceptual Art
"Conceptual Art" has come to be a blanket term for art in which the idea behind the work is more important than the material product. This notion has its roots in the "ready-mades" of Marcel Duchamp, but it was not until the late 1960s that the philosophy developed into a large-scale movement, within which artists began rethinking traditional aesthetic concerns. In some cases they eliminated the physical art object altogether. Joseph Kosuth's landmark work *One and Three Chairs* (1965) invited the viewer to consider the notion of "chairness" through an installation that consisted of a physical chair, a photograph of a chair, and a written definition of the word "chair." Such works repudiated the conventional formal element of art and directed the viewer's attention to its concept, giving the idea priority over the object.

Constructivism
Some Russian artists showed what could be done with geometrical figures in the early 20th century. The sculptor Vladimir Tatlin and his artist colleagues El Lissitzky, Naum Gabo, and Alexander Rodchenko made geometrical figures into works of art. Tatlin christened this highly mathematical approach "Constructivism" in 1930. The artists of the day were just as interested in technology as they were in mathematics, so they often screwed together materials like wood, sheet metal, wire, or cable to form their works. While artists like Tatlin and Rodchenko placed their works at the service of profound social change, painters like Kasimir Malevich were fighting for the independence of art. Many Western artists, above all Piet Mondrian and the Dutch De Stijl group, were influenced by the Russian Constructivists. Alexander Calder was, for a time, a supporter of Constructivism.

Cubism
From the Renaissance onward, artists had tried to create the illusion of depth in canvases with the aid of central perspective. Pablo Picasso and Georges Braque did away with this in Paris around 1907. They deliberately emphasized the two-dimensional quality of their pictures and simply broke down the faces, musical instruments, jugs, and architecture depicted in their portraits and still lifes into flat circles, triangles, and squares. The movement was then named after these squares, or cubes. Paul Cézanne had started to do something similar, but these young artists were more radical than he had been. Early Cubism is called Analytical Cubism, and it dissects forms. Later there emerged Synthetic Cubism, which composed geometrical forms into new figure-collages. Other famous Cubists were Robert Delaunay, Juan Gris, Fernand Léger, and Marcel Duchamp.

Dadaism
After World War I, artists like Hugo Ball and Tristan Tzara organized raucous, drama-filled events in Zurich, Cologne, Berlin, Hanover, and New York, intended to provoke ordinary citizens and challenge the world that had emerged from the war. Kurt Schwitters built his "Merz" houses from found objects, sculptures, and collages. Other Dadaists included Marcel Duchamp, Francis Picabia, and Hans Arp. They were said to have named themselves after the French children's word for a wooden horse, "dada," but that, too, was made up.

Documenta
Documenta is a large, international exhibition of contemporary art held in Kassel, Germany, every five years.

Expressionism
Unlike the Impressionist artists, who sought to capture the atmospheric impression of light in nature, the Expressionists wanted to express their personal perceptions in painting, as the name suggests. The Fauve group in Paris demonstrated this with their exuberant colors and simplified forms. Vasily Kandinsky developed Expressionism further into abstract art. Abstract Expressionism was an American movement in the mid-20th century.

fine art
Art appealing to the sense of beauty, especially painting and sculpture. Today, the term embraces all forms of artistic practice, and therefore includes photography, film, architecture, and design.

graphic art
(Gr. *graphein*: "to write, draw, scratch") Graphic art includes drawing or the result of a technical printing procedure (printed graphics)—for example, an etching, a wood-cut, a copper-plate engraving, a lithograph, or a screen print.

happening → action

idealistic
Idealism in fine art is creating something toward an ideal. Realistic features are suppressed in favor of enhancing and trans-figuring reality.

Impressionism
The French Impressionists loved light. In good weather they would move out into the countryside or the city streets to capture—in the open air (French: *plein air*), in public squares, at racecourses, or in parks—the glowing shimmer of sunlight falling through the leaves, the mist over the Seine, or the steam from a locomotive. They wanted to catch in pure color the fleeting impression of the light at a certain time of day. They applied the paint to the canvas directly in rapid brushstrokes, without framing outlines. When viewed from close up, these paintings seem to dissolve into lines and dots again. It is only from a distance that an impressive picture emerges. Impressionism lasted from about 1860 to 1880. In France, important exponents included August Renoir, Edgar Degas, Alfred Sisley, and Édouard Manet; in Germany, important artists included Max Liebermann, Max Slevogt, and Lovis Corinth; in the United States, major Impressionists included Childe Hassam, William Merritt Chase, and John Henry Twachtman. The movement is named after Monet's picture *Impression, Sunrise*, in which the painter captured the morning mist in the harbor at Le Havre.

installation
Installations are three-dimensional works of art set up in an existing space. A great variety of materials and media can be used.

Minimalism
Minimalism sought to reduce the medium of sculpture down to its purest form. Minimalist sculptors created spare, geometric objects that rejected illusionism and asserted their simple, concrete tangibility. In the 1960s, the Minimalist movement was informed by Post-Painterly Abstraction as well as Minimalist music, both of which sought to reduce their aesthetic to its purest expression. Some artists, such as Donald Judd, employed a Minimalist approach to create universal statements that held no ambiguity—offering only the truth and specificity of their "object-hood." Others, like Maya Lin, used the emotional power of simplicity, as seen in her Vietnam Veterans' Memorial in Washington, D.C. (1981–83).

modern art
Collective term for the various artistic styles since about 1890.

object
Objects are (modern) works of art made of, or assembled from, found objects.

Object Art → Conceptual Art

objet trouvé
(Fr: "found object") A found object from nature or the everyday world that an artist declares to be a work of art or incorporates into a work of art.

performance → action

Pop Art

"Pop Art" suggests the everyday, and the Pop artists from England and the United States did, indeed, want to depict popular, everyday items artistically. Previously, the New York Abstract Expressionists had banished everyday objects from their pictures. Now, suddenly, film and pop stars, famous politicians, cars, road signs, cigarette packages, beer cans, and flags began to appear in art, in the manner people knew them from fashion magazines, the supermarket, or the street. Important Pop artists included Andy Warhol, Richard Hamilton, Roy Lichtenstein, David Hockney, and Claes Oldenburg.

Post-Painterly Abstraction

Post-Painterly Abstraction developed in the late 1950s and 1960s, as many Abstract Expressionist painters began shifting away from the intensity of the visceral, painterly style of the New York School to a more serene and rational approach to constructing images. These artists concentrated on the elemental properties of painting—color and shape—to attain a greater purity in their medium. This new approach ranged from the hard-edged abstractions of Ellsworth Kelly and Frank Stella to the poured paint and stained canvases of the Color-Field painters Helen Frankenthaler, Morris Louis, and Richard Diebenkorn.

ready-mades → objet trouvé

retrospective

A retrospective (literally: "looking back") is an art exhibition, summing up individual phases of an artist's work, or all of it.

sculpture

Sculptures are three-dimensional works of art. A distinction can be made between a work of art created from a malleable material, which was originally soft (for example, clay or cast bronze), and those carved from a hard material (stone or wood). A freestanding sculpture is a work of art that can be viewed from all sides.

series, also edition

In fine art, this means a series of works of art of the same kind.

studio

An artist's workshop or workroom.

Surrealism

Surrealism came into being in Paris as a continuation of Dadaism. The term comes from French, and means something like "beyond reality." Unlike the realist painters, the artists around the poet André Breton did not want to depict the visible world, but rather to reveal a world that lies concealed in our dreams and nightmares. The Surrealists believed that it is possible to look into people's souls in dreams. And as in a dream, they put apparently unconnected and even absurd things together to form new combinations in their pictures. One example of this is Salvador Dalí's *Lobster Telephone*. Important Surrealists included René Magritte, Yves Tanguy, Meret Oppenheim, Joan Miró, Man Ray, Giorgio de Chirico, and Max Ernst.

triptych

A triptych is a picture consisting of three parts.

PHOTO CREDITS

The illustrations in this publication have been kindly provided by the museums, institutions, and archives mentioned in the captions, or taken from the Publisher's archives, with the exception of the following:

Artothek: pp. 26, 30, 42, 98
Ugo Mulas: p. 77
The Henry Moore Foundation: pp. 92, 94, 95
Christopher Burke: p. 108
bpk/Museumslandschaft Hessen Kassel: p. 114
Laurie Lamprecht, New York: p. 119
The NewYorkTimes/Redux/laif: p. 123
Giulio Pietromarchi: pp. 130/131
Larry Rivers: p. 129

akg-images/Bruni Meya: p. 133
akg-images/Binder: p. 141
akg-images/Purkiss Archive: p. 147
Gamma/laif: p. 143
Chris Winget: p. 148
Markus Tretter: p. 150
Prudence Cuming Associates/© Hirst Holdings Limited and Damien Hirst: p. 146

INDEX